The Art of Short Form Content

The Art of Short Form Content: From Concept to Color Correction is an in-depth examination of the craft of creating short form filmic content – a category which includes television commercials, music videos, television promos, movie trailers, digital billboards, corporate videos, and pretty much anything else with a running time under five minutes. Though short form is an important part of the film industry, it is typically overlooked in books on the art of filmmaking. *The Art of Short Form Content* fills this industry void by answering the type of questions that working short form content creators deal with every day. As Cook explains, though short form content is limited in duration, it is not limited in quality and message. In this step-by-step, full-color guide, you will find:

- Interviews with leading short form content creators
- Details on how to create everything from a corporate piece to a Super Bowl spot
- Strategies for how to quickly attract viewer attention to your content
- Extensive information on how to best utilize the craft of filmmaking in an advertising context
- A comprehensive companion website that can be found at www.focalpress.com/cw/cook

Bryan Cook is currently the Executive Content Producer and Director of Multimedia at Team One Advertising in Los Angeles. Over the course of Bryan's fifteen-year career as an Editor and Post Producer, he has partnered with many of the best ad agencies, networks, and production shops in the world, and projects he has worked on have been honored by *Ad Age*, *Adweek*, Cannes, The Effie Awards, The Facebook Awards, FWA, The Golden Trailer Awards, and the Tribeca Film Festival.

The Art of Short Form Content

From Concept to Color Correction

Bryan Cook

Focal Press
Taylor & Francis Group

NEW YORK AND LONDON

First published 2016
by Focal Press
711 Third Avenue, New York, NY 10017

and by Focal Press
2 Park Square, Milton Park, Abingdon, Oxon OX14 4RN

Focal Press is an imprint of the Taylor & Francis Group, an informa business

© 2016 Taylor & Francis

The right of Bryan Cook to be identified as author of this work has been asserted by him in accordance with sections 77 and 78 of the Copyright, Designs and Patents Act 1988.

Library of Congress Cataloging in Publication Data
A catalog record for this book has been requested

ISBN: 978-1-138-91052-2 (hbk)
ISBN: 978-1-138-91051-5 (pbk)
ISBN: 978-1-315-65807-0 (ebk)

Typeset in Adobe Garamond by
Servis Filmsetting Ltd, Stockport, Cheshire

To James, Annika, and my amazing wife Caroline

Contents

Acknowledgments

I would like to thank my editors, Emily McCloskey and Elliana Arons, who have been a fantastic team. I would also like to thank Tim Byfield and Michael Kunichika who were incredibly helpful to me as I was writing this book; Brian Hosay, Pete Barrett, and Chris Guidi, with whom I spent way too much time watching films as a young man; and Tim, Blake, Jeff, and Deb Cook, with whom it all began. Lastly, I would like to thank all the individuals whose work has influenced and inspired me throughout my career and as I wrote this book. It is truly an honor to be able to work in short form content creation and I am blessed to be able to create things alongside so many talented people.

Introduction

For sale: baby shoes, never worn.
Ernest Hemingway

Short form video content is *everywhere*. We take this fact for granted, but if you think about all the video content with a run time of less than five minutes that you consume in a typical day – commercials on TV, viral videos in your Facebook timeline, trailers advertising upcoming movies, promos advertising TV shows, music videos, content on digital billboards, and other out-of-home video displays, etc. – you can see how prevalent this sort of content really is. Despite this – and despite how many talented people make a living producing work of this nature – there has been very little analysis of the *art* of short form video content. The art of long form motion picture creation has been exhaustively examined, but short form content has generally been ignored. There are a number of reasons for this discrepancy – long form work lends itself better to a specific type of theoretical analysis; long form has a more obvious cultural footprint; long form, with its titanic egos and off-screen intrigue, is just *sexier* – but it is still a surprising oversight, as there are some profound differences between short form and long form that

"The art of long form motion picture creation has been exhaustively examined, but short form content has generally been ignored."

affect how the former, from a creative perspective, is ultimately made.

As an editor and post-producer who has worked in short form for over fifteen years, I wrote this book because I wanted to help fill this void. In the pages to come I will attempt to answer, as best I can, many of the questions we deal with every day as short form content creators. Questions like what is the best way to structure a piece? What do we ask images to do in short form? How should music be used? How should sound design be deployed? What is the best way to harness the power of color grading? In my attempt to answer these questions I will start by looking at short form's core objectives – attracting attention, evoking an emotional response, and shaping perception in order to motivate action – and then try to suss out the best way to achieve these goals by focusing on the individual crafts involved in the production of short form work.

Although our examination will situate short form filmic content within the realm of advertising, we will not spend much time looking at the sort of things – strategy, branding, positioning, etc. – that marketers

and ad agencies tend to focus on. These issues concern us in the sense that they motivate short form's creation, but our examination will focus less on big picture marketing questions and more on how the objectives of advertising influence and impact the shape short form filmic content takes. Short form content is born out of the marriage of film and advertising, and we will be looking at how all the elements of filmmaking – editing, sound design, color grading, visual effects, etc. – are impacted by this union.

As you will see as this book moves along, our examination will ignore certain types of short form video content – short films with no affiliation to a brand, video art, etc. – and will instead focus exclusively on short form content that is created within an advertising context. This is not to downplay the importance of these forms, but their objectives are significantly different than the type of short form content we are interested in and, if you're paying your rent making short form content, you are almost always working within the advertising ecosystem (I *wish* video artists and short filmmakers could be better compensated for their work but, alas, this is not the case).

Furthermore, although our examination will look closely at the various disciplines in the short form ecosystem, to avoid getting bogged down we will not be delving too deeply into technical production issues (e.g., which editing software to utilize or the mechanics of lighting a scene). There are lots of wonderful books that look at the various disciplines of filmmaking from a technical perspective, but this particular analysis is more concerned with how these disciplines

> **" Short form video content is born out of the marriage of film and advertising . . . "**

are creatively impacted by living at the intersection of advertising and film.

Lastly, as you will see as we move through the book, we are occasionally going to be dipping our toes into a modest amount of film theory. My motivations for doing this are to add some context to the conversation and also because understanding the fundamentals of a medium can be quite beneficial to the creative process. As a short form content creator you are asked to make thousands of decisions a day, all of which will affect the piece you are working on, and being able to ground some of these decisions in an understanding of how film works can be incredibly useful.

Before we get going, take a look at the epigraph above. The legend is that Hemingway was at the Algonquin Hotel having cocktails with some friends when he made a bet that he could write a compelling story using only six words. His friends, understandably, felt good about their odds, and so they took the bet, figuring that not even Papa could manage this feat. Hemingway thought for a second and then wrote it down: "For sale: baby shoes, never worn." A hush must have fallen over the rambunctious gathering

when he unveiled his creation, as Hemingway's story possessed everything a narrative should contain: a beginning, middle, and end; a rich cast of characters; an interesting tone of voice; and, a powerful emotional punch. Undoubtedly, he won the bet.

I mention this anecdote not to make the obvious point that one can produce rich, evocative work despite having a limited duration to work with – as short form content creators or aspiring short form content creators you already know this – but to illustrate something fundamental about how content of this nature is actually made. If you look closely you will see the trick Hemingway played. Yes he abided by the rules of the bet in the sense that he kept his story to six words, but what Hemingway didn't make explicit when he made the bet was the *punctuation* he would be allowed to use. This was a clever omission on Hemingway's part, as without the punctuation the story completely falls apart. Besides lacking coherence, "For sale baby shoes never worn" desperately misses the pathos supplied by the punctuation (the indifference of that colon is particularly gut wrenching).

As a short form content creator you are asked to make thousands of decisions a day . . .

Hemingway's trick is a perfect example of the art of short form content creation. Yes we have a limited amount of time to tell our stories – that is the impediment – but there is no limit to how clever we can be with the tools available to us. We only have thirty seconds to tell a tale that spans generations and continents? No problem, utilize great sound design and some well-placed effects and we can pull it off. We only have two minutes to evoke the full emotional weight of a feature length film? Not an issue, throw out every non-essential storyline, make some good musical choices, and the trailer will end up being *better* than the film. Because, as we all know, if we expertly utilize all the tools at our disposal, even a thirty-second TV spot for a vacuum cleaner can be emotionally impactful. It's a challenge – after fifteen years of doing this I still sometimes lean back in my chair and think to myself "I can't believe that worked!" – but the fact that it is such a challenge is precisely what makes creating short form filmic content so fascinating and enjoyable. Let's begin.

Signal Through Noise:
The Concept

One must know not only how to play well but also how to make oneself heard. A violin in the hand of the greatest master emits only a squeak if the hall is too big; there the master can be confused with any bungler.
Friedrich Nietzsche, *Human, All Too Human*

The universal human laws – need, love for the beloved, fear, hunger, periodic exaltation, the kindness that rises up naturally in the absence of hunger/fear/pain – are constant, predictable, reliable, universal, and are merely ornamented with the details of local culture. What a powerful thing to know: that one's own desires are mappable unto strangers.
George Saunders, *The Braindead Megaphone*

Kids pick strange things to obsess over, and somehow, for reasons unclear to my wife and me, our daughter Annika became intrigued by hippos. Now, I wouldn't want to say anything bad about *Hippopotamus Amphibious* – despite being herbivores they are notoriously quick to take offense – but I do have to point out that they are not the most appealing creatures in the world. Unlike the sexually adventurous Bonobo monkey or the dissolute male lion, the hippo is actually quite boring. Yes it can urinate backwards, which is certainly a neat trick, but from what I can gather the life of a hippo seems to consist of long stretches of floating aimlessly about with the occasional random attack on an unsuspecting villager thrown in to break up the monotony. Even hippos don't seem to like fraternizing with hippos, as Wikipedia sums up their socializing by pointing out that despite their tendency to huddle closely together, hippos "do not seem to form social bonds except between mothers and daughters, and are not social animals. The reason they huddle close together is unknown."

" . . . we live in a world where the rules of media consumption are rapidly changing."

Despite these character flaws, my daughter can't get enough of hippos, and when the hippo books have been read and the hippo's pajamas put on, there is nothing she likes more than to curl up in my lap and watch clips of hippos online. As a result of this, I have had the chance to see countless clips featuring hippos: a segment from British TV about a hippo named Jessica who lives with a family in South Africa and seems very un-hippo-like in her reluctance to menace her caregivers; a commercial from the 1980s for a board game called Hungry Hippos; a series of clips from the San Diego Zoo of hippos swimming about looking depressed. Sadly, no matter how many times I click to the next page on YouTube, I still have yet to run out of short form video content that a hippo-obsessed kid can consume.

Besides being an annoyance – please YouTube, just kick me to a page on the Meerkat that will interest the child – there is something interesting about this wealth of hippo-related material and how my daughter and I consume it. Namely, that we live in a world where the rules of media consumption are rapidly

changing. From our phones, to our Facebook time-lines, to the video displays at our local gas stations, our media landscape is becoming increasingly filled with short, sharable video content. This evolution, coupled with the short form content we already *were* consuming – television commercials, music videos, promos, trailers, show opens, etc. – has led to an explosion of filmic content with a run time of less than roughly five minutes. While this explosion has been great in the sense of creating employment opportunities and pushing the craft forward, it has also made it much harder to create work that is effective, as there is just so *much* of this stuff competing for viewers' attention (to give just one example, over three hundred hours of content are uploaded to YouTube *every minute*).

So, the question we now must ask ourselves as short form content creators, and the question which motivated the writing of this book, is how do we produce rich, evocative content that can cut through this noise? In order to answer this question we will look at all the unique disciplines that are part of the short form eco-system, but, before we do, we need to take a moment and lay the groundwork for our discussion by defining what exactly makes a piece of short form content a success. This examination will give us a good starting place and will orient us as we move through the different disciplines.

To begin, I believe that there are three interrelated objectives that any piece of short form content must achieve in order to be successful. Since the vast majority of short form content is, in one way or another, an advertisement, **the first thing a piece of short form**

> " *. . . there are three interrelated objectives that any piece of short form content must achieve in order to be successful.* "

needs to do is attract attention. This step is obviously quite crucial, as you could make the most beautiful piece of short form in history, but if you fail to get viewers' attention, you're doomed.

Once attention has been acquired, the next objective is to **evoke an emotional response in the viewer**. You need to do so in order to *retain* attention – any piece of content that fails to make viewers feel something is going to have a hard time keeping them hooked – but also because of the pivotal role emotions play in the buying process.

Once these objectives have been met, the last thing a piece of short form content needs to do is to **shape perception and motivate action**. The way this would look is that a viewer sees a trailer on YouTube and decides that the movie looks good (perception being shaped), and then goes out and sees the movie that weekend

(action being motivated). Let's break these three notions down and see if we can't end up with a good guide to the basic foundation of short form content.

Attracting Attention

I have gently touched upon this notion a few times already so let's just state it explicitly and get it out of the way; the vast majority of short form filmic content is advertising. Yes I know, you probably consider yourself as an artist not an adman, but, if you are getting paid to make short form content, you are almost always making ads. The commercial advertises a product, the trailer advertises a film, the music video advertises an artist/album, and so on. This is quite different from the majority of long form content, as the TV shows and movies you watch are not ads but instead are end products. Long form content can often *feel* like an ad given product placement and other ways programmers have tried to monetize their content, but, at the end of the day, long form content is almost always an end product and short form content rarely is (as I mentioned in the introduction there are exceptions to this, such as short films or video art, but these are definitely in the minority).

Short form's status as advertising means a couple of things for the short form content creator – besides the fact that you might need a stiff drink right now as you contemplate your membership inside the evil empire – but the most crucial is that **the first task for any piece of short form content is going to be getting viewers' attention**. People will pay attention to a TV show because it has a story that they want to engage with. They will go to YouTube to watch clips of cats playing the piano because, well, people seem to enjoy watching cats play the piano. The commercials you make that ultimately pay for all this amazing stuff? Not so much, that is what the DVR is for. So, short form content must be instantly engaging. It must force the viewer to pay attention despite the fact that it is usually an interruption from the content that they actually want to consume. To look at it from the perspective of an economist, the value of any individual piece of short form content lies in its ability to capture that most precious of resources: attention. As Michael Goldhaber put it in his essay on "The Attention Economy":

> So, at last, what is this new economy about? …We are told over and over just what that is: information. Information, however, would be an impossible basis for an economy, for one simple reason: economies are governed by what is scarce, and information, especially on the Net, is not only abundant, but overflowing. We are drowning in the stuff, and yet more and more comes at us daily…But, attention,

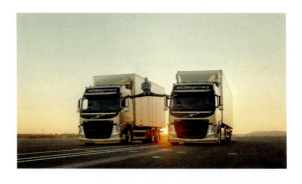

Van Damme and his "Epic Split."

at least the kind we care about, is an intrinsically scarce resource…So, having attention is very, very desirable, in some ways infinitely so, since the larger the audience, the better. And, yet, attention is also difficult to achieve owing to its intrinsic scarcity. That combination makes it the potential driving force of a very intense economy.[1]

I think this is basically correct, and what Goldhaber is positing – an economy based on the value of getting attention in a world awash in information – nicely sums up the challenge we as short form content creators face (as Nietzsche put it in our epigraph, "One must know not only how to play well but also how to make oneself heard."). Let's now take a look at a piece of short form content, the viral video "Epic Split," which does an excellent job of attracting attention.

"Epic Split" was created to promote the dynamic steering found in Volvo's trucks. The spot swept all

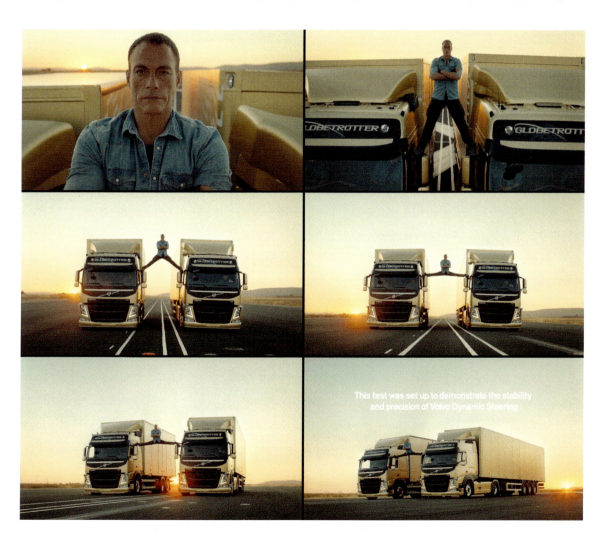

Images from "Epic Split."

the major ad award shows and was an enormous viral hit, with over 77 million views on YouTube, countless parodies, and enough organic PR that some marketer in Sweden probably spontaneously combusted from happiness. If you somehow managed to miss it, "Epic Split" features the actor Jean-Claude Van Damme delivering a monologue on the vicissitudes of his life while perched on top of two Volvo trucks that slowly separate, forcing Van Damme into his "epic split." All of this happens in one majestic take – scored by Enya's "Only Time" – as the camera starts on Van Damme's face and then pulls back and sweeps downwards to reveal the Volvos moving backwards as our hero does his maneuver. The spot ends on a lone title card that simply states; "this test was set up to demonstrate the stability and precision of Volvo Dynamic Steering."

"Epic Split" had no media dollars behind it, which meant that it had to capture and retain attention organically. The ability to do this is what makes or breaks a piece of viral content, so successful work of this nature is engineered to attract attention and be highly shareable. "Epic Split" is tailor-made to do

The opening frame of "Epic Split."

so, as it features a celebrity – always a good thing for getting attention – doing something quite remarkable. Besides having a concept that is guaranteed to attract attention, the spot is executed in such a way that from the first frame – which is a close-up of Van Damme being gently jostled by the movement of the trucks beneath him – to the last, you are hooked.

Although the premise of the spot is quite unique, the piece has a real narrative simplicity, which is key for short form in terms of attracting attention. Viewers opt into watching long form and so they will usually tolerate a more complex narrative that might take them a bit of effort to work out. In short form they will discard the work immediately if they feel like it will take too much cognitive energy to figure out the basic workings of the story. As we have seen, and will continue to see as this book moves along, making great short form content takes a lot of really talented people executing their individual crafts at the highest level. This process involves countless hours of work and thousands of individual decisions for just one piece. That said, no matter how much thinking goes into your work or how novel your approach, at the end of the day, the basic plot and concept of your narrative should be clear and concise. This is why "Epic Split" works so well, as the narrative you need to understand in order to follow what is going on can be boiled down to "a guy doing a split on top of two trucks as they drive backwards." This sort of simplicity in the basic plot is critical for short form, as the way people see our work, whether it be during a commercial break or playing overhead on a video display in Times Square,

necessitates that the basic story can be followed fairly easily.

This way of thinking echoes something that psychologists refer to as "cognitive fluency." As Drake Bennet describes cognitive fluency in an article in *The Boston Globe*, "Cognitive fluency is simply a measure of how easy it is to think about something, and it turns out that people prefer things that are easy to think about to those that are hard." He goes on to note that everything from choice of font to the name of a company can affect human beings' thinking and decision-making process which leads him to conclude that "the human brain, for all its power, is suspicious of difficulty."[2] This notion that people prefer things that are easy to think about is important, as the major problem with short form content that has a narrative that is hard to follow is that most people will encounter it, assess the difficulty involved with comprehension, and turn away. After all, if the deal we offer viewers is their attention in exchange for an emotional experience – which we will get to shortly – the harder comprehension appears to be, the less likely viewers will be to make that deal.

This is not to say that a piece of short form shouldn't be creative or novel, as things that are boring and predictable will also be ignored, but what we can take from this is the notion that in the basic narrative sense, short form ideally should be easy to follow. And this is what "Epic Split" does so well, as although the setup is quite novel and there is high powered creative thinking involved in both its ideation and execution, the basic story is simple enough that a three-year-old can follow it. This simplicity, coupled with its use of

> ❝The **deal** the viewer is offering in this scenario is, basically, their **attention** in exchange for an emotional experience.❞

a celebrity and the way it is executed – every choice, from the music, to the color grade, to the way the camera moves, is pretty much perfect – makes "Epic Split" impossible to ignore.

Evoking an Emotional Response

A few years ago, as I was sitting around waiting for a file to compress, a talented, thoughtful, and diligent assistant editor I was working with came into my bay looking despondent. I asked what was wrong, preparing myself for the worst – assistant editors often come bearing news such as "I just spilled a glass of water in the machine room" or "Edit B won't turn on and just keeps making this weird, clicking noise" – but what he said caught me off guard. "I hate editing."

A bit taken aback, I asked him to explain. "In school I used to love cutting but now, every time I sit down to do a rough cut, I start to get this awful feeling in my stomach. I feel like I have all these choices I could make and that I am not capable of making the right one. How do you know what is the right way to edit something?"

I tried to calm him down with comments like "there is no right answer, what we do is not a math equation" but after he left, looking just as perturbed as when he had come in, I realized that everything I had been saying to him was, to put it bluntly, bullshit. The reason why it was bullshit is that there *is* a right answer to the questions posed by a particular project (or, at the very least, there are a finite number of correct responses). As Duke Ellington put it "There are two kinds of music: music that sounds good and whatever you want to call that other stuff." We all know this divide exists. We all know when a piece is good and when it is "that other stuff." But, how do we describe this?

Later that evening, while having my nightly restorative, I pondered the issue. With short form we know we need to attract attention and shape perception in order for a piece to be effective, but neither of these things are what makes a piece "good" in the sense that Ellington means. So what is that quality, that magical element, which elevates a piece from "that other stuff" to something that really works? After a bit of thought I determined that

the answer to this question was actually quite simple, as the basic thing that connects all short form that is good in the way Ellington means is that it **evokes an emotional response in the viewer.** Sure you want to shape a coherent story that conveys a particular piece of information, that is the basic thing, but what we are really trying to achieve as short form content creators is to make the viewer *feel* something. The emotion we are trying to engender could be anything from a laugh to a tear, but what we are ultimately tasked with doing as short form content creators is to execute in such a way that the full evocative potential of a piece is achieved.

There are two main reasons you need to evoke an emotional response in the viewer. The first is that the average viewer is going to approach *all* content from the perspective of "what will I get out of watching this thing?" They will take a peek at what you are offering and say, "ok, I will watch your advertisement and absorb the message about your product that you are pushing, and in exchange you will make me feel *something*. If you deliver on your promise and evoke a response, I will consume your content and perhaps even interact further with it by sharing it with my friends. If you don't deliver, I will stop watching and, if you *really* annoy me, I will go online and slam your commercial and the product it is advertising." The deal the viewer is offering in this scenario is, basically, their attention in exchange for an

The reason advertisers pay to create and air short form is so that they can generate a need in the consumer.

emotional experience. All good short form honors this exchange, as within every successful short form piece there will be a moment where the viewer is so engaged that they forget about the bills piling up at home, the boss who is always on their back, and everything else in their life that they need a break from.

The second reason you need to evoke an emotional response in the viewer is connected to short form's status as advertising. The reason advertisers pay to create and air short form is so they can generate a need in the consumer. If you go into a movie theater and find yourself getting swept up in a trailer for an upcoming release and turn to your friend and whisper "I have to see that film," that is advertising doing its job. If you watch an iPad commercial and suddenly feel as if the things that the iPad offers are things you can't live without, that is advertising doing its job. If you see a commercial for an automobile and determine that the version of the Self which you are currently constructing *needs* that particular brand in order to be actualized, that is advertising doing its job. As Herbert Marcuse put it when discussing the purchasing cycle in a consumer society: "Again and again new needs have to be aroused to bring the people to buy the latest commodities and to convince them that they actually have a need for these commodities, and that these commodities will satisfy their need."[3] And this, at the end of the day, is the crux of the consumer society. The job of marketers

filmic content is seen as the best way to excite an emotional response and thus motivate a purchasing decision.

is to convince consumers that they have a need and that the only way to meet that need is by purchasing product X. Whatever you feel about this from a moral or social perspective – and one can mount compelling arguments for and against the consumption-based society – this is the reality of the situation.

And how do you generate this need? By exciting the passions of course. As David Hume famously noted "reason alone cannot motivate action," and this is why advertisers in the US spent *72 billion* dollars on TV media placement in 2011, more than was spent on all other mediums combined.[4] The advertisers and marketers who oversee media buying are no dummies, and they know that in order to get a consumer to buy that new car, computer, or vacuum cleaner, they must work on the emotions in such a way that the consumer believes that they *need* this item. And this is where filmic content comes in, as filmic content is seen as the best way to excite an emotional response and thus motivate a purchasing decision. This idea is supported by a recent TVB survey that found "when asked the advertising medium they find most influential in making a purchase decision, 37.2% of American adults singled out TV – almost quadruple the proportion who pointed to the nearest competitor, newspapers (10.6%)."[5] By engendering an emotional response in the viewer, filmic content motivates action, and this, at the end of the day, is what all those dollars sloshing around in the advertising world are trying to accomplish.

Of course this is not a novel thought, as all artists, critics, and studio executives are well aware of how stories are emotion-generating machines. When a story is told properly – the narrative rich and engaging, the characters recognizable and interesting – the evocative power of a narrative can be enormous. Stories can get people to laugh hysterically in a room full of strangers, to buy one brand over another, or to campaign vigorously for the election of a particular political candidate (after all, people weren't weeping at Barack Obama's inauguration because of how strongly they felt about his position on tort reform). The power of stories is so strong that Socrates made it the first thing he tackled when discussing the education of the "guardians" who would be in charge of protecting the Republic from invasion and chaos: "Then we must first of all, it seems, supervise the storytellers. We'll select their stories whenever they are fine or beautiful and reject them when they aren't. And we'll persuade nurses and mothers to tell their children the ones we have selected, since they will shape their children's souls with stories much more than they shape their bodies by handling them."[6] Of course one need not agree with the form of censorship that Socrates is proposing to acknowledge that the power he grants stories – for both good and evil – is a legitimate one.

Despite how important evoking an emotional response is, its primacy can get a bit lost amid the hub-bub of production and endless notes from clients. We have all worked on projects where everything is done properly in the technical and narrative sense, but when you watch the final piece you, and everybody in the room, feel, well, nothing. Sure the client might be happy with the piece in the sense that it is competently made, but at the end of the day a piece that makes you feel nothing is a failure. Let's now examine a piece of short form that does a good job of evoking an emotional response and see what we can glean from it.

The piece we will examine is a promo HBO released in 2013 for Louis C.K.'s comedy special *Oh My God*. The promo is an unusual one, as it explicitly calls attention to the fact that it is a promo in order to poke fun at how promos and trailers tend to be constructed. This tactic is apparent immediately, as we open the spot on C.K. looking directly into the camera and saying "hi, ok, so this is the promo for my new HBO special." This is basically all the setup the joke needs, as once C.K. gets across his premise he can then start delivering punch line after punch line. He does so by utilizing the executional approach common to promos and trailers – fluid movement through time and space, a mix of footage and motion graphics, aggressive pacing, etc. – in order to poke fun at these tactics, with particular mockery being dished out at the way promos and trailers use bombastic voice-over,

Image from Louis C.K.'s *Oh My God* promo.

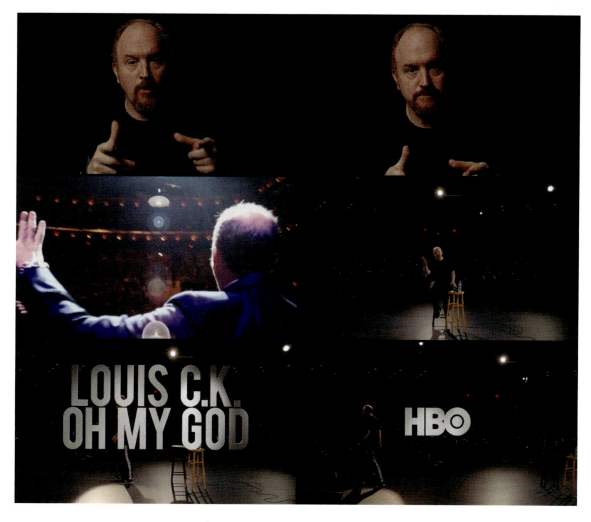

Images from the *Oh My God* promo.

overwrought sound design, and over the top imagery (as C.K. describes what you are seeing as he stalks the stage in a three-piece suit, "and then you'll see me, like, in a suit I would never wear … and then I have, like, a solid gold microphone … eh why?"). By upending the conventions of the promo while utilizing its tactics, C.K. manages to make a spot that fulfills all the functions that a promo needs to fulfill – after all, despite how much fun C.K. has with the conventions of the genre we still end on a title card letting us know where *Oh My God* is airing and at what time – while simultaneously drawing laughs in a way that is in line with his self-effacing brand of comedy.

The first thing to note is how the promo honors the basic exchange mentioned earlier, as C.K. upholds his end of the bargain by giving viewers laughs in exchange for their attention. What the piece also illustrates is how ruthlessly efficient short form has to be in

order to accomplish its objectives. Despite having only a minute and a half to work with, C.K. creates an elaborate structure with constant shifts in time, space, and tone, in order to give viewers as many laughs as possible in the brief duration he has, while also giving them critical information about when and where the special is airing. This efficiency is one of the hallmarks of short form, as its limited duration and need to achieve multiple objectives simultaneously means short form content creators have to be comfortable with structural sophistication, a blend of different types of imagery, and a breakneck pace. The promo for *Oh My God* exemplifies these characteristics but it also reveals them, as one of the great things about C.K.'s approach, for our purposes, is how it calls attention to many of the executional tactics – extensive use of graphics, combination of dialogue and voice-over, constant shifts in time and space, etc. – common to short form. So with this as our starting place, let's now take a deeper dive into how short form tends to be executed and what this means for short form's ability to evoke an emotional response.

From a basic, structural perspective, short form is quite different from long form. Long form content, generally, is linear, as most TV shows and movies move from scene to scene in a way that resembles how we experience time and causality in our everyday lives (there are exceptions to this of course, as filmmakers such as Jean-Luc Godard and Quentin Tarantino sometimes play aggressively with the presentation of time

and space). So, the way your average long form piece plays out is that each new scene picks up threads from previous scenes and then resolves or elaborates upon those threads before pushing the narrative forward to the scenes that follow. For example, imagine a made-for-TV movie – let's call it *A Dance Amongst the Clouds* – about a woman who finds true love, and herself, following a traumatic separation from her philandering husband. The way *A Dance Amongst the Clouds* might play out is that in scene six our heroine is talking with a friend who gives her definitive confirmation that the husband is cheating (photographs and text messages let's say). Then, in scene seven, our heroine confronts her husband and his lover, who is, not surprisingly, the blond secretary we met in scene two and who was clearly up to no good even then (not to spoil any made-for-TV movie you might encounter in your life, but if there is a really attractive blond secretary who has a secretive look about her there is a 75 percent chance that she is having sex with the husband; if the husband is played by Peter Gallagher or Chris Noth, it is a 100 percent certainty that this is what is going on). After an expository montage scored by a lugubrious female chanteuse in which the woman packs up her house and moves to Paris, we arrive at scene nine where our heroine meets Pablo, a doe-eyed Spaniard who is a published poet, sexual powerhouse, and world-class listener. Love ensues, and after numerous candle-lit bathtub scenes, we get to the end of the film where everyone, except

. . . you, and everybody in the room, feel, well, *nothing . . .*

the callow husband who was dumped by the blonde secretary, ends up happy and fulfilled.

Although this sort of linear structure is great when you have a lot of time to tell your story, in short form you have to be much more efficient. As a result of this, short form will often be driven less by a linear progression from scene to scene and more by a series of sequences that are completely out of order spatially and temporally but connected emotionally or conceptually. For example, imagine the trailer for *A Dance Amongst the Clouds*. In this piece, we might open on a shot of our heroine in a meeting, then dip to black and cut to her walking home through busy city streets, then dip to black and cut back to her kissing her husband on the cheek as she enters their impeccably furnished brownstone, and so on. The music would then shift and turn darker as we see our first title card – "In a world where money is king, love is disposable" – followed by a series of shots and sequences that support this idea – our heroine getting out of a limo, helicopter flybys of mansions in the Hamptons, the husband threatening someone over the phone – without any clear temporal or spatial relationship between these shots and sequences (in this example, whether or not the shot of the woman getting out of the limo happens before or after the cell phone altercation is unclear). There will be a logic to the way the story unfolds, but that logic is less dependent on a linear progression from scene to scene, and more on a movement from idea to idea.

> *. . . efficiency* **is one of the hallmarks of short form . . .**

This distinction between short form and long form calls to mind a theory proposed by David Thomson about the history of cinema in general. As Thomson sees it, cinema can be divided into two competing approaches: "Sequence cinema is a way of using the camera to tell a story that is reasonably faithful to spatial and temporal reality, to performance and mood, and to the illusion that we are watching a real event…(in films that follow this structure) space and time are not quite familiar but still are pursued with obsessive exactness." The alternative to this style, which has proven to be much less popular in long form, is montage cinema, which is grounded in the idea that "space and time are conditions on the screen more than in a real world. The alternative is not just a matter of fast, rhythmic cutting. It is also a feeling for infinite coexistence in which divergence or digression begins to accumulate."[7] Although a few famous auteurs – such as Eisenstein – were dedicated to the montage method of constructing films, sequence cinema has clearly proven to be more popular in long form. In short form the opposite is true, as montage cinema is quite pervasive.

This difference in structure affects the way long form and short form are pieced together on a granular level, as most long form work is edited in such a way that the temporal and spatial makeup of each scene resembles the way we experience time and space in our daily lives (as noted earlier, there are certainly exceptions to this, as many films – *Memento* for one – have

> **This, of course, is the essence of the legendary Hollywood Style**

extremely complex temporal structures, so please don't think I am being prescriptive about this issue). So, in scene six, when our heroine is talking with her friend and comes to realize the truth about her husband, the audience will be moved through the scene via a series of straight cuts that changes the viewing angle without noticeably disrupting the temporal and spatial makeup of the narrative. The way this might work is that we open the sequence with an over-the-shoulder shot which shows the friend giving our heroine a photo of her husband and his mistress in bed together. We then cut to a close-up of our heroine as she begins crying. We then switch the viewing angle to a two-shot as the friend consoles our heroine by giving her a big hug. This pattern continues throughout the scene, as every edit would be one that switches the viewing angle but does so in a way that time, space, and causality appear to be being honored. This, of course, is the essence of the legendary "Hollywood Style," where the basic idea is to try and minimize, through eye-line matches, cuts on action, graphic-based edits, etc., the visibility of any individual cut.

The situation is very different in short form work, where it is often the case that the majority of edits will not be straight cuts and instead will be cuts that shift time and/or space. In fact, it is often the case in an individual short form piece that you won't *ever* have a straight cut. For example, imagine a cell-phone commercial where the voice-over is talking about how we live in an interconnected world. In this instance, you might be cutting from a shot of a man in London shaking hands at a meeting, to a shot of a couple in Los Angeles putting their child to sleep, to a shot of a woman in Athens making breakfast. At each edit point you will have a shift in both time and space, as the story is being driven by the concept at the core of the piece rather than by any connection or causality between scenarios.

In order to see this difference play out I decided to do a highly informal analysis. What I did was to take three pieces of long form content – the TV show *Justified* (drama); the TV show *Two and a Half Men* (comedy); and the TV show *60 Minutes* (news/doc) – and contrast how they were edited with the short form content that surrounded them. My goal was to take every cut in both the long form and short form content and assign them to one of five buckets.[8] The five buckets were:

- **Straight Edits**: These are cuts where there is no change in time and space, as the cut merely alters the viewing angle. For example, a straight edit would be a cut where the camera angle switches from over-the-shoulder of one character to over-the-shoulder of the character they were talking with. These kinds of edits are usually intended to be invisible.

- **Spatial Edits**: Spatial edits are those where there is a shift in space but not in time. An example of this would be a sequence where the editor intercuts between a bank robber fleeing the scene of a crime and a group of police officers back at headquarters monitoring his movements via walkie-talkies. With each cut we shift where we are in space but time appears to be fluid.

- **Temporal Edits**: These are edits where there is a shift in time but not in space. An example of this would be a cut from our bank robber in his apartment preparing for the robbery to a shot of him later on, still in his apartment, packing up his supplies (whether or not this cut is a jump-cut, a dissolve, or whatever way the editor chooses to do it is irrelevant).

- **Spatial and Temporal Edits**: Spatial and temporal edits are those in which *both* time and space change. To take it back to our bank robber, this would be a cut from him eluding the police to a shot of him entering the apartment of his girlfriend and throwing the money down on the bed (again, whether this is a jump-cut, dissolve, or whatever way the editor chooses to do it is irrelevant).

- **Reality Edits**: Reality edits are those where the fundamental reality of what is being depicted is altered at the edit point. A classic example would be a cut from a guy in his house to a hallucination or dream sequence with him in a different reality. More pivotal for our discussion would be the interplay between shot footage and graphics that is so prevalent in short form content. For example, a cut from

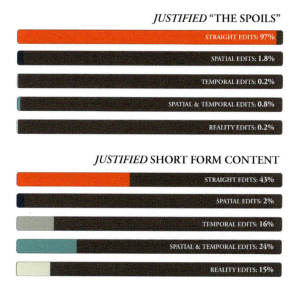

Justified edit breakdown.

a couple frolicking on a beach to a logo-lockup in a cologne commercial would be an edit where the basic reality of the narrative would be shifting at the edit point.

Let's take a look at our long form and short form content and then break it down into key takeaways.

The first piece of long form content we will look at is the show *Justified*, which airs on FX. *Justified* is a crime drama set in the rural south that is relatively straightforward in its narrative structure. I examined the episode entitled "The Spoils." Here is the way it broke down.

For the show itself, there were **620** individual edits. The percents of each edit type were: straight edits – **97** percent; spatial edits – **1.8** percent; temporal edits – **0.2** percent; spatial and temporal edits – **0.8** percent; reality edits – **0.2** percent.

For all of the short form content (including the

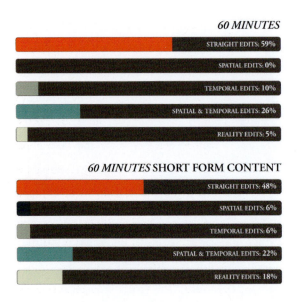

TWO AND A HALF MEN "THE SEA IS A HARSH MISTRESS"

STRAIGHT EDITS: 98%

SPATIAL EDITS: 0%

TEMPORAL EDITS: 1%

SPATIAL & TEMPORAL EDITS: 0.5%

REALITY EDITS: 0.5%

TWO AND A HALF MEN SHORT FORM CONTENT

STRAIGHT EDITS: 54%

SPATIAL EDITS: 2%

TEMPORAL EDITS: 11%

SPATIAL & TEMPORAL EDITS: 8%

REALITY EDITS: 25%

Two and a Half Men edit breakdown.

60 MINUTES

STRAIGHT EDITS: 59%

SPATIAL EDITS: 0%

TEMPORAL EDITS: 10%

SPATIAL & TEMPORAL EDITS: 26%

REALITY EDITS: 5%

60 MINUTES SHORT FORM CONTENT

STRAIGHT EDITS: 48%

SPATIAL EDITS: 6%

TEMPORAL EDITS: 6%

SPATIAL & TEMPORAL EDITS: 22%

REALITY EDITS: 18%

60 Minutes edit breakdown.

show-open) there were **600** total edits. The percents were as follows: straight edits – **43** percent; spatial edits – **2** percent; temporal edits – **16** percent; spatial and temporal edits – **24** percent; reality edits – **15** percent.

Now let's look at *Two and a Half Men*, a conven-tional "3-wall" sitcom. The episode I watched was entitled "The Sea is a Harsh Mistress."

For the show itself, there were **321** individual edits. The percents of each edit type were: straight edits – **98** percent; spatial edits – **0** percent; temporal edits – **1** percent; spatial and temporal edits – **0.5** percent; reality edits – **0.5** percent.

For all of the short form content combined, there were **264** total edits. The percents were as follows: straight edits – **54** percent; spatial edits – **2** percent; temporal edits – **11** percent; spatial and temporal edits – **8** percent; reality edits – **25** percent.

Finally, let's take a look at *60 Minutes*, the long running weekly news show on CBS.

For the show itself, there were **385** individual edits. The percents of each edit type were: straight edits – **59** percent; spatial edits – **0** percent; temporal edits – **10** percent; spatial and temporal edits – **26** percent; reality edits – **5** percent.

For all of the short form content combined, there were **341** total edits. The percents were as follows: straight edits – **48** percent; spatial edits – **6** percent; temporal edits – **6** percent; spatial and temporal edits – **22** percent; reality edits – **18** percent.

As we can see, with all three shows, the structural differences between the long form content and the short form content that surrounds it was huge. For starters, the short form content was much more likely to hop around in time and space, with only **49** percent of the edits being straight cuts and a whopping **32** percent of the edits being some point of transition in time, space, or both. Not surprisingly, the long form

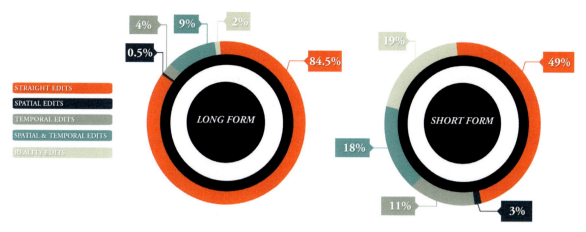

STRAIGHT EDITS
SPATIAL EDITS
TEMPORAL EDITS
SPATIAL & TEMPORAL EDITS
REALITY EDITS

LONG FORM
4% 9% 2%
0.5%
84.5%

SHORT FORM
19%
49%
18%
11% 3%

Combined long form and short form edit breakdown.

content was much more linear, with **84.5** percent of the edits being straight cuts. Those numbers were even larger for the two fictional programs, as *60 Minutes* definitely skewed things back in the other direction (for both *Justified* and *Two and a Half Men*, nearly every edit was a straight cut, with the only aberrations being edits that bridged two different scenes).

Another telling difference was how much more prevalent reality edits were in the short form content, as the short form work had reality transitions at **19** percent of the edit points as compared to **2** percent for the long form content (*60 Minutes* skewed the data here as well, as it relies much more heavily on graphic elements to present factual information). This tracks with my experience in short form, where the interplay between graphics and footage can often be quite high.

Lastly, there was a major difference in pace between the long form and short form work, with the short form work having a combined rate of cutting that was roughly *three times* as quick as the shows around it, a fact which was all the more notable given that the

episode of *Justified* had two fight sequences, which significantly increased the amount of edits in the show. This intensified cutting rate is primarily the result of having to tell a large amount of story in a limited amount of time, but it also is a result of the way in which short form tries to engage the viewer through visual stimulation. Of course, this increased cutting rate demands certain things of the short form content creator – not least of which is a healthy respect for viewers' ability to process information – and it is safe to say that if you are a person who likes to make work that unfolds at a languid pace, short form is probably not for you.

So as we can see there are some major differences between how short form and long form are structured and pieced together (if you're interested, the numbers of the trailer for *Oh My God* – which were tricky to pin down as the spot is a bit vague on what is going on spatially and temporally – roughly went like this: **62** total edits; straight edits – **45** percent; spatial edits – **0** percent; temporal edits – **15** percent; spatial and

temporal edits – **24** percent; reality edits – **16** percent). These differences are not incidental, as they are a direct result of how short form is trying to disseminate information while also doing everything it can in order to evoke an emotional response in its very brief run time. While C.K. might be able to spend twenty to thirty seconds setting up a joke during his stand-up special, he just doesn't have that sort of time here, so as a way of solving this issue, he came up with a gag that only requires a five-second setup and that gives him the ability to move quickly from punch line to punch line.

C.K.'s decision to use a gag that allows him to fly through his setup and get straight to the stuff that will provoke an emotional reaction is classic short form technique. Short form's truncated run times and need to disseminate information is often a pain to deal with, but it has also spurred so many of the innovations we utilize every day. Short form content creators have *had* to be aggressive with things like structure, pace, and the use of motion graphics because we need to do everything we can in order to make enough space to evoke an emotional response in the brief amount of time we have.

can play out, but a good example would be a car commercial advertising a sales event of select models. The spot might open on a car driving through a city while the voice-over describes the standard features available on the car (heated seats, rear airbags, etc.). At the end of the spot we would then come to a lease card that lists all the financing and lease options available during the sales event. The deals look great, but as the voice-over lets us know, we have to move quickly as the sale ends soon ("the Toyota Sales Event ends January 3rd; so hurry down to your local dealer today"). In a spot like this the logic is quite transparent, as we see the ad trying to shape our perception of the car ("that is a good looking car and it seems like it has a lot of standard features,") and then we see it attempting to motivate action ("that is a great deal but I only have a few days to take advantage of it so I better hurry to the dealership").

Now, not all short form follows this model exactly and I am obviously simplifying things a bit as advertisings aims can often be quite complex, but for our purposes this will suffice, as what one notices when

Shaping Perception and Motivating Action

Once a piece of short form has attracted attention and evoked an emotional response, the last thing it needs to do in order to be effective is to shape perception and motivate action. There are countless ways this process

Sam Worthington and Jonah Hill are
"The Vet & The nOOb."

24

looking at short form is that a desire to shape perception and motivate action is the foundation for so much of our work. If you're making a promo, you are trying to get the viewer to think to himself "that show looks funny" so that, hopefully, he will tune in to the show next week. If you're making an ad for detergent, you are trying to get the viewer to think to himself "that looks like good detergent and the price seems right" so that the next time he is at the store shopping for detergent he will consider yours. If you're making a corporate piece you are trying to get the staff to think to themselves "this company is great and I am so happy to be a part of it" so that they work harder and don't quit. Shaping perception and motivating action is all about pointing out a human need or desire – the desire to laugh or be clean or be professionally successful – and then showing how the product being advertised can meet that need better than other products in the marketplace. As short form content creators we usually don't have to worry about determining what the value proposition of a product is as that is the marketers' and ad agencies' job, but, in order to successfully fulfill our responsibilities, we must be able to utilize the techniques of our craft in such a way that whatever value proposition is being proposed is made tangible and emotionally resonant. Let's now take a look at the ad "The Vet & The nOOb" which was created to promote the video game *Call of Duty: Modern Warfare 3*, as it is a piece of short form content that skillfully shows us this process of shaping perception in an attempt to motivate action.

The ad features Sam Worthington and Jonah Hill

People want to feel that they have **agency** and that they aren't being **manipulated**.

playing a mismatched pair, with Worthington as the steely, action-hero ("The Vet") and Hill as the hapless rookie ("The nOOb"). The ad follows the two characters as they fight their way around the globe, killing bad guys and slinging one-liners (typical moment is Hill blowing up an entire office building with an RPG in order to take out a lone bad guy and then asking a dumfounded Worthington "should I have used a knife?"). The intended takeaway of the ad becomes apparent as we move through the spot, as the evolution of Hill's character from "the nOOb" (gamer speak for an inexperienced player) to a savvy vet, as well as the tagline at the end which states "There's a soldier in all of us," makes it clear that this is a game which is trying to reach beyond the hardcore gaming community. As we all know, video games are an enormously profitable sector of the entertainment industry, but there is still the perception that gaming is only for a niche audience, so big releases such as the *Call of Duty* series will often make explicit attempts to illustrate their mass appeal. This is exactly what this spot tries to do, as casting two recognizable and likeable stars helps the ad appeal to

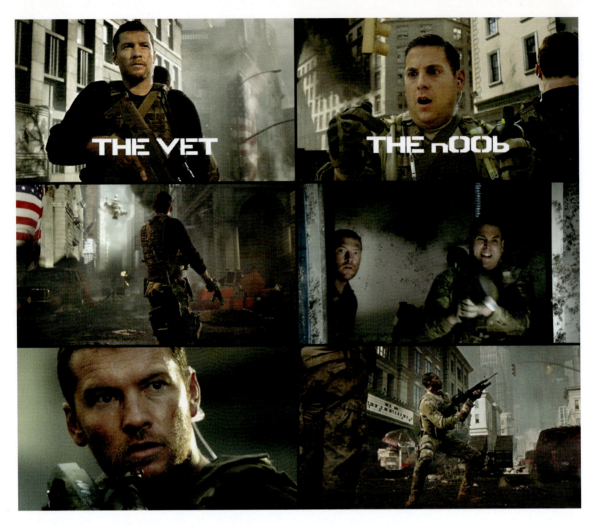

Images from *Call of Duty: Modern Warfare 3* trailer.

non-gamers, and structuring the narrative around the nOOb's rapid improvement at the game makes it clear that the takeaway of the spot is that even though there are a ton of cool things you can do in the game, it's also easy enough to learn that casual gamers will enjoy it. This takeaway is hammered home at the end of the spot when the basketball player Dwight Howard emerges, firing wildly into the air, as Hill looks on and welcomes him, the new nOOb, to the game.

Overall the trailer is very well executed. It was helmed by the director Peter Berg – of *Friday Night Lights*, *Battleship*, and *The Kingdom* fame – and the production values are quite high. It's also a great example of how short form content, more often than not, is "propositional" in the way it attempts to shape perception and motivate action. What I mean by this is that short form content will, more often than not, put forth images and concepts in such a way that viewers will be induced to draw a set of propositions from the work as a whole. For example, in the case of the *Call of*

Duty trailer, what viewers are subtly asked to do is view the piece and then extract the propositions "this looks like a fun game where you can do lots of cool stuff" and "this game appears to be relatively easy to pick up." Now, neither of these claims is made directly in the spot, as the fact that this is even a video game being advertised is never explicitly mentioned. Instead, it is entirely up to the viewer to know that *Call of Duty* is a video game and that the live action characters are supposed to represent gamers controlling the action. It is *then* up to viewers to extract the propositions that the game is easy to play and a lot of fun.

There are a number of reasons why commercials tend to operate like this, but the most basic is that people will be more likely to believe a proposition which they feel they have arrived at on their own. People want to feel that they have agency and that they aren't being manipulated and so commercials, at least effective ones, tend to give viewers the sense that they have control over their response to the stimuli they are presented with.

This way of thinking about short form, and the term I am using, echoes the phrase "propositional editing," which was coined by the academic Paul Messaris. Propositional editing is defined as editing in which the point or overall takeaway of a piece only comes when the viewer synthesizes two or more discrete sets of information in order to extract a proposition. The example Messaris uses is, fittingly, from a political ad (political advertising in general relies extremely heavily on propositional editing). The film is for Ronald Reagan's 1984 reelection campaign, and starts with

Frank Hahn of 72andSunny on *Call of Duty: Modern Warfare 3*

Frank Hahn is a German designer who joined 72andSunny after more than a decade of international creative wanderlust. He is now Group Creative Director over all of the Activision franchises at 72andSunny.

Bryan Cook: Film, like all mediums, has particular things it's good at. What do you think film's strengths are in terms of assisting an overall marketing effort?

Frank Hahn: Films still have the biggest reach when using the right media. They can be a great asset for storytelling and most of the time they are doing the heavy lifting in a marketing mix. If done well a film carries the desired brand or product message in one go.

Bryan Cook: Over the past ten years or so have you noticed any shifts in how television commercials communicate with their audience?

Frank Hahn: Brands don't bet on one-asset-only anymore. Films are part of a media mix and most of the time the film message lives on on second screens. If the initial film is doing a great job and people are intrigued they continue to immerse themselves into a deeper storytelling.

Bryan Cook: The rise of the Internet has made it easier to reach consumers directly but also made it much harder to get their attention given how crowded the media landscape is. Can you speak to the challenges associated with getting viewers' attention and talk about some of the tactics you utilize in order to do so?

Frank Hahn: Interactive or mobile platforms are amazing opportunities for continued storytelling. It all depends on the quality of the content whether you cut through or not. People want to be entertained and it's so easy to lose them after five seconds. Our audience is always on the go. You need to be fast and compelling.

Our "Meet me at Starbucks" films are beautiful and relatable real life stories of people coming together around a coffee. The films were all shot on one day in twenty-eight countries and were put together as one long format film on

continued overleaf

YouTube and starbuck.com first. Selected stories were then cut into shorter formats to air on TV.

Our Activision films have to cut through an endless list of gaming and entertainment competitors. Most of our films are action-packed mini movies, trailers for a big experience targeting a broad audience. Those films work in tandem with a game trailer that goes deeper into the game and is mainly for the hard-core gamers to geek out on new game stories and mechanics.

Bryan Cook: Can you speak for a moment about the way the *Call of Duty: Modern Warfare 3* live-action trailer was conceived and how your team went about constructing it so that viewers would extract the takeaways about the game that you wished them to extract?

Frank Hahn: This film was all about inviting newbies and potential non-gamers into the world of *Call Of Duty* in order to show how much fun it is to play the game. Jonah Hill was the perfect cast for the nOOb alongside action veteran Sam Worthington. "The Vet & The nOOb" is a series of die-and-repeat scenarios, ridiculous weapon choices, and great dialogue and banter between the two. It's a very simple master and student story where the cocky nOOb accelerates to finally become the real hero of the story.

Bryan Cook: What is the one question you always end up asking yourself while concepting a piece of short form content?

Frank Hahn: I'm always driven by the global impact our films are making. The idea will need to be grounded in a human truth or insight. It doesn't need to be relevant for everyone – but it will need to be understood by everyone in all markets around the world. And then it needs to cut through the rest of what's out there.

Bryan Cook: What is the most common mistake advertisers make when creating short form work?

Frank Hahn: Making boring content.

an intercut sequence where we move back and forth from the oath-of-office ceremony from Reagan's first inauguration in 1981 to images of Americans going to work in the morning (farmers driving trucks, construction workers guiding a crane, commuters driving to work, etc.). The theme of the piece is delivered by the voice-over at the end of the spot, which talks about the "new beginning" that Reagan offered to voters. This "new beginning" operates both in the sense of getting Americans back to work after the inflation-riddled 1970s and, as Messaris points out, also in the sense of a larger spiritual renewal.

This sequence is a classic example of propositional short form technique and I will let Messaris break it down. As he posits:

> … *a viewer must be able to do the following two things in order to come up with an interpretation of this sequence that would fit the one intended by its producers: first, extract from the individual images of American workers a more general sense of "America going back to work" or "the nation doing well again"; second, derive from the juxtaposition of the inauguration and the workers a sense of how the inauguration is related to these general phenomena — e.g., "Because of Reagan's inauguration, America is going back to work" (a causal connection), or "Reagan's inauguration is like a new beginning for the nation as a whole" (an analogy or comparison).*

> *The purpose of this sequence, then, is not simply to present a set of events (the president being inaugurated, people going back to work) but rather to make various comments or propositions about the events themselves as well as about*

aspects of reality not represented directly in this film (i.e., the economy, U.S. citizens in general).[9]

As we can see, what is going on here is very different from the type of narrative structure one encounters in most long form work, as outside of documentaries, you rarely encounter a long form piece which is attempting to get viewers to extract a proposition (for example, in any of the comedic sequences from *Two and a Half Men*, the viewer is asked to follow the story enough to get whatever joke is being presented, but she is never asked to understand some further proposition that is not represented directly in the show). Conversely, when you watch a commercial block during *Two and a Half Men* and you see a spot for makeup that features beautiful, smiling women enjoying themselves at a nightclub, you will be asked to see these images, connect them to images from earlier in the commercial when you saw those women applying makeup, and then come up with the proposition "Max Plus makeup allows you to look beautiful and subsequently have a nice night out with your friends." Or, later in that same commercial block, when you watch a commercial for a sports drink that features a famous tennis player excelling at her craft, that shot at the end that shows her taking a huge swig of the beverage being advertised is trying to get you to come up with the proposition "SportsBev seems to make that tennis player better at playing tennis." Basically, whatever value proposition the product might offer – beauty, athletic prowess, fun – is the takeaway the viewer will be asked to extract from the images they are presented with. Once they have done

> **commercials . . . tend to give viewers the sense that they have control over their response to the stimuli they are presented with.**

so, the obvious next step would be the viewer concluding that if they were to consume the same product, they too will enjoy the same benefit. Again, this is much different than most long form work, as the vast majority of films and TV shows shy away from forcing the viewer to create meaning by synthesizing two or more sets of information. Instead, long form usually strives to create a complex web of characters and plot-points so that viewers want to stick around in order to see the resolution of the narrative.

So how did the trailer do in terms of shaping perception and motivating action? Extremely well, as the trailer helped *Call of Duty: Modern Warfare 3* become the largest entertainment launch *of all time*, with over $775 million in global sales within the first five days it was on the market. The game sold over 6.5 million copies the first day it went on sale, and more than 1.5 million people waited in line at retail shops for

the midnight release. It was, as Activision CEO Eric Hirshberg noted, "the largest retail release in Activision's history and in the industry's history." All told, the game sold 26.5 million copies worldwide and the trailer itself was a huge hit, as it received over 27 million views on YouTube and countless media impressions due to its wide reach on broadcast and other paid media.

Let's now turn our attention to the individual crafts that go into making short form content, but keep this discussion in mind as we move through the book, as these three objectives – attracting attention, evoking emotion, and shaping perception in order to motivate action – will usually be behind the tactics each individual discipline utilizes.

1 Michael Goldhaber, "The Attention Economy and the Net," *First Monday* 2 (1997): 2.
2 Drake Bennett, "Easy = True: How 'Cognitive Fluency' Shapes What We Believe, How We Invest, and Who Will Become a Supermodel," *The Boston Globe*, January 31, 2010.
3 Herbert Marcuse and Karl Popper, *Revolution or Reform? A Confrontation* (Chicago: Precedent Publishing Co., 1976), 67.
4 The Nielsen Company, "State of the Media, Spring 2012, Advertising & Audiences," http://www.nielsen.com/content/dam/corporate/us/en/newswire/uploads/2012/05/Nielsen-Adv-Aud-by-MediaType-Spring-2012.pdf (2012), accessed August 6, 2015.
5 Marketing Charts, "Data Dive: US TV Ad Spend and Influence," http://www.marketingcharts.com/wp/television/data-dive-us-tv-ad-spend-and-influence-22524 (2013), accessed August 6, 2015.
6 Plato, *The Republic*, trans. by G.M.A. Grube. Revised by C.D.C. Reeve (Indianapolis: Hackett Publishing Company, 1992), 53.
7 David Thomson, "American Movies are Not Dead: They are Dying," *New Republic*, October 4, 2012.
8 A few methodological notes: In terms of why I selected these three pieces to examine, I did it as randomly as possible, with the only criteria being that I wanted a drama, a comedy, and a documentary style piece. The only other methodological notes were that in order for me to count something as an edit the incoming shot had to be two frames or longer (this rules out a one-frame white-flash or a flash-frame of any sort). Also, a temporal edit had to be clear and unambiguous in order for it to be counted as a temporal shift (e.g., if we cut from a scene of one group of characters to a scene of another group of characters at a different location, unless there was a clear indication of a temporal shift – perhaps a character from the outgoing scene being in the incoming scene or a shift from day to night – it would only be counted as a spatial edit). Finally, all cuts to graphic cards or any other full-frame graphic element were a reality edit: A lower-third or some other graphic over picture was not treated as a discrete edit and was thus not counted in any bucket.
 As a side-note, my friends who work in the sciences were fairly withering about how small my sample size was until I showed them how unpleasant a task counting edits actually is. This of course does not negate the fact that my sample size is too small to make this study worth much more than anecdotal support, but until I have an assistant with a masochistic streak, it is the best I can do.
9 Paul Messaris, *Visual Literacy: Image, Mind, & Reality* (Boulder, Westview Press, 1994), 107–108.

2

Tom Cruise and a Bazooka:
The Image

The painter constructs, the photographer discloses.
Susan Sontag, *On Photography*

A generic stock image is a cost-effective way of signaling to
people that you have nothing different or worthwhile to say.
Lee Clow's Beard, *#leeclowsbeard*

There are statements you tend to hear a lot when you work in this industry – "it needs to be done ASAP"; "the client wants the budget to come down"; "we might need you to do some weekend work" – and one of the most common is, "I know we have to use stock footage, but I really don't want it to 'look like stock.'" Now, despite how impossible this request is to meet, as there is an ironclad metaphysical law that states that all stock must look like stock or else it ceases to be stock and all time and space collapses, it does beg some interesting questions. What exactly makes an image "look like stock?" Why is a piece of stock video so different from something one might shoot in other circumstances given that they are both shot on good cameras by people who generally know what they are doing technically? Given that the women I know rarely walk through wheat fields while holding their arms aloft, who was the guy who decided that every stock library must have ten shots like this and was he the same guy who decreed that every shot of a depressed man must feature these poor souls leaning against a window while rain falls outside? And, most importantly, why is stock so "stocky," and what can the answer to this question tell us about its opposite: images that are powerful and singular?

In order to answer these questions, let's start by examining a few stills from a classic piece of stock footage entitled "Businessman Cheering With Arms Raised" (if you're a student and haven't worked with stock footage before, the term describes previously shot footage that you can purchase and use in an edit once you pay a licensing fee). I would strongly suggest watching the full twenty-second clip as it is amazing and will change your life, but these stills should be enough to get a sense of what is going on.

As we can see from the stills, the businessman is quite excited. The reason *why* he is so excited is explained by the man clapping in the background and the piece of paper the businessman is holding which reads "New Client." The businessman is also holding a fencing saber and behind him another man walks sadly towards the door while also holding a fencing saber. I had no idea why these guys were holding fencing sabers but the description supplied by Getty Images indicates that the whole fencing saber thing is, I guess, some sort of a metaphor. Here is how Getty describes the image, "Dolly shot of a young excited businessman cheering and celebrating while his new client gives him applause for winning the contract. In a [sic] meanwhile his business competitor walking out disappointed and defeated in fencing challenge."

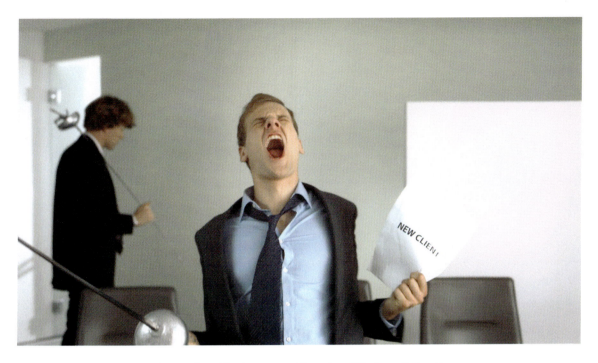

Image from "Businessman Cheering With Arms Raised."

So, what do we make of this shot? From the perspective of being an image that could be utilized in a piece, it's not all that helpful. The first problem with the clip is that it fails on a basic informational level. For example, Getty indicates that the guy clapping in the background is the new client, but there is no way to know this from the clip itself. The fencing saber thing is also perplexing, as I had no idea why the guys were holding fencing sabers or why one of the fencers looked so depressed until I read the description. Even the temporal/spatial information you generally want an image to supply is lacking, as I still have no idea what space these men are in (at times they seem like they might be in an office, but as the shot continues you then start thinking they are in a hotel conference room, so who knows). In short, the clip is flawed in the basic informational sense, as the usual information we expect an image to possess – who are those people, where are they, what are they doing, and why are they doing it? – is in short supply.

The second issue with the clip is that you would have no way to use it editorially. I like that there is some motion with the camera, but the way everything is blocked out you would be pretty limited in how you could edit the shot, as you couldn't start the shot when the businessman is at his most excited as by then the actor playing the "new client" has already exited the frame. Basically, if you felt that you needed all the main story points represented, you would have to let the clip run for a looooong time, and if there is one thing you can state definitely about short form, it's that individual shots usually don't get that much time to play out.

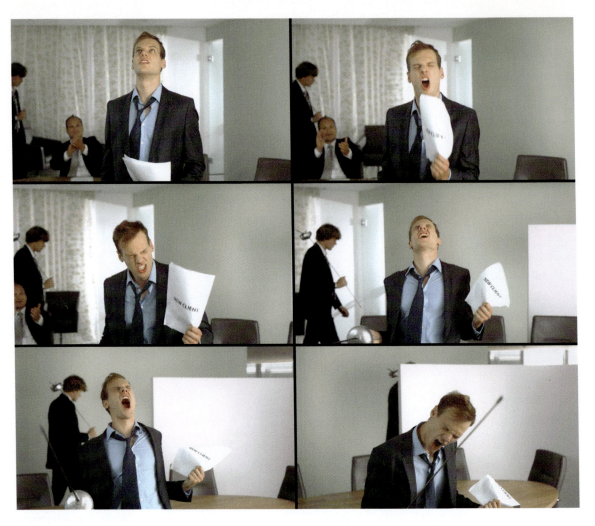

Images from "Businessman Cheering With Arms Raised."

The third major issue is that the clip, like much stock footage, is boring from a cinematic perspective. The reason why the clip is lacking in this regard is that the main objective of stock is to make the footage as universal as possible. This is why stock footage tends to be overly lit, as the guys producing stock footage have no idea where their footage will be used, so they have to go for the most universal approach possible in order to maximize the possibility that their footage can integrate with *other* footage. In other words, you have to light and shoot generically when making stock because the goal is to *be* generic. The problem with this approach, and the reason people constantly say they want stock footage that doesn't "look like stock," is that when you're making short form content you need your footage to be singular and attention grabbing.

The last issue with the clip is that the way the event is being depicted is so unrealistic that it is impossible

to have any emotional connection to what you are seeing. A new business pitch is actually quite an emotional experience for those who are involved in it, but this clip, because of the way it is choosing to depict the event, loses all of that emotional weight. In fact, the depiction is so ludicrous that I can definitely state that no new business pitch in the history of capitalism has ever looked anything like this (even ignoring the fencing saber thing for a moment, I have never seen a new business deck which is entitled simply "New Client," and I have never seen anyone respond to winning a piece of new business by unbuttoning his shirt, loosening his tie, and screaming ecstatically for twenty seconds in front of the client).

So, we can see that the clip fails because it doesn't do the handful of things we need an image to do in short form content. Before we take a look at what an image in short form *wants* to do, I should point out that although I will be focusing on short form imagery that is captured, in the traditional way, by a camera, I will also be examining images that are created in post-production and images that are being repurposed in ways that they were not originally shot for (imagery used in short form is often not created for that particular purpose, as promos, trailers, and sizzles are almost always comprised solely of imagery shot for another purpose). One of the things one notices when examining short form content – as we

" . . . when you're making short form content you need your footage to be singular and attention grabbing."

saw in Chapter 1 when we noted how often short form work contains "reality edits" – is how aggressive short form content creators have been in utilizing repurposed footage, typography, motion design, and visual effects to accomplish their goals. There are a number of explanations for this, but the most critical is duration, as short form content creators have had to be extremely innovative in order to supply information but also tell emotional, complex stories in brief snippets of time. For this reason, I want to look at the "image" in short form regardless of how that image was created.

Let's now take a look at what we ask images in short form to do. The list begins with basic informational content, as **every image in short form will usually supply some amount of narrative information** (this information is often referred to as the "Five Ws"). As we know, short form cannot afford to waste even a frame of screen time, and, for this reason, nearly every image in a piece will be doing some amount of storytelling.

The second thing you want in almost all short form imagery **is motion, either within the frame or with the camera (or both)**. This is because motion is incredibly useful in the editorial stage of content creation, and short form tends to be crafted, to a large extent, in editorial. There are a couple of reasons for this, but the main one is that much short form – promos, trailers, sizzles, corporate pieces, and more – is created

out of footage that was shot for some other purpose, which means the piece really takes shape, and is often actually written, when you are already in edit.

Third, **any image in a piece of short form should be able to attract attention**. In short form, we never really know when someone will begin engaging with the content we make, as they might start tuning into your spot halfway through while watching sports at the bar or right at the end when they look up at a video display at the mall. For this reason, there is a maximum value put on every frame being able to hold attention regardless of the viewer's involvement in the larger narrative.

Lastly, in short form we want every image to be able to **evoke an emotional response in the viewer**. In short form, we don't have the run time to assume that the narrative we are telling will be enough to get viewers emotionally engaged with the content we are presenting them with, and for this reason we need the imagery we use to be emotionally impactful on its own.

Images and Narrative Information

Let's begin with the way images in short form need to give the viewer a certain amount of narrative information. Because of short form's limited run time, every frame is usually going to be asked to supply some bit of information that is necessary for viewers to follow the story. In order to see this play out, imagine you are creating a commercial for Coca-Cola entitled "Share The

nearly every image in a piece will be doing some amount of storytelling. 99

Happy Moment." The premise of the spot is that every can of Coke you open brings you a rush of happiness. The characters in the spot are a young man named Max and his girlfriend Anna, and the story takes place at night in their loft as they get dressed to go out to a party. Although they are having fun getting ready for the party, they really start to enjoy themselves when Max opens up his can of Coke and has his "happy moment" (this "happy moment" is shown through a special effects shot where effervescent bubbles pop out of his head). Max then shares this happy moment with Anna by handing her the Coke. The spot has no voice-over and no title cards, but the notion of "the happy moment" that the product offers, and the sharing component of that line, is clearly communicated through the visuals and sound.

After an exhausting pre-pro and shoot you head into editorial where you quickly realize that the director failed to get the medium shot where Max hands Anna the soda (imagine the camera had a focus issue for this setup). As you sit in the bay and comb through

the footage, you finally come up with a way to communicate that the hand-off is taking place. Although your solve works, you now need three shots instead of one to communicate that the hand-off is occurring, as you now need a close-up of Anna starting to smile, a close-up of Max nodding his head in a way that says "go on, take it," and then another close-up of the soda going into Anna's hand (to pull this off, you reverse a shot that was supposed to happen later in the spot when Anna puts the can down on a table).

Besides being clumsy storytelling that somehow feels a little off, the main issue with the solve is that a piece of information that should have taken a second to get across now takes four seconds. This doesn't sound like much, but in a thirty-second spot, those three extra seconds have to get taken from *somewhere*, so now you have to lose the great shot where Max and Anna canoodle that happened to be the agency's favorite image. You also have to shave two seconds off the product sequence and the client is fuming because you promised them eight seconds of product and now they only get six. The producer is also upset because you had to spend two hours making the solve work and now the whole team has to go into overtime which will wreck her already stretched budget. So now the agency creatives are pouting, the client is screaming at everyone over the speakerphone, and the poor producer is crying in the bathroom, and all of this occurred because the director messed up one image that needed to do a fairly modest amount of narrative lifting.

Now that every editor who is reading this is muttering to themselves about the time that director screwed

we need the imagery we use to be emotionally impactful on its own.

them by spending four hours on a useless crane shot while never getting them the one close-up they really needed, let's turn to the organizing principle that people refer to as the "Five Ws." The Five Ws are the basic elements that any narrative needs in order for the audience to be able to understand it, and as we saw with "Share the Happy Moment," if one of these elements is missing, the piece you are creating can quickly unravel.

"Five Ws"

Where: *Where are we in space?* This is most often covered by the establishing shot. The "where" changes every time that the location shifts, and given how sophisticated the modern viewer is, more often than not a medium shot will contain enough information to carry you through (for example, in "Share the Happy Moment," we would not need an establishing shot from outside of the apartment building to know that Max and Anna are in a loft in a city, as there would be enough information in a wide or medium shot with windows behind them to indicate all of this).

> *"Wondering why something is occurring is what human beings do all day long "*

When: *What time of day and historical period are we in?* This information will usually be supplied by the establishing shot. For "Share the Happy Moment," the information that the spot is set in contemporary America in the evening would be supplied by the production design, the fact that it is dark outside, and so on.

Who: *Who is the piece about, who is/are the subject(s)?* Often handled with a tighter shot(s), images that include "who" information will establish who our story is about and will include age, socioeconomic indicators, gender, and so on. For "Share the Happy Moment," the only characters in the spot are Max and Anna, and the casting, wardrobe, and production design lets us know that they are hip, urban, well-to-do twenty-something's with a taste for mid-century design.

What: *What is happening?* This changes with every shot and is all of the information that lets us know what is happening at any given moment (there are the characters getting dressed, now they are hugging, etc.). This is the most dynamic informational type in most

short form, and as we saw with our botched handoff shot, not getting one of these moments can be problematic for everything that is supposed to follow it.

Why: *Why is it happening?* Once a viewer knows *what* is happening they will generally try to figure out *why* those events are occurring. In "Share the Happy Moment," if the editor hadn't come up with his solve to show the soda hand-off and then we suddenly cut to Anna having her happy moment, there would be a question in the viewers' mind as to why this moment is occurring. Wondering why something is occurring is what human beings do all day long – Why did Shelly dump David? Why does everyone like brunch so much? Why is there a Starbucks on every corner? – and when you are making short form, it is imperative that you supply the necessary amount of information to enable viewers to answer any "why" questions your piece might engender.

Although these five pieces of information are not the sexiest component of short form storytelling, every story will need this information so that viewers can follow along, and the quickest way to get this information across is through the visuals. Besides simply following the story, proper handling of the Five Ws should also get the viewer asking the type of questions you want them to ask. For example, if the thing we want the audience to take away from "Share the Happy Moment" is that "Coca-Cola gives you a moment of happiness," then if the Five Ws are confusing, the viewer might not be able to come up with this takeaway. To see this, imagine that the actor playing Max was feminine looking and that his wardrobe and

body language were ambiguous in terms of gender. It's possible, given that Max and Anna are dressing up during the spot, that the viewer might spend ten seconds thinking "Max" is really a woman dressing up as a man and that "Max" and Anna are actually two women who are going to a Halloween party rather than a boyfriend and girlfriend. This is fine if you want the viewer to be thinking about this, but a colossal distraction if you don't.

Now, one of the things that allows short form to work, given its compressed run time, is that the filmic image can get across an enormous amount of information extremely quickly. The first shot of "Share the Happy Moment," which is roughly one second long, can tell the viewer; "here is a loft in an urban environment. In this loft are a young man and woman getting changed for a party and having a good time doing so. Furthermore, the man and woman's body language indicates that they are in a romantic relationship. They don't appear to have children – their home is not furnished in a child friendly way and there is no kid stuff lying about – and they seem to like mid-century furniture and have a lot of disposable income." We take it for granted that one shot can tell us so much in such a short period of time, but how does the medium even do this? As Paul Messaris puts it, "How is it that pictures, both moving and still, can conjure up a world of almost palpable objects and events despite the many differences between the appearance of the real world and the appearance of any kind of picture, no matter how realistic?"[1] What I believe to be the correct answer to this question is something called *natural generativity*, and although it is a slightly academic topic, I have always found it quite helpful when dealing with questions about how we use images to give factual information.

Natural generativity is the term the philosopher Flint Scheir uses to describe the fact that, unlike with a language, learning to understand pictures does not involve learning a vocabulary. Instead, we understand photographs and moving images by calling on the same perceptual faculties we use when understanding people and objects within the world. So, the same way I recognize that my friend Steve has just entered the room is also how I recognize Steve in a photo. The process by which this happens is complicated, and I urge you to avoid slipping into the idea that the way that this works is simply that the objects and people in moving images "resemble" that which they depict. The reason why you want to avoid this is that, in fact, there are lots of ways Jack Nicholson's filmic depiction is nothing like him (his filmic depiction is in 2D, he is not twenty feet tall in reality, etc.). Instead, what many philosophers and psychologists now argue is that pictures activate the same recognition capacity as their referent (i.e., the way my brain recognizes Steve in reality and Steve in a photo is the same). Now, many parts of the brain will be active in this process, as one subsection

> **. . . learning to understand pictures does not involve learning a vocabulary.**

of the brain might interpret motion, another color, and so on. The benefits of this "divide and conquer" strategy are speed (it is much easier to allocate tasks), a form of checks and balances (one section backs up or negates another's input), and an ability to compensate for an injury or malfunction to one subsection (if one's ability to see depth becomes hindered, their ability to see color and motion could still allow them to make out an approaching lion). This is also what explains the fact that when you watch a horror film you aren't running from the theater to call the police, as while you receive information that tells you about the story – that there is an axe-wielding maniac stalking coeds – you *also* receive information that tells you that you are watching a movie and not reality.

Now, the idea that pictures are understood in this way is not uncontroversial, and in an attempt to test it, a number of studies have been conducted. One of the more famous was run by the academics Julian Hochberg and Virginia Brooks, who tried to assess how we decode images by depriving their son of any representational imagery until he was nineteen months old. No cartoons, no magazines, no TV, nothing. They even blacked out the windows of the family car so that billboards would not be visible from the backseat (and yes, I too would love to see what other experiments Hochberg and Brooks conducted on their child and, yes, I too wonder how the lad turned out). Instead, the boy received his education in language acquisition entirely through a process of examining real objects, not depictions. Despite this deprivation, the boy was able, when tested, to recognize twenty-one,

two-dimensional depictions of objects that were familiar to him from his environment.[2]

Another study was done by researchers in Africa. In this one, psychologists looked at a semi-nomadic, geographically isolated, illiterate tribe in Kenya who had no previous exposure to mass media or anything remotely resembling the cinematic form of depiction. The researchers filmed the tribe acting out a familiar story of theirs and then played the unedited footage back to them. Not one person in the tribe had difficulty recognizing any of the objects or people that appeared in the film. Studies like these support the idea that the way that people understand pictures lies "in the activation by pictures of perceptual skills (object recognition, depth perspective, etc.) developed in real-world experience, skills which are then transferred to pictures."[3]

If this is accurate – if it is in fact true that the same mental processes that allow me to recognize that my friend Steve has entered a room are also what allow me to recognize Steve in a photo or home movie – then how we understand images is much different from the way we understand language. This is because language is an arbitrary system of signs, as in order to understand a particular language one must be taught to do so, since a word's referent is only attached to it through convention, e.g., "elephant" refers to an elephant because the conventions of our language say that this is the case; "elephant" could just as easily refer to a giraffe if our language had made *that* the convention.

As we can see, expressions like "the language of film" are a bit misleading, as, unlike with a language,

how moving images represent things is not arbitrary. But, I think it goes further than this, as I believe that many things that are regarded as arbitrary cinematic conventions actually have their communicative power as a result of how we perceive reality. Some examples of this would be high/low angles to show power discrepancies, close-up shots to indicate intimacy, and the familiar "camera pulling away at the end of a film" device. If film really was a language, one would want to argue that we understand that a character is weak as a result of a high-angle shot looking down on him because we have watched enough cinema and/or taken enough film theory classes to know that this angle will be used in this way. But, I think this interpretation would be incorrect, as, instead, "this visual convention reproduces the structural features of real-life situations: looking up at powerful people and looking down at weak people, a realm of experience that is likely to be particularly relevant during the formative years of childhood. In other words, this visual device is based on perceptual habits a viewer can be expected to have developed in everyday, real-world experience."[4] Or, to take another example, the reason a close-up makes the viewer feel bonded to the character on screen is not because we have learned this convention from watching moving images all of our lives – although this training will probably reinforce the effect – but because, in real life, being close to someone generally means that you are intimate with them. There is even a name for this phenomenon, as the researcher Joshua Meyrowitz has coined the term "paraproxemics" to describe cinematic practices

How we understand images is much different from the way we understand language.

that "appear to derive their meaning from the way in which intimacy and involvement are related to distance and orientation in real life."

In order to test this idea, the same researchers who did the study in Kenya went back a year later, and this time they presented the tribe with a film about themselves that had been edited much like an American television show. There were close-ups, parallel editing techniques that showed two storylines happening concurrently, and even a flashback. Even *with* techniques such as these, which most people would assume you would have to be familiar with the conventions of cinema to understand, the tribe's comprehension of the story was nearly flawless. Tribe members could follow the story fully and understood what was being asserted about time and space when the filmmakers made whatever leaps they were making. As Messaris puts it, "what makes images unique as a mode of communication is precisely the fact that they are *not* merely another form of arbitrary signification. Learning to understand images does not require the lengthy period of initiation characteristic of language learning, and

permeability of cultural boundaries is much greater for images than it is for language."[5]

Now when we look at "Share the Happy Moment" we can start to see how we come to understand it. The objects and people that we see in the spot activate our recognition capacities so that we understand who these people are, what they are doing, why they are doing it, and everything else that we need to know about them and the situation they are in. Furthermore, we understand all the subtle elements of the dynamic we are observing, such as the fact that Max and Anna are lovers rather than friends, because performance cues – gazing into each other's eye, holding hands, etc. – mimic behaviors that would indicate a romantic relationship in real life (perhaps the director heightens this by getting a POV shot from the woman's perspective as the man moves in close to her). Most importantly, at least for the client, we understand that the Coke that they are drinking is making them happy because of the special effects but also because Max and Anna smile when they take a sip, and all of us, even a baby, know what a smile means.

In order to see how much information can be contained in the moving image, let's take a look at a spot David Fincher did for Nike a few years back entitled "Fate." "Fate" begins with two baby boys in the hospital and then follows the boys as they mature into the famous football players LaDainian Tomlinson and Troy Polamalu. The spot eventually culminates in a sequence that features the two players running towards each other and having a huge collision as Polamalu tackles Tomlinson after a big gain. They then get

Image from "Fate."

up, pat each other on the head, and go back to their respective huddles.

"Fate" has no voice-over and only one title card at the end – which simply states "Leave Nothing" – but the viewer can easily decipher what the piece is about just from the visuals and audio. Even without knowing that the title of the work is "Fate," it is clear by the juxtaposition of the two boys growing up and training to be stars that they were destined to have this collision. This insight comes from a host of cues that help guide the viewer there – the score, a remix of Ennio Morricones' song "The Ecstasy of Gold" from *The Good, The Bad, and the Ugly*, which signals the "epic duel" at the core of the story is a major hint – but it mainly comes from the imagery itself, as nearly every shot is chock-full of details which help guide us to the thought that Tomlinson and Polamalu's upbringing, talent, and work ethic have fated them to have this encounter.

To see this play out, let's take a look at three stills chosen entirely at random (if you want to see just how good Fincher is, watch the spot closely, as every image is incredibly thought through). All three of these shots are stand-alone images, as there are no cuts to other shots that are from the same temporal/spatial space. This means that each image exists on its own to tell its moment of the narrative.

First take a look at the previous image, which is a shot of one of the babies running out of the bath with shampoo on his head. This is one of the longer shots in the piece, as it clocks in at just over three seconds. Besides revealing the fact that the baby has an exuberant nature and clearly likes to run, it also gives us a multitude of insights about the world that the baby inhabits and how that world might be shaping his destiny. Just by scanning this one frame we can tell – given the design and materials of the house – that the boy's family is probably lower or middle class and that they take a lot of pride in their home (look at the two matching towels folded and hung neatly over the towel rack, a clear sign of a home that is well tended to). We can also see that the boy's family is filled with people who love playing sports, a fact we can glean by noting the baseball glove and football on the floor in the hallway. Finally, in the last fourteen frames of the shot, we see an adult emerging from the bathroom and chasing the baby down. The adult, we can assume, is the boy's father, and his attire indicates that he is just getting home from work. His clothes, particularly his boots, indicate that the man works at a job that is probably physically demanding and strenuous. Despite this fact, he has come home in time to bathe the baby and is diligently doing his job, which indicates an involved parent. So, from just this one frame we can see how much the boy likes to run, the fact that he comes from a lower or middle-class family who loves sports, and the fact that his parents work hard but also take the time to care for him. Not to simplify all the factors that go into creating an elite running back, but if I had to come up with a list of what I would assume would be some common ones, these would all be on that list.

Moving on to the second still, we are now in the boys' middle-school years, and here we get a shot of

Image from "Fate."

Tomlinson – although the spot doesn't make explicit which boy is Tomlinson and which is Polamalu until they get to college and we see their uniforms, Fincher always frames Tomlinson going left to right in the frame and Polamalu going right to left, and we also get a bunch of clues based on their hair and the positions they are playing – running the ball up field. This shot reveals the budding stardom of Tomlinson as he evades tackles, as well as continuing to add details about his world. For example, we can see that the boy lives in a suburban or rural environment (interestingly, I did a little research on both men, and Tomlinson was raised in Texas, which is exactly what I had assumed given the shots of his childhood). We also see the electrifying effect Tomlinson's athletic prowess has on those around him, as the fans cheer wildly as he darts in and out. We even get a clue about his larger family by looking closely at the three young-ish men standing and watching on the left side of the frame. These men are pretty clearly not coaches, given their body language and attire, but the intense way that they are watching, and how close they are to the field, indicates that perhaps they are family members of the boy who is running: they just *seem* like they are older brothers or cousins watching keenly as their younger counterpart excels at a sport they once played. Yet again, more details that lead to this notion of fate or destiny, as being from Texas and being from a family with older relatives who are actively involved in your maturation as a football player would seem to me to be an ideal setup for future football success.

Image from "Fate."

Moving to the third still, we now see that our protagonists are in high school, as we see one of the boys listening as his coach explains a play. As Fincher tracks the camera behind the boy and we see him spinning his pencil, we realize how much the boy is focusing on what the coach is saying, as well as how quickly his mind is processing that information. This indicates the boy's commitment to the sport as well as how bright he is (one of the things people often fail to realize about elite athletes is how gifted they are in terms of processing the physics and geometry of the sport they play, and this shot shows this process perfectly). So, not only is our boy talented physically, he also has the mental makeup and dedication one needs to be an elite athlete. Yet again, we can see how fate is moving these boys towards the NFL and their showdown with one another.

As we can see, by skillfully playing with the Five Ws and with the information the audience is being given, Fincher is painting a detailed portrait of these men and their upbringing, which subsequently helps the audience to absorb the central message about fate and athletic success that the spot is positing. Fincher is able to do this because his images are giving us information in a controlled and expressive fashion, as we always know exactly what is going on and what each image is trying to tell us about the events it is depicting.

Another way short form content can powerfully impart information is by utilizing design elements and typography. For example, a few years back the Director and Designer Patrick Clair – who is famous for his work on the *True Detective* title sequence –

Images from Stuxnet Video.

released a video that traces the history and impact of the Stuxnet computer virus that attacked Iran's nuclear enrichment facilities in 2010. The video is less than four minutes long, but Clair's use of CG, motion design, and typography takes an arcane topic and makes it easy to digest, as viewers learn how the virus was created and deployed, what it did once unleashed, who was rumored to be behind it, and where the virus will go next. The Stuxnet video illustrates per- fectly why short form content creators have been so quick to adopt motion design and CG in their work, as not only does it allow for incredibly fast dissemi- nation of information, but it also allows us to show something that would be impossible to film in the tra- ditional way (after all, if you were trying to film the Stuxnet virus what would you record, lines of code on a computer?).

The Importance of Motion

Imagine your caveman ancestor, let's call him Oogh, going to fetch water from the local pond. It is late and Oogh has had a terrible day (cavelady has been hassling him, caveboss got annoyed with him for not smashing rocks together quickly enough, the usual). All Oogh wants to do is head back to his hut, kick up his feet, and relax by the fire, but, first, he must get some water so that he can make breakfast for the cavekids in the morning.

As Oogh shuffles his way towards the pond, grunting to himself about how his feet hurt and how he wishes someone would just invent shoes already, he suddenly notices that the usual sounds that would accompany his walk are strangely absent. No birds, no bugs, nothing. He tenses up a bit, as he remembers how that blowhard Grugg Clugg mentioned to the clan at yesterday's "omega meeting" that he had spotted a Saber Toothed Cat by the watering hole (truth be told, Grugg is full of it so Oogh just rolled his eyes at the time but now, as fear seizes him, he thinks maybe the bastard was actually telling the truth).

Just then, on the other side of the pond, Oogh sees a flash of white fur. The moon is obscured by the clouds overhead so it is hard to see, but something *definitely* moved out there. Oogh looks around and spots a large stick on the ground; it won't be much help against a full-grown Saber Toothed Cat, but if a juvenile decides to attack he might be able to beat him off. He picks up the stick and slowly begins walking backwards, his eyes fixed on the far side of the pond.

Suddenly, in the bushes on *this* side of the pond, Oogh notices that the leaves are shaking despite the fact that it is a windless night. He stops, peers closer, and steels himself for what he is sure will be a swift and decisive mauling. "Just my luck" he thinks to himself, "I am going to get eaten by a freaking Saber Toothed Cat, and I just know Grugg Clugg is gonna be all 'I told you there was a Saber Toother Cat by the pond' to the rest of the tribe. God, being a caveman is the worst." The bushes heave and out of them comes blasting … a small white bunny, who stares at Oogh for a second before careening wildly toward the hills.

Oogh takes a deep breath and chuckles to himself before turning and slowly walking back to his hut ("these moonless nights can wreak havoc on a caveman's delicate nervous system" he thinks to himself). He has survived another day and his survival – and the survival of all of your ancestors – is why you are alive and holding this amazing book in your hands. One of the main reasons Oogh has survived is that he, like all successful cavemen, is very good at picking out motion in the world around him (if something moves in Oogh's world, chances are it wants to eat him or he wants to eat it). And, luckily for us as short form content creators, human beings' tendency to perceive motion means that motion within the frame can be a huge help for us in terms of allowing us to tell compressed stories.

This is because motion within the frame (and this motion can be objects moving within the frame and/ or motion of the camera) also allows us to easily make

edits. This is an incredibly important thing for short form, as a static six-second shot which is impossible to cut into or out of except at the beginning or end of those six seconds is generally going to be unusable as, more likely than not, you won't have six seconds to devote to just this one narrative moment. Conversely, a shot which has movement will allow us to edit it wherever we choose, as movement will distract the viewer from the transition and ease them from one shot to the next.

The importance of movement within an image is at its most critical when you are making pieces such as sizzles, where you are basically just taking a whole mess of footage and trying to create something out of it (a "sizzle piece" is a video that is usually business to business rather than business to

Images from Esquire Sizzle.

consumer and is, more often than not, created out of existing footage in order to give an overall sense of a product or brand). In instances like these, you need each image to be as dynamic as possible, as there will usually be nothing happening narratively that will motivate an edit. For example, take a look at the previous sequence of images, which shows the first frame of six shots from a sizzle for The Esquire Channel created by the entertainment marketing company Stun. Notice how each frame is a dynamic one that is depicting a big action? This is because a piece like this, which is essentially a series of clips from content that is totally unrelated, needs to be built out of dynamic imagery or else it completely shuts down.

Attracting Attention and the Image

Below is a still from a Carl's Jr. commercial that features Kate Upton. I don't want to speak for the creators of this ad, and I am not privy to their marketing strategy, but I think we can assume, given the fact that Kate Upton was utilized in this particular way, that they were targeting young, heterosexual males. Whatever you might feel about using sex in this fashion – and as a heterosexual man I am fine with it but as the husband of an awesome, strong woman and the father of an awesome, strong daughter it makes me want to karate chop someone, so let's just say I'm as conflicted as you probably are – it undoubtedly works

Image from Carl's Jr. commercial.

in the sense of drawing your attention. Furthermore, given that the target of the commercial is often seeing it in spaces such as bars while watching sports, it is a good strategy in the sense of being a simple, clear piece of communication – which can work without sound – that uses Kate Upton and all of her assets to get you to pay attention and then shots of a juicy burger to make you hungry for Carl's Jr. Again, I can't speak for the creators of the spot, but the script literally could have been "Kate Upton and her assets and shots of the food," and that would about cover it.

Of course there are other ways you can draw attention with the visuals you use. Sure sex will always work, but so will violence, celebrities, beauty, dynamic action, and a host of other things. The thing about us humans is that we are very visual, so if you show us something that we find interesting to look at, we will do so. For example, a few years ago the director Romain Gravas shot a video for M.I.A. for her song "Bad Girls." Besides featuring shots of cars driving on their side, which would definitely draw your attention, the video also features eye-catching imagery such as Arab women driving while wearing a niqab and M.I.A. standing in front of burning oil-wells. The video plays a very shrewd game with the imagery it presents us with, as it shows us images that seem somehow taboo and draws our attention by doing so.

This strategy is particularly clever given how music videos, which used to be seen on TV, are now primarily consumed online. As a result of this shift, music video directors have had to change their tactics in

M.I.A. in the "Bad Girls" video.

order to create content that fits inside of the collaborative, sharing ecosystem that is the Internet. The "Bad Girls" video was tailor made for this shift, as the way it touches on issues of Arab identity, war, ethnicity, and gender makes it an Internet think piece waiting to happen. The importance of the imagery extends beyond the video itself, as the way the Internet works is that all of those think pieces and Facebook posts which referenced the "Bad Girls" video pulled the most provocative frames from the video to use as stills. Those stills, which hit you harder than text describing them ever could, are a big reason why people clicked through to see the entire piece. Not surprisingly, the video was quite controversial, and the buzz around the piece led to it being viewed roughly sixty million times on YouTube alone, the most views any M.I.A. video has ever received.

Of course it is not simply the *type* of imagery which you use that can garner attention, as short form content creators have come up with a number of tactics – quick cuts, extreme shifts in contrast and luminance, fast motion within the frame, etc. – which they deploy to get people to look their direction. Furthermore, in short form there is always a premium put on images being novel and fresh, as even though we are usually showing people something that they have seen before in terms of the content we are presenting them with, there is no limit to the ways we can film these actions. This is because natural generativity also means that, unlike with a language, there is no limit to the way something can be described on a basic level. For example, imagine I placed you in a bare room with a rose lying on the floor and asked you to tell me what is in the room. You, and almost anyone else I would ask, would probably respond by saying something like "there is a rose." Now, people might differ in the exact way they describe it – the more poetic amongst us might recite something about the beauty of the rose being a symbol of the

Images from "Bad Girls" video.

importance of love – but, at the end of the day, in order for me to fully understand what is in the room, you would be limited to a finite set of words ("rose," "red flower," "thorns," etc.).

Conversely, imagine I gave a hundred different people a camera and told them to go in and film the object in question so that I could know what it was. Every one of them would, barring some fluke, come back with footage that was unique but that all told me the same thing: viz., that the thing in the room is a rose. In fact, given all the different factors that go into the production of a shot (f-stop, angle, lens, etc.) it is fair to say that there is an infinite number of ways that I could depict that rose while still getting across the basic information about what the object is. The difference lies in the fact that the language user is

limited by the words that preexist in a lexicon, while a filmmaker is not limited by any conventional minimal units of meaning. As the philosopher Gregory Currie puts it, "there are no atoms of meaning for cinematic images, every temporal or spatial part of the image is meaningful down to the limits of visual discriminability."[6]

The fact that short form content creators are not limited by any conventional units of meaning allows us to present content in a way that is novel and fresh no matter how tired the subject matter. For example, a few years back the production company Gentleman Scholar did a series of TV spots for The Cosmopolitan Hotel of Las Vegas for a campaign entitled "Misfit Right In." The spots are a mix of bold typography, stills, and stylized footage, and are quite effective at

Image from "Misfits" commercial.

Images from "Misfits" commercial.

drawing your attention, particularly on TV where the work ran heavily. Hotel advertising is never an easy thing, as it is a category that goes boring really quickly, but "Misfit Right In" goes in the opposite direction and presents us with imagery that is pretty much impossible to turn away from.

Attracting viewers' attention is never an easy thing, and what makes the "Misfit Right In" campaign so successful is how it manages to do so while still serving to highlight the product in an appropriate way. The Cosmopolitan Hotel positions itself as a sexy, edgy alternative to the traditional Vegas hotel, and the "Misfit Right In" work perfectly hits this mark. By standing out from the typical advertising one finds in the category, the campaign accomplishes the very difficult task of getting viewers to pay attention while still positioning the end product in a way that works for the brand.

Gentleman Scholar on "Misfit Right In"

Gentleman Scholar was founded in 2010 by the "Two Wills," also known as William Campbell and Will Johnson, a directing duo based out of Los Angeles. It's under this moniker that they have been able to create stunning visuals for brands such as HP, Coca-Cola, Microsoft, The Cosmopolitan Hotel in Las Vegas, Chevy, Skullcandy, Hyundai, and many more. Gentleman Scholar has made the shortlist for AICP nearly every year since its inception and their film "Butterflies" with John Malkovich was featured at Cannes in 2011.

Bryan Cook: Over the past few years design shops such as Gentleman Scholar have started to evolve beyond what that label has traditionally meant by taking on tasks like directing and overseeing other aspects of the production pipeline. Why are we seeing this shift in the industry and what does it say about the role of design in short form content?

William Campbell and Will Johnson: The industry as a whole is always evolving, as the cliché goes. The evolution of a medium and craft is just second nature for any type of artist, designer, or creative thinker. The thing about any evolution is that it always revolves around storytelling, and has for centuries. The minute a story is attached to a beautifully designed piece of type, a clever animation transition, or cinematic piece of footage it takes on a whole new layer of intrigue. It's an exciting time for design to be honest. The fundamentals stay the same, it's just the canvas that's changing.

Bryan Cook: In terms of the campaign Gentleman Scholar did for The Cosmopolitan Hotel of Las Vegas, what was the basic brief and what were you guys asked to bring to the table?

William Campbell and Will Johnson: The brief was simple. Create something that stood out from the opulent, gold and diamond encrusted champagne glass noise of Vegas. We were brought in to help along the story, curate the visuals, create the pace, and find something new that rocked the established voice of Vegas as a whole.

Bryan Cook: One of the noteworthy elements of that campaign is how good it is at attracting attention in the Broadcast

Evoking an Emotional Response

We have tackled information, motion, and attracting attention, so let's now look at how images in short form need to evoke an emotional response in the viewer. This is quite a difficult challenge, as, unlike in long form where you can count on the viewer being involved emotionally with the characters you have been presenting them with for the past hour, in short form we need imagery to be emotionally powerful with very little narrative support.

In order to get our heads around how it is that moving images can be so emotionally evocative I want to briefly discuss a term used in philosophy: qualia. Qualia is the term philosophers use to describe the way a perceptual or physical experience actually *feels* to the person who is having it (e.g., the way it feels to have a headache or what it feels like to be drunk). In other words, if you had never had a headache and I was trying to explain headaches to you, I could give you a long list of the causes of headaches and how they work physiologically, but until you had experienced one yourself, you would never know what a headache actually *felt* like. As the philosopher Frank Jackson put it when arguing that qualia is a necessary component of explaining how human beings respond to the external world:

> *… there are certain features of the bodily sensations especially, but also of certain perceptual experiences, which no amount of purely physical information includes. Tell me everything physical there is to tell about what is going on*

in a living brain, the kind of states, their functional role, their relation to what goes on at other times and in other brains, and so on and so forth, and be I as clever as can be in fitting it all together, you won't have told me about the hurtfulness of pains, the itchiness of itches, pangs of jealousy, or about the characteristic experience of tasting a lemon, smelling a rose, hearing a loud noise or seeing a sky.[7]

Jackson goes on to give us some examples in order to prove the existence of quales. In one of these he asks us to imagine a color scientist named Mary. Because she is a color scientist, Mary is aware of the physics of light and how colors exist in certain wavelengths; she knows about the way the brain interprets these signals and how they translate into various colors; and she has read all of the research that looks into how human beings tend to respond to certain colors. But, despite knowing all of these things Mary has, sadly, been confined to a black and white room her entire life and has never *seen* an actual color. But one day, happily, whomever has been cruelly locking Mary up in this black and white world lets her go, and when she first enters the world of color that we all inhabit, Jackson argues that Mary now gains new insight into colors. Namely, she learns for the first time what it *feels* like to see colors. In other words, she might have known all the scientific information about color beforehand, but when she first sees the color red, she learns what it feels like to see red.

What we can take from all of this is an explanation, or at least an analogy, for what cinematic images do. In order to see this, take a look at a spot Apple did for the iPad Air entitled "Your Verse." The spot is comprised

TV space. Was this a conscious objective or more of a byproduct of the approach you settled on?

William Campbell and Will Johnson: This was something that we set out from the beginning to accomplish. We played with music track after music track in the initial pitch before we settled on that loud, in-your-face call to arms. In order to do something for Vegas that felt so unabashedly different, we needed to break a few eggs, or rather, egg a few casinos.

Bryan Cook: Given that many of the words are only on screen for a handful of frames, how did you determine what the threshold of understanding was (i.e., what was your process for determining when the average person could process the words they were being presented with)?

William Campbell and Will Johnson: We imagined the words as the Fight Club dick shot to be honest. The, "wait, what did that just say?" moment. Rather than risqué imagery, wouldn't it be more fun if we blasted the screen with the poetry of misfitting right in and used those moments as our subliminal lining. We did run the spots through a few epilepsy tests before broadcast to make sure we didn't hurt anyone, but the goal was to catch people off guard and allow them to absorb as much or as little as they wanted, but either way it was there and in your face.

Bryan Cook: The Cosmopolitan spots invert the typical balance in TV work where typography is generally subservient to footage. How did this affect the way you selected footage and what were you asking the footage to do when you used it?

William Campbell and Will Johnson: We loved this. Our background is type and design and using that foundation to help propel the story forward is what pulled us into the project in the first place. The footage to us was the exclamation point. We shot everything ourselves so we knew exactly the right amount of art direction to complement what type was being used. It wasn't necessarily even a perfect metaphor for any of the phrases, or even a representation of our thought process. It was us taking what existed and, in a way, turning it on its head.

Bryan Cook: In terms of the title treatment you worked on for *Spring Breakers*, what were the different visual cues and ideas you started with and how did they eventually coalesce in such a coherent way?

continued overleaf

Image from *Spring Breakers* title sequence.

Image from "Your Verse" commercial.

William Campbell and Will Johnson: Well firstly, Harmony Korine is the best kind of collaborator. He allowed us into the process early, so we were able to watch one of his versions of the film and then have at it any way we could imagine. We had worked with Harmony in the past and it was his trust in us that really led to us having some fun and making something that we all thought would fit perfectly into his vision. Any time you mix spring break, cornrows, and Gucci Mane, that's a pretty awesome jumpstart to any creative process.

Bryan Cook: What is the one question you always end up asking yourself while working on any piece?

William Campbell and Will Johnson: Why? It's important to know *why* any one thing is happening. Why is the story *this* story? Why is the type *this* type, or the character *this* character? If you can define the "why" within your choices then there is a good chance your choices are going to hit the mark.

of a series of vignettes from around the world (an LA Kings practice, a Bollywood choreographer on set, a team of engineers working on wind turbines at sea, etc.) and is narrated by a clip from *Dead Poets Society*, which sums up what the piece is attempting to communicate: "We don't read and write poetry because it's cute. We read and write poetry, because we are members of the human race. And the human race is filled with passion. And medicine, law, business, engineering – these are noble pursuits and necessary to sustain life. But poetry, beauty, romance, love – these are what we stay alive for." The visuals of the spot support this notion by showing how the iPad Air can help you achieve amazing things that will help you write "your verse."

The commercial is one that advertisers refer to as an "anthem spot," and it is very effective at causing that little tingle in the back of your spine. I believe it does so because the images, besides merely being beautiful, are triggering the quale of what they depict. What I mean by this is that the spot is so well executed in terms of how each image is composed, lit, and framed, that when you watch it you feel, to some degree, what it feels like to perceive and experience these events in

Images from "Your Verse" commercial.

reality. This is obviously not an easy thing to pull off, as, if the camera was positioned just slightly differently in the sequence inside the small club in Asia, you would not be able to experience what it feels like to be inside of a packed club filled with people as in synch with the music as you are. When cinematic images do this, when they manage to capture the things they are depicting so perfectly that you get the same feeling that you would get if you were experiencing them directly,

it is almost as if the camera is revealing reality to you. As Sontag notes in *On Photography*, "The painter constructs, the photographer discloses."[8]

The images in the spot are able to do this because of how they are framed, how the camera is positioned, the lens being used, etc. But, at the end of the day, they are able to do so because of the fundamental relationship between a camera and the reality that it records (even with work that is completely CG, the images

usually "work" because the artists creating them have mimicked how a camera and the world interact with each other). For me, the best way to understand the relationship between a camera and the reality it records is to turn to our last philosophical term: *counterfactual dependence*.

Counterfactual dependence is a term that describes the fact that photographic images are caused by the reality they depict. For example, if a mustache appears above my lip in a home movie, it's because I actually have a mustache in reality (CG obviously complicates this but let's leave that aside for now). Or, to look at it another way, unlike with a painting or a book, a photograph cannot be taken of something that doesn't exist, since even a monster movie or a photographic hoax does indeed depict something, e.g., an actor in a monster costume. Counterfactual dependence is unique to photography and film and has led to some interesting claims about what exactly these mediums do.

Probably the most famous of these claims is what Andre Bazin said about film in his seminal essay "The Ontology of the Photographic Image": "The photographic image is the object itself, the object freed from the conditions of time and space that govern it. No matter how fuzzy, distorted, or discolored, no matter how lacking in documentary value the image may be, it shares, by virtue of the very process of its becoming, the being

of the model of which it is the reproduction, it *is* the model."[9] Bazin means this claim literally, as he wants to say that when I watch *Chinatown*, I am actually seeing Jack Nicholson (which is, of course, very different from seeing a painting of Jack Nicholson). This identity claim is a problematic one, as Bazin is now in the unfortunate position of having to assert that in 1974, when *Chinatown* first opened, Jack Nicholson was simultaneously at three hundred theaters around the country as well as in Los Angeles sipping a martini. Bazin never really explains how he is going to support such a philosophically unorthodox identity claim, but his argument does go somewhere interesting in the hands of the philosopher Kendall Walton.

What Walton argues, to put it very simply, is that because of counterfactual dependence, photographs are not depictions like paintings, but instead are like prosthetic aids to vision such as microscopes, binoculars, and telescopes, which allow us to see objects in a different way than we could with the naked eye, but still let us see the object itself, not a depiction of it. Walton attempts to use a slippery slope argument to get us to consider cameras in the same way that we do prosthetic devices, as he wonders what is the difference between a microscope and a live television broadcast, since both involve seeing, through the aid of an instrument, the object itself? One wants to bring up the temporal distinction in that with film you are generally seeing things that happened in the past – and

photographs . . . reveal actual events and offer testimony to truth and falsehoods concerning reality.

thus could see a person in a movie who has long since died, an unlikely event with binoculars – but Walton counters this with the fact that with telescopes we sometimes have the same disjunction, as we can use a telescope to see stars that are actually extinct.

Now, even if you don't fully agree with Walton's argument on philosophical grounds – and I don't, but it would take us too far afield to get into it – I think it does acknowledge a basic fact about how viewers position themselves in regards to photographs that helps explain the power of film in terms of generating quales. For example, look at the difference in how people respond to photographs of atrocities or pornography and paintings of the same subject matter. The heightened emotional reaction most people have to photography's treatment of these subjects is not due to the fact that photographs are always more "realistic" in the sense of looking more like the world – as this is not always true – but because we believe, based upon our knowledge of the medium, that what we perceive in a film or photograph has actually happened. A startling proof of this is a picture taken high above a rally in Germany in 1914. In the photograph there are upwards of two thousand people. Upon blowing up the photograph it is possible to make out a young, unknown Adolf Hitler. This is something which is clearly not possible with a painting, as the human being is only capable of so much in terms of depiction and there is no way that the artist could have drawn a particular individual who was unknown to her from the distance at which the photograph was taken. Furthermore, one could not hope to point to a painting of the same scene and state

"here is Hitler" with any hope of making an assertion about reality. In short, photographs, unlike paintings and words, reveal actual events and offer testimony to truth and falsehoods concerning reality.

Counterfactual dependence obviously functions differently in the case of fictional work, as when we see Tom Cruise shooting people with a bazooka while riding backwards on a motorcycle we don't take this to be a claim about reality. But I do think that some of the power of counterfactual dependence leaks into fictional worlds. Furthermore, in short form, much of our work straddles the line between fiction and non-fiction anyway. For example, the vast majority of commercials are filled with generally unrecognizable actors playing "real people" doing mundane things (going shopping, mowing the lawn, etc.). The reason advertisements do this is to get the viewer to believe, on some level, that this is an actual consumer who is getting something positive out of whatever product is being sold. This is also why one of the toughest parts of any commercial production is the casting, as advertisers will have very concrete ideas about who their target consumer is and what they aspire to be.

Even if we put aside the way viewers psychologically position themselves relative to photographic images, because of the way a camera works, reality will often just reveal itself through it. For example, a few years back I was scrubbing through footage when I stumbled across a moment where the DP, who was doing a camera test, got an image which evoked a very strong reaction in me. It was a simple shot, completely un-noteworthy in the boards, but something about the

way it played out – the camera was tracking to the left as the actor moved in the opposite direction and a small sliver of light was revealed behind the actor's head as a curtain gently blew in the background – had an effect on me, as I was suddenly hit with the sensation of sitting in a friend's kitchen as we made breakfast on a warm summer day. It wasn't that the actor resembled my friend or anything obvious like that, it was just that the way everything was composed and how the events on set unfolded – without that curtain blowing in the background who knows if I would have had the same feeling – elicited a visceral feeling in me that I would describe as "the way I felt on that morning when I cooked breakfast with my friend."

The net result of all this talk of quales and counterfactual dependence – and please excuse the density of all of this but the only other option was to throw up my hands and say "we make pretty pictures, pretty pictures are good" – is that short form content creators are able to generate images that are powerful enough that they can elicit an emotional response without narrative support. As we mentioned in Chapter 1, evoking an emotional response in the viewer is a huge part of what we as short form content creators are tasked with doing, and one of the best weapons we have for pulling this off is the images we use. This is the reason why advertisements shown during the Super Bowl frequently feature animals and children, as you show any Mother a poignant image of a child, and, even without any investment in the rest of the narrative – perhaps she just got back from the kitchen where she was fetching nachos – she will be emotionally impacted. It might seem a little cheap at times – when I am cranking out a corporate piece I will throw a baby and a Mom cuddling in that edit faster than you can say "that is really manipulative" – but it works, and, well, it's our job.

So that is a look at how images tend to function in short form. Now we are ready to move into editorial and look at how we organize and deploy these images in order to accomplish our goals.

1 Messaris, *Visual Literacy: Image, Mind, & Reality*, 2.
2 Julian Hochberg and Virginia Brooks, "Pictorial Recognition as an Unlearned Ability," *American Journal of Psychology* 75 (1962): 628.
3 Stephen Prince, "The Discourse of Pictures: Iconicity and Film Studies," *Film Quarterly* 47 (1993): 22.
4 Messaris, *Visual Literacy: Image, Mind, & Reality*, 9.
5 Messaris, *Visual Literacy: Image, Mind, & Reality*, 39–40.
6 Gregory Currie, *Image and Mind: Film, Philosophy, and Cognitive Science* (Cambridge: Cambridge University Press, 1995), 122.
7 Frank Jackson, "Epiphenomenal Qualia," *The Philosophical Quarterly* 32 (1982): 127.
8 Susan Sontag, *On Photography* (New York: Picador, 1977), 92.
9 Andre Bazin, "The Ontology of the Photographic Image," *What is Cinema?*, trans. Hugh Gray, vol. 1 (Berkeley and Los Angeles: University of California Press, 1967), 13.

Into the Windowless Rooms:
On Editing

struc•ture (struk´cher), n., v., -tured, -turing. –n. 1. Something made up of a number of parts that are held or put together in a particular way: *hierarchical social structure*. 2. The way in which parts are arranged or put together to form a whole; makeup: *triangular in structure*. 3. The interrelation or arrangement of parts in a complex entity: *political structure; plot structure*.
Houghton Mifflin, *Dictionary of the English Language*

In a certain sense, editing is cutting out the bad bits, the tough question is, *What makes a bad bit?*
Walter Murch, *In the Blink of an Eye*

At a party a few years ago I was chatting with an architect friend about her profession. The conversation had begun casually enough but had grown, as these things often do when wine and shop talk mix, increasingly nuanced (terms like "spandrel area" and "rectilinear style" were beginning to be bandied about). Eyes beginning to glaze over and wine glass perilously close to empty, I wanted to wrap things up and so I asked her: "What is the conventional view within your profession of the single factor that makes a building really work? In other words, if you asked a hundred different architects what separates a great building from a lousy one, what would be the most common answer they would give?"

She thought for a moment and then gave me her answer, an answer which, given all that "spandrel area" and "rectilinear style" business, was charmingly succinct (truth be told, her wine glass was also perilously close to being empty, so she probably wanted to wrap things up as well). "Well," she said, adjusting her glasses, "I don't think any two architects would give you the exact same

" . . . short form content, with its condensed narratives, rapid shifts in time and space, and need to quickly communicate numerous concepts, is absolutely dependent upon a solid foundation."

answer to that question, but I think we all would agree that you definitely want to make sure that the thing isn't going to collapse and kill everyone inside."

I love this response, and have used this anecdote many times when lecturing a junior editor on the importance of a solid structure (and I really do get annoyingly didactic on this issue; while a piece of short form content that has a shaky foundation might not kill everyone who watches it, *I* die a small death when forced to watch something that is a mess structurally). Of course, structure is imperative to all of the arts, but short form content, with its condensed narratives, rapid shifts in time and space, and need to quickly communicate numerous concepts, is absolutely dependent upon a solid foundation. With a good structure in place, you will get work that is engaging, coherent, and effective. Without it, you will be lucky to end up with something that isn't a complete mess.

The importance of structure is a major reason why the editing process is so crucial for short form, as it is usually in the edit bay that the narrative shape of a piece

will be figured out. Yes short form work usually begins with a script, but short form scripts are often nothing more than a cool concept, a few sound bites, and a line or two of copy, and everyone in the short form world is pretty comfortable with the notion that the structure of a piece will really be worked out in the editorial phase of production. This is significantly different than the editing process in long form, where working this way would be completely impractical given that you will usually have hundreds of hours of footage to deal with and, often, multiple editors working on the same piece. Of course the short form editor is still charged with finding the best takes, making individual edits, and connecting shots together in a way that is resonant and interesting – and we will get to this process later in the chapter – but the short form editor is *also* the one who is usually tasked with giving shape and structure to a piece, so let's start our look at short form editing there.

To begin, take a look at the definition of structure in our first epigraph, which points out that the way a thing is structured determines, to a large extent, what that thing actually is (as the epigraph puts it, a structure is "something" that is "made up of a number of parts that are held or put together in a particular way"). For example, Carnegie Hall and Madison Square Garden are comprised of roughly the same materials (concrete, glass, etc.), have the same basic elements (doors to allow people in and out, seating to allow them to enjoy the performance, etc.), and perform the same basic function (allowing people to watch a performance safely and with visibility). Yet,

despite these similarities, the two buildings look and feel very different from one another as a result of how their materials and elements are combined. In other words, the way in which a thing uses its parts, the way it is structured, is what makes an X an X, and not a Y. It is the essence of a thing, its core.

Image from *Spiderman 3* trailer.

But what makes a particular structure work in short form content? Well, at the risk of oversimplification, I believe that all properly constructed short form work will have the following elements: **a beginning, middle, and end that each do unique things** and **an explicit separation of all major ideas and concepts**. Before I break these concepts out further, I want to take a look at a particular short form piece so that we have a point of reference for our discussion. For our example, let's turn to the place where the importance of structure is at its most obvious: movie trailers. The trailer I will examine is for *Spiderman 3*, as it offers a master class in short form structure. Take a look at the breakdown below and note how, even with all the story points and transitions that the editor manages to work into the two minute and twenty-four-second

piece, the structure remains tight, as we are moved through the story with fluidity and emotional engagement:

a) We open on three quick shots of New York City and cheering fans scored by some heavy drum hits. The shots build suspense and act as a teaser for the action that is to come. *8 Seconds.*

b) Spiderman flies into screen, an action that is scored by a dramatic orchestral hit. We cut quickly to most of the major characters – Mary Jane, Harry Osborn, and the junior photographer Eddie Brock – who are watching Spiderman's entrance. *8 Seconds.*

c) With an elegant audio transition to a tension-inducing musical bed, we see the Columbia logo and get our first main plot point, as Peter Parker announces to his aunt that he intends to marry Mary Jane. His aunt warns him that with marriage comes responsibility, something that the confident Peter cavalierly dismisses. *12 Seconds.*

d) Another elegant musical transition, as the tempo increases and we are introduced to the Sandman, Spiderman's main antagonist in the film. We also learn that the Sandman (in the form of his earlier incarnation, the petty criminal Flint Marko) is the actual killer of Peter's beloved uncle. We see Peter's desire for revenge, as well as seeing the first battle between the Sandman and Spiderman. We also get our first three title cards, which are spread throughout the section and read: "Every hero has a choice," "To face the darkness," "Or be consumed by it." On the last title card we get another musical hit and the score drops out. *23 Seconds.*

e) The music gives way to a dramatic audio bed and the major struggle of the movie, the conflict inside Peter between his desire for revenge and his ethical code, becomes clear. This information is given to us in a sound bite from Peter's aunt, who tells him, "Revenge is like a poison. It can take us over. Before you know it, it can turn you into something ugly." We also see the physical manifestation of Peter's struggle in the form of the new, black Spiderman suit, which increases his powers but destabilizes his ethical code. *15 Seconds.*

f) The musical bed drops out and a long rise enters. We see Spiderman in his black suit and all of the additional powers that the suit has given him. We see how Peter is seduced by the power of the suit and how it increases his desire for revenge. *15 Seconds.*

g) A driving score leads us forward as we now see the major conflict points. These include Spiderman vs. the Sandman, Peter vs. his friend Harry Osborn, Peter fighting to save his relationship with Mary Jane, and the conflict within Peter himself. This internal conflict is made explicit by a number of shots of Spiderman inflicting damage upon others, as well as a shot of him dangling beside a building in his black suit while his reflection in the glass shows him in his normal red suit. *35 Seconds.*

h) The music drops out and a series of big drum hits and a vocal rise take over the audio track. Peter announces to Mary Jane that he needs her help and we see him struggling to remove the black costume. *8 Seconds.*

i) We conclude with an action-filled montage that is interspersed with the last four title cards: "This summer," "The greatest battle," "lies," "within." The pace of this montage is quick and most of the shots feature characters and objects moving forward in z-space towards the camera. The act ends with Spiderman, his red costume torn and frayed, thrusting his hand forward. This action ushers us into the logo for the film. *16 Seconds.*

j) We end on the logo lock-up as well as a title announcing the date that the movie will be arriving in theaters. The audio is mostly a drone but there is a nice sting on the end as the premier date flies off and we are left with a few, dramatic seconds of black. *5 Seconds.*

With this as our example, let's begin by looking at the importance of a clearly defined beginning, middle, and end.

Beginning, Middle, and End (and Each One's Unique Function)

Although it sounds obvious to posit that all short form needs a structure based on a clear beginning, middle, and end, much of it does not have this basic scaffolding. Instead, what you often get with short form content is a long middle, no real beginning, and an end that is simply a logo. This is the easiest way to lose or bore an audience, as viewers want a story to be structured in such a way that they are moved through it in three basic steps.

Beginning: The first few seconds of any piece of short form content are absolutely critical to its success, as it is within this brief period that the editor attracts attention, lays out the tone and tempo of the piece, and peaks curiosity by giving, and withholding, information. Correctly controlling the amount of information that is supplied and withheld is important, as viewers will turn away from a piece of short form content at its inception for two reasons: either because they are confused by it and what emotions it is promising to evoke, or because they feel like they can tell what is going to happen and thus do not feel that the work is worth their attention (this latter problem is the main one that plagues TV commercials, as all too many spots are ignored because within the first three seconds the viewer thinks to himself, "oh, another hair care commercial, I know what will happen here – lots of slow-motion shots of women flipping their hair around scored by an innocuous house music track – so I can ignore this and move on with my life"). Viewers want to solve something when they interact with short form content: they want to be an active participant and play a role in supplying answers to questions that you ask. Thus, the editor must give enough information to make the story seem interesting and

> *. . . all short form needs a structure based on a clear beginning, middle, and end . . .*

coherent, while also withholding enough information that viewers don't know what the end will be before they get there (as the inimitable P.G. Wodehouse describes the opening of a story: "the snag I always come up against when I'm telling a story is this dashed difficult problem of where to begin it … I mean, if you fool about too long at the start, trying to establish atmosphere, as they call it, and all that sort of rot, you fail to grip and the customers walk out on you. Get off the mark, on the other hand, like a scalded cat, and your public is at a loss. It simply raises its eyebrows, and can't make out what you're talking about.").[1]

Now, one of the neat things about human beings is that we are naturally curious. If we are presented with the beginning of a story we will wait around for hours to see what happens. As the suspense writer Lee Child put it when discussing the basic foundation of his work, "'how do you make your family hungry?' You make them wait four hours for dinner. As novelists, we should ask or imply a question at the beginning of the story, and then we should delay the answer."[2] As Childs then goes on to acknowledge, having great characters and a rich and intricate plot is great, but all you ever really *need* to do is to pose a question and then withhold the answer to this question as long as you can. As he states, "Trusting such a simple system feels cheap and meretricious while you're doing it. But it works. It's all you need. Of course, attractive and sympathetic characters are nice to have; and elaborate and sinister entanglements are satisfying; and impossible-to-escape pits of despair are great. But they're all luxuries. The basic narrative fuel is always the slow unveiling of the

> ## "The first few seconds of any piece of short form content are absolutely critical to its success"

final answer." As short form content creators this fact is particularly relevant, since we are always fighting against the fact that our total running time is so brief, and our greatest ally in this battle is simple human curiosity.

With the *Spiderman 3* trailer we are given a beginning (acts A and B in the scheme above) that has the correct mix of mystery and information. As I noted, the first bit is simple, just three shots – two of New York City and one of a cheering crowd – scored with large drum hits. At this point, we don't know what the story is about, as we have yet to see Spiderman or any of the other main characters – which peaks our curiosity – but we do know immediately the genre, tone, and scale of the movie being advertised (the grandeur of the shots, coupled with the power of the drum hits, signals right away that this is not going to be a trailer for a romantic comedy).

Spiderman then flies dramatically into frame and we crosscut between him soaring through the city and shots of all the other main characters, as well as a few crowd shots. This section does two important things,

as it sets up the main characters in the story while also introducing the theme of Spiderman's relationship to the populace he protects. We still don't know what the story will be about, but we do know which characters will play a big role in the film – Peter Parker/Spiderman, Mary Jane, Harry Osborn, and Eddie Brock – and we also know that Spiderman's status as "protector of the innocent" will come into question (this point is driven home by the fact that one of the three crowd shots features all children).

So, in a mere sixteen seconds, the editor has done everything he needed to do in his beginning. He has gotten us curious about the story he is about to tell, introduced us to all the main characters, and indicated the genre and mood of the piece. As Christopher Booker describes the beginning of almost all narratives – no matter the medium – in his excellent book *The Seven Basic Plots*: "(in the beginning) we are introduced to our hero or heroine in an imaginary world. Briefly, or at length, the general scene is set. The purpose of the formula 'Once upon a time …', whether the storyteller uses it explicitly or not, is to take us out of our present place and time and into that imaginary realm where the story is to unfold, and to introduce us to the central figure with who we are to identify."[3] As we can see, the editor of the *Spiderman 3* trailer has done exactly this, as he has introduced us to our hero (Peter Parker/Spiderman), and he has also let us get a glimpse of the imaginary realm (a comic book version of New York City) that he will inhabit.

The primary result of this beginning is that the audience is intrigued. Like all good beginnings, this one has created a need in the audience: a need to see what happens next. As Goldhaber puts it, "anyone who speaks or writes or seeks attention in any way has to become something of a success in the special rhetoric of persuading listeners, readers, and so on, that he or she is meeting their individual needs, when in fact some of these needs have been artfully set up in advance. You want to know what I am driving at, for instance, because I have already provided clues galore that I am driving at something that should matter to you."[4] Now that the editor has done this, now that he has convinced us that the story he is about to tell will matter to us, we are primed for the main thrust of the story, the information-rich middle.

Middle: Generally the longest section, the middle is where the story is explicitly told and where information is imparted. Because of this, the middle is often the trickiest section to navigate, as the editor will have to battle a bit here in order to avoid the piece becoming boring, muddled, or confusing. The best way to win this battle is to not allow the piece to get stuck in one tone or emotional register. Change is key in the middle, as ideally there will be a change of some sort for every major new idea that is introduced. Let's look

> **. . . all you ever really *need* to do is to pose a question and then withhold the answer to this question as long as you can.**

Images from *Spiderman 3* trailer.

at how the editor of *Spiderman 3* deals with the middle of his trailer.

The middle of the *Spiderman 3* trailer has six discrete acts (*C–H* in the scheme on p. 68) and shows us nearly every major plot point of the film (Peter proposing to Mary Jane and then struggling to keep her; the introduction of the Sandman; the battle inside Peter Parker between a desire for revenge and his oath to protect the populace; and the fight between Peter Parker and his friend Harry Osborn). For each of these plot points, the editor makes a major transition in tone for the new idea. This helps give a sense of order to a fairly convoluted tale, as well as keeping the audience on the edge of their seats.

So, for example, in act *C*, we hear of Peter's desire to marry Mary Jane. This desire elicits a warning from Peter's grandmother about the responsibilities that come with such a big step. This act lasts twelve

seconds before the editor fades to black and brings in a new musical score to introduce the plot point that the Sandman was the actual killer of Peter's uncle (**D**). This pattern continues throughout the middle of the piece, as every time the editor introduces a new plot point we have a change in music, mood, and pace. These moments of change allow us to digest the information easily and keep us interested.

As we can see, the middle is doing an enormous amount of work for the piece as a whole, as it is setting up all the main points of conflict, as well as all the major players and their roles. This is what middles tend to do, as they are where the majority of the story gets told. As Booker says about the middle of most narratives:

> (after meeting our hero in the beginning) something happens: some event or encounter which precipitates the story's action, giving it a focus … the action which the hero or heroine are being drawn into will involve conflict and uncertainty, because without some measure of both there cannot be a story. Where there is a hero there may also be a villain (on some occasions, indeed, the hero himself may be the villain). But even if the characters in the story are not necessarily contrasted in such black-and-white terms as 'goodies' or 'baddies', it is likely that some will be on the side of the hero or heroine, as friends and allies, while others will be out to oppose them.[5]

As our breakdown shows, the middle section of our *Spiderman 3* trailer has all of these elements. After being introduced to our hero and the imaginary world in the open, the audience is quickly moved into the

> ❝*. . . the middle is where the story is explicitly told and where information is imparted.*❞

middle where the hero is drawn into conflict and uncertainty, villains are introduced (Sandman, Harry Osborn, and yes, Spiderman himself), friend and allies are established (Mary Jane and Peter's grandmother), and the narrative world in general is laid out.

Once the narrative has been set up and the viewer is invested in finding out what ultimately happens, it is now time to finish it off with a dynamite ending.

Ending: Ideally, the ending should wrap up the narrative, reinforce the themes and ideas established in the rest of the piece, and give one last shot of adrenaline that will motivate the viewer (as we noted in Chapter 1, short form ultimately needs to motivate the viewer to *do something* in order to be a success). Given this fact, the best endings are the ones that bypass the brain and head straight for the gut. If the middle is where you speak with the viewer in a rational way, the end is where you grab him by the lapels and give a firm shake. Good short form is aware of this fact, as it recognizes that once you have made your case rationally as to why

the viewer should engage with the end product, you need to hook them emotionally.

You can see this pattern in the *Spiderman 3* trailer as the editor, after laying out all the plot points in the middle, heads into a frenetic sixteen-second montage broken up by four title cards: "This Summer"; "The greatest battle"; "Lies"; "Within". These title cards reinforce what the ultimate point of the story is, and serve as a last reminder that unlike the previous two Spiderman movies, part three of the saga is as much a story of Peter's internal struggle as it is about a battle with a new foe. The montage has a faster pace editorially than the rest of the piece and features shots from all the major conflicts we have been teased with earlier (Spiderman fighting Sandman, Peter trying to save Mary Jane and fighting with Harry, etc.). It shows all the major conflict points but attempts to leave the viewer uncertain as to their resolutions. This uncertainty is reinforced by the fact that within the montage a newscaster says "this could be the end of Spiderman" which indicates that our hero might actually perish in the film (incidentally, this "cliff-hanger" style ending in trailers and promos is quite common, as many a trailer or promo will end with one of the heroes being hurt or threatened in some way. The obvious benefit of this technique is that it piques viewers' curiosity and motivates them to tune in to the long form content you are advertising by making them curious about whether or not the hero survives). Besides being quicker in pace, the final montage raises the adrenaline level by utilizing shots with objects and people moving rapidly towards the camera. Things moving rapidly within the frame are always going to engender anxiety and excitement in the viewer, and when those objects are moving really quickly towards the camera it just increases the effect (see the images below).

After the furious montage, the piece wraps up with a quiet logo treatment. This moment does two things, as it lets us catch our breaths in order to take in essential information – this is the trailer for a movie called *Spiderman 3* that comes out on May 4th – as well as giving a space for us to gently move out of the narrative world (I think about this like that moment when you get off a roller coaster and all you want to do is stand there and savor the solidity of the ground as your senses recalibrate themselves).

Images of objects moving towards camera from *Spiderman 3* trailer.

Although the ending is only two acts and takes a mere twenty-one seconds, it does everything you need a short form ending to do, as it wraps up all that has come before it while also giving the viewer a visual and aural thrill ride intended to motivate some future action (in this case, rush out on May 4th to see the movie). As Booker puts it when summarizing the way endings tend to work:

every story … must work up to a climax, where conflict and uncertainty are usually at their most extreme. This then leads to a resolution of all that has gone before, bringing the story to its ending. And here we see how every story, however mildly or emphatically, has in fact been leading its central figure or figures in one of two directions. Either they end, as we say, happily, with a sense of liberation, fulfillment and completion. Or they end unhappily, in some form of discomfiture, frustration or death.[6]

All this talk of heroes and villains might seem a bit grand when talking about most short form work, as the average piece of short form doesn't advertise something as epic as *Spiderman 3*, but even a mundane commercial for laundry detergent will generally have some resemblance to this way of structuring a piece. After introducing our heroine (suburban housewife) and her world (laundry room, middle-class home) in the open, we enter a middle where our heroine battles dirt and odor (the antagonists) with the aid of her trusty ally, Tide Fresh Scent detergent – which is 100 percent organic and thus "tough on dirt but easy on your family's delicate skin" – before moving into an ending where we see our heroine best the forces of evil and hugging her smiling, fresh-scented children.

Dirt and odor might not be as menacing as a giant monster made of Sand but keeping your children clean is obviously something which parents care deeply about. As I mentioned earlier, products are designed and marketed as a solution to a particular need, and your job as a short form content creator is to use structure – and everything else at your disposal – so that this need/solution dynamic is clear and emotionally resonant. Even with less visible types of short form content – such as corporate work – this dynamic will often dictate one's structure, as we might begin a corporate piece with a message from the CEO (our beginning); then move into a montage that pits the heroes – the company's employees – against the enemy (perhaps a ruthless competitor or complacency); then conclude with an ending where the company meets the challenges that were presented in the middle in order to go on to magical new heights of market-share.

So, to conclude, no matter how many acts a piece of short form content is comprised of, you want a beginning, middle, and end that each do unique things. The beginning should intrigue the viewer, establish the main characters, and make the audience want to stick around because they believe that the piece of content

. . . the best endings are the ones that bypass the brain and head straight for the gut.

you are presenting them with will, in some way, matter to them. The middle is where you tell your tale, where the action takes place, where the audience becomes completely wrapped up in your story. The ending is where you conclude your narrative, push rationality aside, and appeal to the viewer on an emotional level. The ending should be big, brassy, and evocative, as what you want the viewer to do when they are finished watching your piece is to be motivated to interact with the thing you are advertising in some deeper way (even if that action is simply to "like" the video on Facebook). If you utilize a structure of this nature, chances are good that you will create a piece that pops and that is easily understandable in the narrative sense.

Now let's turn to the second fundamental element of short form structure.

Explicit Separation of New Ideas and Concepts

A few years ago the social scientists Christopher Chabris and Daniel Simons conducted an experiment where they asked subjects to watch a two-minute video of people passing a basketball back and forth. All the subjects were asked to do was to watch the movie and count how many passes the team wearing white shirts made over the course of the two minutes.

After the movie was over, the experimenters asked the subjects how many passes they counted and then asked the subjects if they saw a gorilla. Surprisingly, roughly *half* of the subjects claimed that no gorilla

had ever entered the frame. When the experimenters then played the video back, the skeptical subjects were shocked to see that an actor in a gorilla suit does in fact enter the scene, pound his chest, and then leave. So why did roughly half of the participants not see this bizarre sight?

Well, to put it simply, it's because people can only pay attention to a limited number of things. When something demands our attention we will, invariably, lose sight of everything else (I wonder, when pondering this experiment, how much less the subjects' "gorilla recognition" would have been if all the subjects had been heterosexual women and all the actors in the scene had looked like Ryan Gosling and Brad Pitt. Maybe 20 percent of the participants would have noticed the gorilla in this case. Less?). When humans lock onto something we block everything else out; so short form content creators have to be skillful in terms of directing the viewer's attention from one story point to the next in a fluid and dynamic way. If this process of directing the viewer's attention is not handled well, the short form content creator risks losing the viewer due to boredom or lack of comprehension.

This is where the explicit separation of new ideas and concepts comes into play. As we saw in our breakdown of the *Spiderman 3* trailer, every new idea should come with some fundamental shift in how the story is told, as short form, because of how much ground it has to cover, always has to do whatever it can to remain coherent. So, with every new concept, you have to change *something* to signal to the audience that a new concept is now being presented. With our *Spiderman 3*

trailer, and with most short form content, this process is usually driven by the audio track, as the easiest way to indicate to viewers that there is something new that they have to pay attention to is to change the music or sound design. Using the audio track to signal change also has the added benefit of indicating to the viewer what they are supposed to *feel* during this new section, as music/sound design is very good at quickly establishing the emotional tone of a scene (more about this in our chapter on music but suffice it to say, if you score a scene of a woman looking forlornly out a window with a melancholy piano tune, viewers will (a) realize the woman is sad and (b) start to feel sad themselves).

Explicitly separating ideas and concepts in this way allows the viewer to digest the information you are presenting them with, as the separation of major plot points into their own narrative and tonal space allows the audience to digest each thought as a discrete entity before moving on to what is next. Our minds are always looking to make meaning and add order, and when you structure a piece into clear sections, the mind can work through the data it is being presented with in an efficient way ("oh, OK, Peter Parker is going to propose to Mary Jane … Oh, I get it, the new enemy is the Sandman and he killed Peter's uncle …"). If you don't do this, if you don't change things in a major way when moving from idea to idea, you risk overloading the viewer, as so much gets stuffed into the same narrative space that they will start losing track of the story. To go back to our gorilla experiment, imagine that there was a jazz song playing at

"… every new idea should come with some fundamental shift in how the story is told …"

the beginning of the video. Now imagine that once the gorilla enters the frame we change the musical cue (perhaps the jazz song gets replaced by a track with heavy, menacing jungle drums). How many people notice the gorilla now? 80 percent? 90 percent? All of them? Simply shifting the score would have said to the audience, "something new is about to happen so pay attention and try and make sense of why the music has shifted." This is why the theme from *Jaws* is so necessary, as without it all you would have is people swimming about in the water and then suddenly being devoured. With it, before the shark is even visible, the ocean shifts from a carefree playground to a terrifying nightmare, and the audience is aware of this shift and tension can build.

Besides adding coherence, explicitly separating new ideas and concepts allows you to give a dynamic quality to your work. In our *Spiderman 3* trailer we have *ten* major transitions. This is a lot of change, and although one would think this would make the piece confusing, all of these transitions actually give propulsion and clarity to the work. The modern viewer

is inundated with visual information and gets bored quickly, so in order to keep their interest you must offer as much variety as possible. By playing with a wide variety of tones and textures, the editor keeps the viewer interested and pushes the story forward. Short form content is all about rapid temporal and spatial shifts, and rather than fearing these moments, the short form editor should look at them as opportunities to add dynamism and tension to a piece. By changing things every time you add another idea or story point to the mix, you take the viewer on a more intense emotional ride, which is, ultimately, what the viewer wants ("you make me feel something, I will engage with your content").

On Individual Edits

Now that we have tackled structure, let's get a bit more granular and **look at what makes individual edits work.** This process – taking two shots and placing them side by side – is what most people think of as the essence of editing and what many argue is actually the foundation of the art of motion pictures. I tend to agree with this argument as, yes, perceived motion is the *sine qua non* of cinema, but it was not until filmmakers began experimenting with cutting different shots together that the medium went from an advanced tool for documentation to being the most powerful persuasive device our image-besotted species had ever come up with. This is not to discount what takes place on the purely pictorial plane, but when one

looks at the art of motion pictures, it becomes clear that without the possibilities that are opened up by the linkage of two separate shots, the medium would be marooned.

Andy Warhol recognized this fact and toyed with it in his early films, most famously *Sleep*. By making a film over five hours long that consists of one static shot of a man sleeping, Warhol removed that which makes a film a film. This act of cinematic self-deprivation embodies what Louis Menand views as the crux of Warhol's artistic approach. "The essence of Warhol's genius was to eliminate the one aspect of a thing without which that thing would, to conventional ways of thinking, cease to be itself, and then to see what happened."[7] With *Sleep* and *Empire* Warhol did just that, and we saw what happened when you remove editing from film: things get very, very boring.

But what exactly are we doing when we cut from one shot to another? Well, at its most basic level, cutting two shots together is about directing the viewer's attention. First you point at one thing, let's say a car – "here is a grey Cadillac on a beautiful road in Italy" – and then you cut to another thing, let's say a man inside of the car – "now here is the guy who is driving that Cadillac. He is about fifty years old, handsome …". As the Russian film theorist Vsevolod Pudovkin says, editing is about "guiding the attention of the spectator now to one, now to the other separate element. The lens of the camera replaces the eye of the observer, and the changes of angle of the camera – directed now on one person, now on another, now on one detail, now on another – must be subject to the same conditions as

those of the eyes of the observer."[8] I think this is about right, and I think Pudovkin is correct to frame it in the sense that the editor is primarily a gatekeeper in terms of the flow of information.

Furthermore, as the example above illustrates, editing is inherently cumulative. What I mean by this is that if you place two shots side by side, viewers are going to expect that the information contained within each shot will have some connection to its neighbors. So, in our example above, if you cut from an exterior shot of a grey Cadillac to an interior shot of a car and a man driving, the viewer will expect, unless you give them a reason to believe otherwise, that the man in the incoming shot is driving the Cadillac they saw in the outgoing shot. Furthermore, the way in which you combine those shots – the length of each one, the composition of each frame at the edit points, etc. – will add other pieces of information to the puzzle (perhaps if each shot is short in duration the viewer will feel that the man is driving fast). So, what we have so far is that an individual edit directs the viewer's attention from one thing to another and that it establishes a web of connections that adds new layers of information with each new shot.

" . . . cutting two shots together is about directing the viewer's attention"

OK, that's a start, but what makes an individual edit a good one? Most books on editing argue that a good edit is an edit that is invisible. This type of analysis is usually filled with talk of match-cuts and eye-line edits and is interesting but always feels slightly besides the point, as clearly a cut can be invisible yet still be "bad." We will get into this larger issue in a moment, but I do agree that more often than not you will want an edit to be "invisible," so here is my list of the five things, in order of importance, which will do the most work in terms of obscuring a cut point:

1. **Motivation:** Something is happening with picture and/or sound that motivates the introduction of a new image.

2. **Information:** The incoming shot contains new and interesting information.

3. **Motion or action in the frame:** There is something moving in the incoming or outgoing shot.

4. **Composition:** The visual composition of each frame guides the eye cleanly through the transition.

5. **Continuity:** There is continuity in movement, sound, and mise-en-scéne between the outgoing and incoming shots.

Let's unpack each one of these.

Motivation can come from pretty much anywhere – a sound effect, a head turn, an eye-line match – and experienced editors will be searching for these moments the first time they screen through any batch of footage. As editors know, as long as something makes the viewer want to see what is happening off screen, you have a reason to cut, and no one will be jarred by the edit if your timing is right.

An example of motivation driving the edit can be found in the classic, "serial killer stalks sorority girl"

sequence. Let's imagine our girl, looking suitably fearful and curiously underdressed (if horror movies are to be trusted, sorority girls are apparently always in a negligee), hiding under her bed as the mask-wearing psychopath prowls about. First shot would be our girl under the bed. After a pause we hear the sound of the door creaking open as her face goes white with terror. Cut to the doorway from the girl's point of view (POV) as the serial killer's mud-caked boots enter the room. His right foot pivots slightly as he starts looking around to see where she might be hiding. We use the pivot of his foot, visible from her POV, to cut to *his* POV as he scans the room. He does this for a moment while breathing heavily, until his gaze, and the camera, settles on the bed. He takes a step towards it. We cut back to the girl's POV as the boots move forward and … well, you get the idea. As you can see, with all of these edits, some motivating factor, either an on-screen visual or an off-screen sound, is driving the cut.

What makes this work is that motivation-driven cuts mirror very closely how we ingest information in our daily lives. Imagine that you were under that bed with our unfortunate sorority girl. What would you do if you heard the sound of the door creak? Look in that direction of course! And this principle, this mimicking of how we take in the world in our daily life, is the basis for why motivation-driven cuts work so well. If there is something within the current frame that will make the viewer want to see what is happening *outside* of that frame, you can cut without fear that anyone will notice the edit.

In terms of each shot containing **new information**, the thing to recognize here is that viewers *want* the editor to give them information, and this curiosity will always help obscure an edit. For example, if you are making a commercial and the hero is opening up a closet that might or might not contain a secret passageway, the viewer will ignore the cut to a new angle because they *also* want to see whether or not the passageway will be there.

Clearly any edit will lead to new information, as film's natural, automatic representational powers necessitate that if you change anything following a cut – and if you changed nothing at all in terms of camera angle, lens, and mise-en-scéne there wouldn't actually *be* an edit – new information will be given. But, if the edit contains information that is interesting or evocative in some way, this will help to obscure the cut point. Conversely, cuts where the information being given in the incoming shot is boring or has already been touched upon – imagine a cut to a close-up where nothing is going on that wasn't contained within the medium shot that proceeded it – will either bore the viewer or rip them out of the narrative by making them question why they are being asked to look at this new image in the first place.

To see how the informational quality of an incoming shot can help obscure an edit point, think about how you might cut a web video for an auto manufacturer that was based around an interview with an engineer and featured footage of the car driving around. At one point the engineer might be discussing how the car handles and you would probably choose to cover

this bite with a shot of the car that demonstrates this capacity. While often derided as "see-say," this type of coverage is often quite useful, as there always will be additional information imparted by a shot of something that language could never convey. So, with our car example, you would get a sense of what exactly the handling of the car looks like, while also getting information about things such as the car's appearance, the steering capabilities of the car, and a host of other things. This information helps to hide the edit point by giving the viewer something interesting to focus on.

The importance of **motion** in obscuring edits can be traced to our biological makeup. Not so long ago, an individual's survival depended on perceiving motion in their environment – think back to our discussion from Chapter 2 of your cave dwelling ancestor getting water out of a lake while being on guard for a predator – so when something moves you can be sure that a human being will look at it. This perceptual trait is why viewers will tolerate the editing style of a fight or a car chase where the editor might want a fast pace and be willing to disregard all temporal and spatial logic to get it. Viewers don't notice cuts in a sequence like this because all that quick motion within the frame will distract them from any temporal/spatial discrepancies.

Motion is a huge help in short form given how much we need to hop around in time and space. For example, Nike did a spot in 2013 entitled "Possibilities," where the premise of the spot is that if you can do something simple like go for an early morning jog, then you are capable of running a race or even a full marathon. The spot moves around *a lot* temporally and spatially, as the

Image from "Possibilities."

protagonists are shifted from one situation to another every few seconds (for example, in an eleven-second sequence midway through the spot, one of the protagonist's spatial and temporal position shifts *five* times, as he moves from a high-school hallway, to a wrestling match, to a football game, to a training session, to a boxing match). The voice-over helps to make the spatial and temporal leaps work, but the editor, Angus Wall, also does a great job getting you through the leaps by making sure there is a lot of motion – either within the frame or with the camera – happening at every cut point which accompanies a spatial or temporal leap. All the motion Wall utilizes at these cut points is essential for the spot as a whole, as without it, the viewer would find all the temporal and spatial leaps hard to follow and grating.

Motion combined with a match-cut – e.g., cutting to a close-up of the villain as he places the cigarette in his mouth where the cut comes at some point in the upwards motion of his arm – is even more powerful. The reason why is that besides taking advantage of our tendency to be distracted by motion, match-cuts direct the viewers' attention to one thing within the frame – in this case the arm moving upwards – as

Images from "Possibilities."

well as reinforcing a sense of linear time, which helps viewers swallow an edit. So, with our smoking villain, cutting halfway through his motion to a close-up feels right to the viewer – and by "right" I mean it resembles the temporality of "bringing a cigarette to your mouth" in real life – as there is something about how time is presented that makes the edit feel smoother.

For **composition** I think there is one main thing to note which is that when you cut, the viewer's eye is going to go from looking at something in the outgoing shot – let's say a character's face – to something in the incoming shot – let's say a bright red car. So, if you are trying to use composition to obscure the edit, the thing you want to do is to match the screen geometry of these objects of interest. What I mean by this is that if the character's face is in the lower left quadrant of the frame in the outgoing shot and the red car is *also* in the lower left quadrant of the frame in the incoming

Images from "I am Unlimited."

shot, the audience will not feel jarred by the edit, as they will not have to move their eye about in order to understand what they are supposed to be paying attention to. If the viewer has to search around for a beat in order to understand the focus of a shot it can be disorienting and compositional matches can eliminate this.

Graphic matches are often quite effective in short form. For example, in 2013 Sprint released the commercial "I am Unlimited," where almost every shot is a total break from its predecessor in terms of what is happening in the frame. These shifts are often profound, as the opening six-shot sequence alone moves us from a macro shot of a vein, to a macro shot of a leaf, to a satellite shot of the earth, to a close-up of a hand holding a phone, to a shot of downtown Los Angeles, to a graphic that represents neurons firing inside the brain. The cuts shouldn't work, as there is no obvious motivation or motion to move you from one shot to the next, but the editor, Josh Bodnar, expertly uses graphic matches to hold it all together. To see this, look at the images on the left where you can see the first and last frame of each shot, and note how the main object of interest in each incoming image tends to be in the

Images from "I am Unlimited."

Josh Bodnar on "I am Unlimited"

Josh Bodnar is an Emmy Award winning editor who has cut spots for clients such as Bose, Nike, Toyota, Samsung, and Hyundai. He has also edited title sequences for Dexter, The Killing, *and* Captain America: The Winter Soldier *amongst others. He currently works at Whitehouse Post in Los Angeles and just finished editing D.J. Caruso's latest feature film* Standing Up.

Bryan Cook: What are the critical qualities a successful short form editor must possess?

Josh Bodnar: Being a great listener is the key to success; shhh, don't tell anybody. Whether it's long form, short form, montage, or music video, listening is imperative. We're in the business of servicing our directors and clients. Making the story come to life in an emotional way that will connect the audience with the brand. That's the goal. Listening to thoughts, theories, and creative dreams of what the work is supposed to evolve into, as an editor, you can really dial in your edit. Being passionate about your work always helps too. No one wants to work with someone who's *kinda* into it.

Bryan Cook: What is the one question you always end up asking yourself while working on any piece?

Josh Bodnar: How much time do I have to edit the piece?

Bryan Cook: Let's talk about the "I Am Unlimited" spot you edited for Sprint. Cutting a spot like this is always tricky as there are so many options for the footage and there is not the usual logic to motivate individual cuts. How did you approach this spot and how much footage were you ultimately pulling from?

Josh Bodnar: I approached this spot how I approach all of my projects. I talked to the director, read scripts, reviewed the pre-production books, did some research of my own, and then began laying down the building blocks of my first assembly. There wasn't that much footage that was shot for the spot. A lot of the creative referenced stock footage for certain sections of the script. Using stock can always be a challenge for any project. For the editor he or she is just scrambling to get something in the cut – the post-producer often wants a financially easy solution and the creatives want to see something

same area of the screen (and roughly the same size) as the main object of interest in the outgoing shot that preceded it. Using graphic matches like this is a fruitful approach to take, as it allows you to make your edits palatable while also making each edit decisive, graphic, and bold, which adds a real punchiness to the work.

The other benefit of this style is that it allows the viewer to draw connections between things that might seem unrelated. For example, midway through the spot there is a cut from the camera lens on the back of a phone to an eyeball in extreme close-up (see previous image). The graphic match is perfect – if you overlay the iris of the eye over the lens you will see they are in the exact same area of the frame – and putting these two shots side by side forces the viewer to see the parallel between these two things. The spot as a whole follows this sort of logic, as Bodnar continually places images next to one another in such a way that the synthesis between shots leads to various thoughts about the product (it's spots like this, by the way, that lead me to conclude that Eisenstein would have been a great commercial director, which is kind of an amusing thought given his political bent).

Finally, although most editors don't like privileging **continuity**, as they don't want a small continuity issue to determine an edit, continuity *can* be a real problem when the break is so egregious that the temporal space of the narrative is placed in conflict with the temporal space of its construction. For example, if a glass of beer that a character is drinking suddenly gets much lower from one shot to the next, the viewer is made aware that the temporal space of the narrative is not the same

as the temporal space of the narrative's creation (i.e., the viewer is forced to confront the fact that the way in which time is being presented on screen is not legitimate). This realization pulls the viewer out of the story, as it forces her to see the story as what it actually is: a construction. Conversely, a cut with solid continuity that matches our expectations about how time unfolds in reality will be easier to ignore.

OK, so that is our list of the five things that go into making an individual cut invisible, but to my mind these are not necessarily what makes an individual cut *good*. In fact, there are many examples of short form content where the editor deliberately makes the edits *visible* in order to give a propulsion and sharpness to the piece. Furthermore, any decent editor can make an edit invisible by manipulating the elements that we discussed above, but what separates the decent edit from the great one is that the latter elegantly pushes the story forward but also generates that charge, that electric jolt, that results when two shots are linked together in an interesting way.

In order to begin let's take a look at a piece of content. The piece, which was made for P&G, was

Image from "The Hardest Job is the Best Job."

amazing that they've never seen before. In the past when I've done speaking engagements I use the analogy that editing is a puzzle. Most of the time the pieces just fall right into place like you think they should. However, sometimes you're working on a 5000-piece puzzle with all black pieces. And that's never an easy puzzle.

Bryan Cook: One of the noteworthy elements of the "I Am Unlimited" spot is how you used composition and graphic matches to allow yourself to cut between shots where you didn't have the normal things – motivation, motion, etc. – that make a cut "work" (an example of this use of graphic matches would be the cut from the lens of the camera on the back of the phone to the actor's eye in extreme close-up). The net result of this approach is that the piece as a whole has a propulsion and bite to it but individual edits are still easy to digest. Can you talk about how you used composition and graphic matches while editing the piece?

Josh Bodnar: This style of editing is very visual. Shapes and movement help define visual editing. It's an editing feeling more than a sense. Meaning that some things feel weird. You can't put your finger on why it's weird – it just is. Technically, it's really all about the frames. You've probably heard people in an edit session boast to an editor about adding three more frames to a shot or slip a clip by two frames. Believe it or not those frames matter. Those frames are key to creating that sense of feeling or vibe. The typical human can process twenty-five frames per second. We can see almost eleven frames per second. As an editor when you add or subtract frames you're telling people where to focus and for how long. When you dive further into an edit sequence of fast cuts you're starting to restrict what the eye can pick up for the brain to process. These flutter cuts become a creative vehicle to hide or show certain pieces of footage to push the story forward or communicate a feeling. Match cutting, in addition to the flutter cutting, helps the brain piece together the missing elements of one shot and connect them to a different, yet similar shot, making you feel as if it's one flowing piece of footage. In the end it's a magic trick.

Bryan Cook: On a related note, the spot has a nice contrast to it, as individual shots remain discreet and personal – almost as if all the imagery had been captured by different people – but still have a sense of connection to one another (e.g., that great cut from the little girl blowing out the candles on her birthday cake to the group of people getting showered with blue chalk). This contrast works perfectly with the copy in the spot so I assume it was intentional, but how much of it

continued overleaf

edited by Peter Wiedensmith and is entitled "The Hardest Job is the Best Job." The spot is a long one, clocking in at two minutes, and it has a complicated narrative that follows four athletes – a gymnast from the United States, a swimmer from China, a sprinter from England, and a volleyball player from Brazil – from adolescence until the moment that they win gold at the Olympics. Besides focusing on the athletes as they train, the spot also looks closely at the athletes'

mothers, who work tirelessly behind the scenes to feed, clothe, and care for their young prodigies. The sacrifices these Moms make is the true point of the spot, as despite how different the families are, all the Moms sacrifice so much so that their children can achieve something remarkable. At the end of the spot, following a touching montage of the athletes celebrating with their Moms, we get our lone line of copy, which is a title card that reads: "The hardest job in the

Images from "The Hardest Job is the Best Job."

world, is the best job in the world. Thank you, Mom. P&G Proud sponsor of Moms."

The spot has a quick tempo editorially, with about a hundred individual edits for its two-minute run time (each shot has an average length of roughly 1.2 seconds). The piece makes a spatial and temporal leap at nearly every edit, and connections are constantly being drawn between the different families and the similar sacrifices they make in pursuit of their goals (e.g., we cut from the child waking up at dawn in China to the child waking up at dawn in the US; from the mother in the US hanging laundry in her basement to the mother in China hanging laundry on the line outside their apartment). Although the spot is briskly cut, no shot feels like a throwaway inserted simply to add pace, as each edit adds a new piece of information or emotional resonance (e.g., the look of concern on the American Mom's face as she watches her daughter sleep while icing her hand, or the frightened look on the Chinese swimmer's face as her bus pulls away as her mother is waving goodbye). With "The Hardest Job is the Best Job" as our model, let's dive into the elements that I think make an individual edit a strong one.

To move through this discussion somewhat logically, let's begin with the outgoing shot at an edit point. To my mind the most important issue pertaining to the outgoing shot deals with the most obvious question, viz., at which frame do you cut? This is going to sound a bit obvious, but the way I think about it is that the last frame of any shot should be **the exact moment where what you want to communicate has been transmitted and not a frame longer**. Knowing where

was planned out beforehand and how much was discovered in editorial?

Josh Bodnar: A lot of these shots were staged and planned to look like multiple people on multiple formats were shooting their personal experiences. That was an intentional creative decision. However, how we got there was a journey of its own. It's the puzzle I spoke about earlier. Moving pieces around from the front to the back until they find their home. Believe it or not the baby in the spot is my daughter. We were having a hard time finding the right baby stock shot. I pulled out my iphone 5 and imported video of my daughter that I took at a Halloween party. It just so happened that she had Sprint yellow on her outfit and a cute enough face for 17 frames so she made the cut. Some things are planned for months and others happen on the fly. The edit room is an environment where anything can happen and I think that's honestly what I like best. Controlled chaos.

Bryan Cook: Besides working as an editor on commercials you have also edited title sequences for shows such as *Dexter* and *The Killing*. What do you think are the two to three most critical things a title sequence must accomplish in order to be successful?

Josh Bodnar: The main titles ideally are the quick read of what a show is about. You want to entice the viewer into a hypnotic state of enchantment before the big show. A good analogy is how a stand up comic has a monologue – a warm up. Or how your favorite band always has an opening act. Something that gets you pumped up for the big performance. But truly in the end it's all about the show. If the show does well everything and everybody associated with the show does well. That's Hollywood.

Bryan Cook: One of the unusual things about title sequences is that unlike most short form content viewers will often watch the piece over and over again. Does this fact influence how you creatively approach title sequences and if so how?

Josh Bodnar: It does. I can't even begin to describe how important it is to have every detail correct. Knowing that this movie or TV show will be seen by millions of people, most likely multiple times, you always want to have checks and balances with your work. Which is why screening your work is always key. My Emmy Award Winning main title for *Dexter* still gets referenced to this day. *Dexter* was on Showtime for eight years. That's a lot of viewings and a lot of exposure for my work. Especially when you consider the VOD market now. Those titles will always be with me.

this point is can be somewhat subjective, so I think the best way to look at it is to imagine the shot went one frame longer. Would we get any new information or would our emotional engagement be enriched by that extra frame? Would we see something we haven't seen in the twenty frames that preceded it? Is there any particularly pressing pace or rhythm issue that the extra frame solves? If the answer to these question is no, then it is probably time to cut. In fact, a number of editors I have worked with preach the notion that the only way to know if you have chosen the correct frame to cut on is if you hit that same frame numerous times (i.e., they argue that you should make your edit, then undo it, then recut the sequence again and see if you chose the exact frame to edit on the second time as well). Walter Murch was the first person I heard propose this theory, as he says that when he is making an edit he chooses his frame, rewinds, hits play again, and sees if he chooses that same frame again. As he puts it, "If I hit frame 17 first and then frame 19 the next time, that means something in my approach is wrong … Maybe we need more time: I'm not giving enough time to absorb that the actress in the scene is also taking off her coat. She says the line but she's taking off her coat. The line is a thought, but so is 'taking off coat.' … It takes time for an audience to understand and appreciate both the line of dialogue and the idea of coat-taking-off. I have to allow for that."[9]

"The Hardest Job is the Best Job" is extremely disciplined with the outgoing frame at each edit point, as every shot is just long enough to allow the viewer to absorb its informational/emotional content, but no

> **For the incoming shot, there must be an immediate and clearly recognized object of interest within the frame.**

shot demands more attention than it merits (this must have been quite difficult to manage in the bay, as the spot is so well directed – it was helmed by acclaimed director Alejandro González Iñárritu, who directed *Birdman* and *21 Grams* – that you just *know* they left some really beautiful imagery on the cutting room floor). Sometimes we linger on shots – such as in the open when the young athletes are woken up at dawn to train and we get the time to feel the heaviness of their bodies as they emerge from slumber – and sometimes the shots are quite brief – such as when we get a montage of the Moms cleaning the dishes after breakfast and we just get enough time to work out the task that is being performed (the quickness of the shots in moments like this also helps to get across the idea of constant sacrifice, as the repetition and pace of the shots related to cleaning and cooking really helps the viewer feel the constant effort that comes with caring for children). No matter what the length of each shot is they all feel perfectly calibrated to give you the information

you need while remaining short enough to push the story forward (after all, the spot has four narratives and covers about ten years of time, so speed is critical).

For the incoming shot, **there must be an immediate and clearly recognized object of interest within the frame.** In long form it is fine if a shot takes a few frames to decode in order to figure out what is important. But in short form, where so much has to happen so quickly, the primary object of interest in any shot should be clear in the first frame. This might seem didactic or rigid, but in short form you have to move as quickly as possible, and you always run the risk that you will lose the audience if they are confused. When someone pays twenty dollars to go and see your movie they will give you leeway to monkey around a little; when you are making the commercial or trailer that goes before the movie, you simply don't have that freedom.

"The Hardest Job is the Best Job" recognizes this fact, as the edit is constantly pushing your eye towards whatever the primary object of interest is. So, when one of the Moms is sitting on a crowded bleacher and the point of the shot is her reaction to her daughter's training session, the Mom's head is starting to turn at frame one in order to draw your eye to her. Or, when we get a shot of a Mom tenderly taping up her son's injured ankle, your eye traces perfectly from the ankle and the Mom working on it – as the action within the frame is her hands moving – to the despondent boy: your eye goes up to the boy about ten frames in as he jerks his head slightly to the left. The first few frames of each incoming shot are critical in short form work,

Image from "The Hardest Job is the Best Job."

and "The Hardest Job is the Best Job" recognizes this fact and keeps the visual plane as orderly as possible.

The third piece of the puzzle is **that each shot must comment and build upon the shot that has preceded it.** This can be relatively straightforward to achieve when editing most long form – after all, if you are editing a dialogue sequence for a movie or TV show you will generally be bouncing back and forth in a logical way from speaker to listener – but in short form it can be harder to pull this off since so much short form work is montage based. Still, even in a montage-based piece, the incoming shot has to be, in one way or another, a comment on and/or continuation of some concept or idea that was articulated by the outgoing shot.

"The Hardest Job is the Best Job" plays with this idea beautifully, as there always is a connection between each shot and its predecessor. So we move from a montage of the Moms cooking breakfast to a montage of the Moms taking the children to practice, and so on. Each shot continues the thread that has been expressed in the previous shots and moves the narrative forward. This gives the work a real propulsion as well

as helping to reinforce the overall idea of the piece. In this way, the work illustrates what Eisenstein was getting at when he said, "if montage is to be compared with something, then a phalanx of montage pieces, of shots, should be compared to the series of explosions of an internal combustion engine, driving forward its automobile or tractor: for, similarly, the dynamics of montage serve as impulses driving forward the total film."[10] Although Eisenstein's take on montage can seem somewhat narrow to a modern reader's ears, the basic idea that a good cut is one which generates a thought by the juxtaposition of the two separate ideas contained within the outgoing and incoming shots seems appropriate.

So there you have my take on the structure good short form content tends to have, as well as the elements that go into making an individual edit a successful one. As both the trailer for *Spiderman 3* and "The Hardest Job is the Best Job" illustrate, even in our era of elaborate visual techniques, a piece that utilizes nothing more than the basic tools of editing can still be quite powerful. Both are great examples of how the essence of editing can lead to a really powerful piece.

Of course what is impossible to quantify or explain is how each individual shot should be *selected*. Sure there are certain instances where a shot is fulfilling a logical function and can be intellectually justified – such as an establishing shot where you need to situate the viewer – but most of the time intuition – which is honed by practice and study – is all we have to guide us. And this is where the emotional IQ of the editor comes into play. One of the paradoxes of editing

is that it is a highly technical profession that also demands that its practitioners be emotionally open and curious. These qualities are not generally found inside of one individual, but *both* are necessary to make a great editor. Editors tend to be a butch bunch, always "cutting" and "slicing" away at the material, yet, without vulnerability and empathy, how can one ever hope to engage the viewer? This is why I love work like the *Spiderman 3* trailer and "The Hardest Job is the Best Job," as both illustrate what the basic building blocks of our craft are capable of achieving when applied with sensitivity and thought.

1 P.G. Wodehouse, *Right Ho, Jeeves* (New York: Penguin, 1999), 1.
2 Lee Child, "A Simple Way to Create Suspense," *The New York Times*, December 8, 2012, 8.
3 Christopher Booker, *The Seven Basic Plots: Why We Tell Stories* (New York: Continuum, 2004), 4.
4 Michael Goldhaber, "The Attention Economy and the Net," 1.
5 Booker, *The Seven Basic Plots: Why We Tell Stories*, 18–19.
6 Booker, *The Seven Basic Plots: Why We Tell Stories*, 13.
7 Louis Menand, "Top of the Pops: Did Andy Warhol Change Everything?", *New Yorker*, January 11, 2010, 58.
8 Vsevolod Pudovkin, "On Editing," *Film Theory and Criticism*, ed. Gerald Mast and Marshall Cohen (New York: Oxford University Press, 1985), 85.
9 Michael Ondaatje, *The Conversations: Walter Murch and the Art of Editing Film* (New York: Random House, 2002), 269–270.
10 Sergei Eisenstein, "The Cinematographic Principle and the Ideogram," *Film Theory and Criticism*, ed. Gerald Mast and Marshall Cohen (New York: Oxford University Press, 1985), 98.

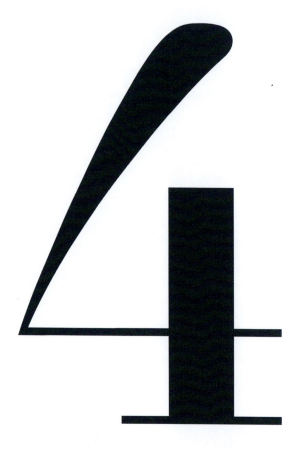

Because Tramps Like Us, Baby We Were Born to Run:
On Music

For an adult, the world is constantly trying to clamp down on itself. Routine, responsibility, decay of institutions, corruption: this is all the world closing in. Music, when it's really great, pries that shit back open and lets people back in, it lets light in, and air in, and energy in…People carry that with them sometimes for a very long period of time.
Bruce Springsteen, *The New Yorker*

For me, it is Bach's Cello Suites. No matter what mood I might be in, one note of "Suite No. 2 in D Minor" and I'm instantly filled with a sense of wonder. Why Bach? I have no idea. I'm from New Jersey and was reared on Springsteen and Motown before eventually migrating to the hardcore punk of Fugazi. I know all the lyrics to "I Like Big Butts," Sir Mix-A-Lot's classic ode to women's backsides, and I'm still not clear whether a viola and a cello are different instruments. But, despite what a philistine I am when it comes to music, if I put on a Bach Cello Suite I am instantly transported, and somehow life makes sense to me in a deep and profound way.

For my wife Caroline it's Danzig's "Mother." A respected educator, passionate Hybrid owner, and devoted parent, she is oddly captivated by that primitive dirge. All it takes are the few first power chords and that Glen Danzig growl, and my lovely wife transforms into a head banging lunatic who warns other Mothers "not to let your children walk my way" (which, incidentally, is one of the creepiest lyrics ever written, and

"Viewers understand how powerful music is, and when they see it being slathered on indiscriminately or without respect to the story itself, they feel insulted."

rivals the ick factor of "Young Girl" by Gary Puckett & The Union Gap, which somehow managed to make it to #2 on the 1968 Billboard Charts despite being about an older man annoyed to find out that his girlfriend is under the age of consent).

No matter what your taste is, music is undoubtedly a powerful force. Renowned neurologist Oliver Sacks' *Musicophilia* is filled with anecdotes that illustrate the effect music can have upon people: a person incapacitated by Parkinson's suddenly animated by song; stroke victims regaining the ability to speak after listening to music; and, on the negative side of the ledger, people who suffer "musical hallucinations" where they are assaulted by imaginary music for weeks on end (as someone who once edited a piece scored to Madonna's "Ray of Light" and subsequently had the song stuck in his head for four days, I found this section particularly harrowing). What all these examples illustrate is just how much music is intertwined with the human experience or, as Sacks puts it, how "it really is a very odd business that all of us, to varying degrees, have music in our heads."[1]

Early filmmakers recognized the power of music for their nascent medium, as they could immediately see that music's ability to charge past the conscious mind and quickly hit the emotional nervous system was a great way to take the emotional stakes of a scene and distill them in such a way that they became palpable and resonant for the viewer (as Aaron Copland described it, the film composer "makes potent through music the film's dramatic and emotional value"). Short form content creators adopted similar tactics, as they immediately saw how the use of a particular musical cue could help them with one of their most difficult challenges: emotionally affecting viewers in a short period of time.

The downside of this power is that music, when handled inexpertly, can just as easily wreck a piece as redeem it. We have all seen work that relied too heavily on its musical score and as a result felt boring and predictable or, worse, seemed manipulative. Viewers understand how powerful music is, and when they see it being slathered on indiscriminately or without respect to the story itself, they feel insulted (being aware of another person attempting to manipulate you is always a disquieting sensation, and music handled inappropriately is usually pretty transparent in this regard).

So, what to do? Well, there are four things that strike me as critical to the effective use of music in short form (there is also the matter of just picking a cool track that people like listening to, but that is kind of a given). The first is that a good musical cue **offers viewers access to what the characters are experiencing emotionally**. Second, **a good musical cue doesn't dis-**tract from the narrative. Third, **a musical cue creates structure and signals change.** Fourth, **a good musical cue offers viewers a sense of transcendence that draws them towards the product or content that is being advertised.** Let's unpack all of these and by the end of our examination we should have a good understanding of the best way to approach music in short form content creation.

Music and the Emotional State of the Characters on Screen

Probably the most common use of music in short form is to give viewers access to the emotional state of the characters on screen while simultaneously engendering those same emotions in the viewer. So, when a short form content creator uses a particular musical cue, she is both commenting on the emotional state of her characters at that moment – "this use of a melancholy guitar piece signals that my character is feeling nostalgic" – while simultaneously making the audience feel the same emotion – "my use of this melancholy guitar piece will make you, the viewer, feel a similar sense of nostalgia." A swelling orchestral score underneath a first kiss by star-crossed lovers signals the passion and love the characters are experiencing while also inducing the same feeling in the viewer. Atonal piano music in a horror movie trailer signals the terror our young coed is experiencing as the machete-wielding maniac stalks her while also making the viewer feel a sense

of dread. In this way, one can see that if you have a character experiencing a nervous breakdown and the scene is scored with fast, arrhythmic drums, the music will help the audience understand what the character is going through while also allowing the audience to get some sense of how that breakdown *feels*. The result of this process of binding the viewer to the characters is a transference of emotional energy that then leads to a much richer engagement with the narrative.

Examples of using music in this way are too plentiful to count, but there are particular cases that stand out for how deft and original they are. One such example is the celebrated score for the third trailer for Christopher Nolan's *Inception*. The track is entitled "Mind Heist" and is by the composer Zack Hemsey.

Inception is about a group of criminals who break into the subconscious of corporate bigwigs in order to extract information that can be used by their business rivals (explaining the plot of *Inception* would take us three pages so let's just leave it at that). The third trailer for *Inception* was widely regarded as one of the best of the year, and one of the reasons it works so well is "Mind Heist."

Image from *Inception* trailer.

The song (and trailer) opens with strings that have an incessant, relentless quality to them (the strings reminded me of the mental condition monomania, a pathology where the sufferer has a sound mind but is so obsessed with a single idea that it drives him mad. As Melville put it when describing Ahab's quest for the "White Whale" in Moby Dick: "the White Whale swam before him as the monomaniac incarnation of all those malicious agencies which some deep men feel eating in them, till they are left living on with half a heart and half a lung."). The basic premise of *Inception* is being laid out in this section of the trailer, and "Mind Heist" does a nice job of setting the tone and driving the piece forward.

The track fully springs to life when we get to our first titles, which are ushered on by a drum hit that is augmented by what sounds like a digitally alerted foghorn. The foghorn is deep and heavy and sounds a bit like a siren (the sound is so distinct that people can simply say "The *Inception* 'BRAAAM'" and everyone knows what they are talking about). When the trailer first came out, we all sat around the edit house I was working at and tried to describe the sound. Some of the best efforts included "the sound a star would make if it exploded"; "the sound of a spaceship launching a laser strike against Earth"; and, my personal favorite, "the sound God would make if he was really angry with you and wanted a chat." What all of these descriptions touch upon is how the sound makes you feel as if you are coming face to face with something beyond your understanding: something that is emerging from a dark, primitive place (if your

Images from *Inception* trailer.

caveman ancestor was walking in the forest and heard the sound, I am confident that he would be concerned enough about what was making the noise that he would immediately start running in the opposite direction). The effect the sound has upon the trailer and the way it integrates with the rest of the song is profound, as suddenly the reality these characters are living in becomes palpable due to the contrast between the relentless strings and the sharp, percussive blast supplied by the "BRAAAM."

The score continues on from there, increasing in intensity, until it finally opens up as we enter our ending. By now the viewer is fully engaged in the universe the characters are inhabiting, and the score, as it pushes the narrative forward, grounds the viewer in the strange reality they are experiencing (a reality of weightless flight, trains barreling through city streets, and cities collapsing in on themselves). The division between the surreal, ever expanding dream state, and the more hidebound, logic driven world we inhabit

Zach Hemsey on "Mind Heist"

Zack Hemsey is a recording artist and songwriter whose music has appeared in movies, television shows, and video games. Hemsey's work has been particularly effective in film trailers, as compositions of his have appeared on trailers for 2 Guns, The Town, Lincoln, Insurgent, *and many more.*

Bryan Cook: When you are composing for a piece of short form content what are you usually given at the beginning of the job (a rough cut, a brief, a conversation with the larger creative team, etc.)?

Zach Hemsey: It can vary, depending on the type of project. From a composer's standpoint it is usually ideal to work against picture, regardless of short or long form content – naturally it makes sense to see what it is you will be scoring – this is typically the case with respect to film, but from what I have gathered it is atypical with respect to trailers. Of course, if you're composing music for a client, that client will communicate their ideas and goals, verbally or in writing – sometimes these can be specific and sometimes they can be vague – and sometimes they don't know what they want, and it's up to the composer to figure out an approach that works.

Bryan Cook: As a composer who spends much of his time creating music specifically for short form content – particularly trailers – what do you think the musical score should bring to the piece as whole?

Zach Hemsey: In actuality, I don't spend any time creating music specifically for short form content, or any other content for that matter. I have scored a few short films in the past, and there was a brief period years ago where I was doing custom music for trailers, but overall these situations have been the exception and not the norm. I'm simply a recording artist whose music tends to have emotional and/or cinematic qualities that lends itself to Film/TV use. I don't make music with the specific intention of licensing it in trailers, or any other medium…I just make music. If it happens to get used in a trailer, great; and if not, so be it. The prominence I've had in trailer licensing is perhaps the unintentional result of this philosophy, in that I don't create what I think people want to

while awake, is bridged by the musical score, as "Mind Heist" allows us to really feel the liminal state that the characters exist within.

The song – and trailer – end, fittingly, on the "BRAAAM," which by now has established itself as the auditory incarnation of the theme of *Inception* (it is, at least to me, what "Inception" – the process of placing an idea in a person's subconscious – sounds like). As a result of "Mind Heist," the viewer feels locked into the narrative world of the trailer and is granted a visceral sense of what the characters are going through emotionally. The song and the trailer are inextricably linked, and it's a testament to how strong the connection is that the editor felt no need to change his musical cue at any point in the piece, a definite departure from the typical trailer which generally changes its cue frequently.

As we can see with "Mind Heist," music in short form is able to thrust the viewer into the psychological/emotional space the characters are in, while also engendering an identical psychological/emotional reaction in the viewer. By allowing the viewer to see what the characters are feeling, and then making the viewer feel the same thing, a musical score allows the viewer to become invested in the narrative world that the characters are living in. This investment, of course, causes the viewer to want to see things through to the end, as once you are invested in the characters being depicted, you will want to see what their fate is.

One of the added benefits of using music in order to reflect the emotional state of your characters is that it forces everyone working on a project to actually think

about what the emotional stakes of the piece are. Music is one of the few things that everyone on a project will usually have a firm opinion on, and although this can make finding the right cue laborious, it also helps in the sense of getting everyone in the room to consider what the piece is actually trying to accomplish emotionally. Furthermore, failure to find a good cue – and we have all been on projects where the music just doesn't want to click into place – is actually a helpful insight, as what it usually means is that the emotional stakes of the work are opaque and need to be further explored.

In this way, finding a musical cue is like an emotional litmus test, and if Copland is correct that music makes potent the film's dramatic and emotional value, failure to find the proper cue indicates that something has gone wrong with the piece as whole. Although it's always a bit depressing when this occurs, the nice thing is that you can actually work backwards and use music to try and help you see what the piece wants to be. In order to use music in this way I actually have a folder of songs I carry with me to every job that is organized into a hierarchy based loosely on the emotional classification system created by the psychologist M. Gerrod Parrott. What Parrott attempted to do was to catalog the deeper emotions all human beings share by organizing emotional states into primary emotions (e.g., love), secondary emotions that are manifestations of these primary emotions (e.g., affection and lust), and tertiary emotions (e.g., adoration and infatuation). I used Parrott's logic and have about ten tracks for every secondary emotion. Then, if I am in an edit and can't figure out what a piece wants to be at

hear; I create that which is authentic to me, as a composer and songwriter.

Bryan Cook: As the famous quote puts it, "Talking about music is like dancing about architecture." Given how often you will be dealing with clients and others in the production ecosystem who have to use language to discuss music, how do you manage to successfully navigate this?

Zach Hemsey: Even musicians have to use language to discuss music. No one communicates with each other in tones or through sheet music. The disconnect between clients and composers can stem from the former's improper use of music terms, or more commonly, differences in the way each party understands and relates to subjective characterizations. For example, the descriptions "epic," "badass," "dramatic," "dark," "menacing," etc. can all be interpreted and applied in different ways, so the task of a composer is deciphering what this particular person/client means when they use a given term. Naturally, sometimes there can be an initial feeling out process while everyone gets their bearings, but if need be, one can always reference a preexisting piece of music as an example of the mood or quality that they are trying to convey.

Bryan Cook: About halfway through the Inception trailer – right after Cobb informs Ariadne that what they do is not "strictly speaking, legal" – a percussive element enters the score. Why was it necessary to introduce that element alongside the strings at that moment?

Zach Hemsey: This question might be better suited for the trailer's editor or producer but I'm not sure anything is ever necessary. There are many ways to slice an apple. Musically speaking, I did what felt compelling to me within the context of the song – the arrangement and orchestration was not an intellectual exercise, but rather, unfolded organically.

Bryan Cook: What is the one question you always end up asking yourself while working on any piece?

Zach Hemsey: Why am I doing this?

that moment, I begin applying songs from each group of possible secondary emotions and see what fits (e.g., if I am cutting a promo for a thriller I might look at songs that are secondary emotions of fear [horror and nervousness] or anger [irritation, exasperation, rage, disgust, envy, torment]). The system is quite helpful when you are working on a piece where the emotional stakes are not revealing themselves and is a nice way to get everyone – even the lead marketer who just silently sits there the whole time – to chime in with where they think the piece wants to go emotionally.

Select Music that Doesn't Distract from the Narrative

While you want to select music that evokes a feeling in the viewer by connecting her with the characters on screen, you also want to use music that doesn't call so much attention to itself that it pulls you out of the narrative. As Roger Corman puts it, "Music best enhances a film when it evokes and modulates a specific emotional response in the audience to the unfolding story without the audience being aware of it."[2] This is a reality in long form work as well of course, but short form is under even more pressure to meet this criterion, as you obviously want to move people as much as possible, but you also don't want them so engaged by the music that they ignore the story and the product you are advertising.

The way people generally deal with this issue is to try and select music that the characters on screen seem like they might listen to. So, if your piece is a commercial for Doc Marten boots and features a bunch of toughs hanging about a pool hall, scoring your piece with punk is a safe way to avoid distracting from the story. The main reason why you want to do this is that if the musical cue feels diegetic (as if the characters on screen had put a track on in the background), the viewer will be far less likely to question its placement. If you don't do this, if you score your Doc Marten commercial with Celine Dion, the audience will ignore the story and instead try to figure out why Celine Dion is playing under a scene with tough guys hanging about a pool hall (of course you could have fun with this and make a joke out of the disconnect, but obviously your spot would have to be structured along these lines and would eventually have to reveal a justification for this incongruity).

The logic behind this is what drives thinking about music as "color." Color is the term used to describe music that is associated with a particular time and milieu. So, if you were making a commercial set in rural Scotland in the early 20th century, the director might ask for bagpipes, as bagpipes say "rural Scotland in the early 20th century" much more than dubstep. Besides having the benefit of helping to establish time and location, using music as color helps to keep the musical score from being obtrusive as it avoids a disconnect between the narrative space and its aural accompaniment.

This way of thinking about music harkens back to our discussion of the "Five Ws" in Chapter 2. What I mean by this is that music in short form can work,

> ## " ...a musical cue that is banal and expected lessens our emotional engagement to the story. "

alongside the imagery it is connected to, to establish where we are in space, what historical period we are in, who the piece is about, what is happening, and why it is happening. For example, if we were making a trailer for a biopic about the legendary jazz musician Jelly Roll Morton, we could open the trailer with one of his upbeat compositions from the early 20th century and instantly establish that we were in New Orleans during the Jazz Age, that this was a movie about Jelly Roll Morton, and that times were good and that the future looked bright. When music is used in this way it can work alongside the imagery to help us quickly communicate factual and emotional information to the viewer.

Of course this is not an excuse to make obvious choices, as a musical cue that is banal and expected lessens our emotional engagement to the story. For example, our toughs in the Doc Marten spot certainly don't have to be listening to punk. Would they listen to Celine Dion? No, probably not. Might they listen to Muddy Waters, Neil Young, Johnny Cash, or Billy

Holiday? Yes, of course, as all of those musicians share certain traits with punk and the Doc Marten wearer that Celine Dion does not (they are novel, unconventional, somewhat wild in their ways, etc.).

The other trick to not distracting from the narrative with your musical cue is to use only the orchestration and instrumentation that is necessary to evoke the response you are going for. In other words, if a lone piano playing a simply melody can generate the same amount of pathos as a full orchestra, this will be the more effective way to accomplish your goals, as the more simple the song and instrumentation, the less cognitive work the viewer must do in terms of processing the music. This will then leave the viewer's mind free to deal with the nuances of story and performance rather than dealing with the music. Taking this one step further, experiment with not using music at all when cutting. Sometimes silence, or at least holding back your musical cue for an unexpected beat, can lead to wonderful results, as the viewer can experience the emotions you want them to on their own, without them feeling like you are somehow commenting on the action being depicted. As Murch puts it, "When music makes an entrance in a film there's the emotional equivalent of a cutaway. Music functions as an emulsifier that allows you to dissolve a certain emotion and take it in a certain direction. When there's no music, the film-makers are standing back saying, simply, Look at this."[3]

Use Music to Generate Structure and Signal Change

As we saw with our *Spiderman 3* trailer – which has five different musical cues as well as a number of sound effects beds that function in a similar way – using music to create structure in short form is pivotal. Music is uniquely suited for generating structure, as changing the musical cue lets the audience know that something is changing as well as alerting them to the emotional stakes of the incoming act. So, when we first meet the Sandman and learn that he is the actual killer of Peter's uncle, the pace of the score accelerates and the music gets darker and more foreboding. Then, later on, when we get to our final montage, the music is adrenaline pumping and the editing rhythm falls in line with the pace of the score.

Short form, which is all about quick and elegant transitions, relies heavily upon music to help it move seamlessly through time and space. By making adjustments to the musical score, you can quickly bounce from one narrative thread to another, even if those threads are in different eras and different locations

Image from *Spiderman 3* trailer.

(imagine a trailer for a movie about time travel, where all you would need to signal large temporal shifts would be swapping one cue – perhaps the hip-hop that scores the scenes in present day Chicago – for another cue – maybe a waltz which scores the scenes in 18th-century Vienna). Even if you aren't making a radical shift in time and space, changing the musical cue alerts the viewer to the fact that some new storyline is being introduced which they need to pay attention to. Using music in this way helps ensure that the viewer knows a new idea or plot point is being introduced while also helping them see what the emotional stakes are of the incoming scene (if all of a sudden your cue in a promo turns dark and sinister, what you are doing is telling the viewer that a dark and sinister element is entering the hitherto happy world the characters were existing in).

Music and Transcendence

The most difficult thing to quantify about music and the moving image is how the two, when coupled together, can be so good at transporting viewers into the narrative world. Music on its own is obviously quite powerful in this regard, which is what The Boss was getting at in our epigraph when he noted that music, "when it's really great, pries that shit back open and lets people back in, it lets light in, and air in, and energy in." No matter how stultifying life might be, if your favorite song comes on the radio, you will usually find yourself singing along at the top of your lungs

and forgetting, for a moment, the pressures of your daily existence.

When paired with evocative imagery and a strong narrative, music becomes even more powerful, which is why so many of the most famous scenes in cinema are inextricably linked with their musical score (a few famous examples include the opening scene of *Apocalypse Now* and "The End" by The Doors, "The Pittsburgh Connection" scene from *Goodfellas* and "Gimme Shelter" by The Rolling Stones). Moments like these, where the music and visuals completely pull the viewer into the narrative, are great examples of how music and the moving image combine together to create a world that viewers cannot help but step into.

The way filmic images allow viewers a temporary reprieve from reality is quite pivotal for short form. We need to supply this reprieve in order to hook the viewer into the narrative and thus keep them watching, but also to get the viewer to engage further with whatever end product we are advertising. As we noted in Chapter 1, what products and content offer to consumers – when you drill all the way down – is freedom from need. The cleaning detergent offers you freedom from dirt – with all that this means psychologically – and the movie offers you freedom from your daily existence. So, using a cue that grants the viewer a moment of transcendence and freedom subtly implies the promise of the product or content that you are advertising. Think about your response after watching a particularly good trailer when you turn to your friend and say, "I have to see that film." On the one hand you are saying this because the characters and story being

Gabe McDonough on Music and Advertising

Gabe McDonough is a music and branding professional who has led the music departments of advertising agencies such as TBWA\Media Arts Lab, Leo Burnett, and DDB Chicago. He is currently a Governor of the Chicago Chapter of the Recording Academy and in 2012 he was voted one of Billboard Magazine's "40 Under 40 Power Players on the Rise."

Bryan Cook: As a music director for major ad agencies, what's the first question you ask yourself when you're starting the process of finding the right song for a spot?

Gabe McDonough: Who is the audience and, most importantly, how do we want them to feel? Because I think that's the real secret sauce, the real value that the music part of advertising brings to things. We all intuitively know how much music affects the emotions, but music literally hits your brain differently than rational thought does; it actually goes right past the part of your brain that processes rational thought and goes straight to the emotional center. Music is the gateway to people's emotions, and it's magical that way because it can communicate really complex emotions and feelings in a second, in a single tone or in a single chord.

There's consuming information and then there's *experiencing* information. If your communication evokes an emotional response, then you're letting people experience that communication versus just forcing them to basically read the details of a product manual.

Bryan Cook: When you hear a song and immediately think that it would be perfect for an ad, what exactly are you responding to in that song? Is it just that it contains that emotional quality or there are other elements that make you say, "That's a perfect song for a spot."

Gabe McDonough: When you're working on certain brands, you can't help but feel like "okay, yeah, this song in the wheelhouse for this brand." Every brand has a different musical language that they use which connects to what the brand's about in general; which is important as every brand *should* have a musical point of view.

That's more of an intellectual approach, but I think what you're asking is, every now and then, a piece of music, you

continued overleaf

hear it, and it's got an X factor where you just go "ooh, this has all the right elements to be a really special song in an ad." Besides having an emotional weight, songs like that have something that's different and that stands out and doesn't sound like everything else. Those type of songs also usually will have sonic signifiers that will just naturally appeal to certain types of people, and if you can put something that's in the aesthetic of the audience that you're trying to reach, that's your cost of entry, that's what brings them in to accept the emotional information.

Bryan Cook: Getting music approved is always one of the most difficult components of creating an ad so what is your process for this and how do you attempt to wade through all the client notes that will inevitably come in on the music?

Gabe McDonough: People in advertising get a lot of stick, sometimes justifiably. But something that always really impressed me, coming from indie and punk rock land, was how people in advertising can be so professional with their creativity. They can turn it on like a faucet. I've been at recording studios with musicians where the band will waste time and be like, "I don't know. I don't have any idea …". People in advertising would never let that happen. They always get something out, and that's down to them being professional.

In the same way I try to approach my job as professionally as possible and ask myself "what are we in the business of doing? Why am I here?" Well, we were hired by our client to sell whatever the product is that they're selling, and they are paying for what we do. The magical thing about music is there is no right or wrong music; the music that is "good" is the music that you personally like. That's it. You can't talk someone into liking a piece of music. It's an entirely subjective decision. Which is why it usually just comes down to who is the ultimate decision maker? Do they subjectively like this piece of music?

My proof point on this is that we know that arguably the most popular music in America is New Country. Everybody knows that. It's popular across all demographics. Yet you will almost never hear a New Country song on an ad. Why? Well, it's the subjectivity thing. It seems stupid but it probably boils down to "Cool guys and gals who work in ad agencies on the coast, and CMOs who are in similar positions, don't like New Country music in general so they won't put it on their ads even though they know quantifiably it's probably going to reach more of their core audience." Music is so powerful that if someone subjectively is averse to a type of music, no matter what the research tells them, they still can't get past their own personal taste in music.

continued overleaf

advertised seem interesting to you. On another level though, you are saying this because the sense of escape that you felt while watching the trailer is something you want to experience again, and the logic of advertising implies that you *can* experience this feeling again if you just pay fifteen bucks and go watch the movie.

Of course it's not easy to find a song that simultaneously does all of these things, but when you do, life gets pretty simple (when I'm cutting a piece with the perfect cue, I always end up feeling like my main responsibility is just to avoid screwing the whole thing up). To see this in action take a look at the trailer for *American Hustle*, which is scored entirely by the Led Zeppelin track "Good Times Bad Times." The trailer is quite fun, and the reason why it works so well is the marriage between the imagery and the song. "Good Times Bad Times" manages to establish time and place (the film is set in the 1970s, which is roughly the same time the song was released), set the emotional tone of the piece, supply structure, and allow for a moment of transcendence (I defy anyone to watch the trailer and not be fully absorbed by its combination of visuals and music).

Image from *Spiderman 3* trailer.

Images from *American Hustle* trailer.

The song is so perfect for the piece that the editor lets it do almost all of the heavy lifting, as the trailer features very little dialogue from the film and is almost entirely free of title cards or voice-over (the only creative card in the piece comes towards the end and simply states "Only in America"). I love when a piece of short form is allowed to stay this simple and pure – not always the easiest thing to do – as not only does "Good Times Bad Times" do all the things we need a song to do in short form, but it even manages to capture some of the main themes of the movie (*American Hustle* is about a lot of things, but it could pretty accurately be described as a movie about good times and bad times and the different ways people deal with either).

With music out of the way, let's move on to one of the most fascinating parts of the short form ecosystem: sound design.

Bryan Cook: Using music as "color" or simply to establish time and place is always an impulse but one that generally leads to a boring cue. How do you deal with this?

Gabe McDonough: Sometimes music just needs to do some heavy lifting for you. Sometimes it needs to say "this is in Afghanistan" or "this is taking place in the 1920s." And that's the power of music, right? You can quickly and affordably do that. You could set something in a room with very little set decoration and put 1920s music on and in a second, people think to themselves, "oh we're in the past."

So I'm not against using music as color. I think that's another one of the great ways of using music as a tool.

Bryan Cook: The best music in ads tends to be somewhat surprising in the sense that the track works but it was not the obvious choice in a genre sense. What do you think this element of surprise buys you?

Gabe McDonough: At the end of the day you're trying to make your ad stand out as much as possible. It's just like if you're scrolling down a line of people and there's one person who's tall and, inevitably, that person stands out. So you want to stand out but obviously the song also has to be good. You have to get people to turn their head and then also, you know, reward that attention with, like, a good story or a great song.

Bryan Cook: Using a popular or recognizable song affects an ad in a profound way. Can you speak to your experience with what a widely known track does to an ad?

Gabe McDonough: A Creedence Clearwater Revival song, or a Rolling Stones song, or a Beatles song, these are towering cultural achievements. These are massive pieces of human culture. Songs like this supercharge communication, that's why those songs are so expensive, because they bring so much to the table. We get caught up in "it's got to be new, it's got to be different, it's got to be original." But when I talk to my parents, they're like, "Oh, hey, I saw that Journey song in an ad!" People love it.

If you look at the statistics, music discovery is basically unimportant to most people. I personally love music discovery. All my friends are big music heads. If you're in the creative industry, I think you tend to be more into discovering new things, but to the majority of people, they don't care that much about hearing new music. In my experience, good music to most people equals music that they've heard before. If you're at a wedding, you can put on the new Taylor Swift single that no one has heard before, and it could be the most amazing pop song ever written, but way less people are going to dance to it than the one that they know already. Being able to give people a point of reference, something to be familiar with in the communication, that can be hugely valuable.

Bryan Cook: What would you say is the best marriage of an ad and a song you have ever encountered?

Gabe McDonough: The only time I ever heard the Beatles when I was growing up was oldies radio and it was shit like "I Want To Hold Your Hand." I was just not down with it. I didn't like it at all. But when I was in 5th or 6th grade this ad came on for the first iteration of the Nike Air, and they had "Revolution" by the Beatles on it. I went to the mall the next day, bought a Beatles compilation that had that song, and then I saved up and bought the shoes too.

I'm sure this would horrify some people, but that's what really turned me on to the magic of the Beatles. I didn't realize that they weren't some bubble gum band, honestly, until I saw that ad. That ad turned me on to the Beatles, which is a massive thing, and then it also achieved exactly what the brand wanted which is that I bought the shoes. Basically, the song sucked me in and at the end of it I was like, "well, I like that, and then I also like those Nikes." If you can do that, if you can turn someone on to great music, important music, valuable music, and then also sell the products that you're trying to sell, I mean, that's the gold standard for me.

1 Oliver Sacks, *Musicophilia* (New York: Vintage, 2007), 43.

2 Roger Corman, "The Best Music in Film," *British Film Institute*, http://old.bfi.org.uk/sightandsound/filmmusic/detail. php?t=d&q=10, accessed February 8, 2006.

3 Ondaatje, *The Conversations: Walter Murch and the Art of Editing Film*, 103.

Rise into Hit:
Sound Design

"Aaaaaaarrrrrrrrggggggggggggghhhhhhhhhhhhhhhhhhhhh!!!"
The Wilhelm Scream aka *Man Getting Bitten by Alligator*

Ah, The Wilhelm Scream. Heard in over two hundred films – most famously when Luke Skywalker shoots an anonymous Storm Trooper who subsequently screams in agony while plummeting to his death in *Star Wars* – it is arguably the most recognizable sound effect of all time. Thought to have made its first appearance in the 1953 film *The Charge at Feather River* when the character Private Wilhelm gets shot by an arrow, it was actually originally used in the 1951 film *Distant Drums*, when a soldier tramping through a swamp in the Everglades gets attacked by an alligator (hence it's other title, "man getting bitten by an alligator"). As evidenced by its use in over two hundred films, The Wilhelm Scream has become something of an inside joke amongst sound designers, who fight to get it into their work over the objections of their directors and producers who recognize, rightly, that it is a pretty terrible sound effect (amongst its other distinctions, The Wilhelm Scream might be the most famous bit of bad acting in the history of film, which is saying a lot for a medium that has counted Adam Sandler amongst its practitioners). Here is sound designer Stephen Altobello, who has used the scream in three

"Sound design is the secret weapon of film . . . "

different movies, describing The Wilhelm Scream: "I don't want to say it's a stupid sound, but it's ridiculous. It's certainly extremist. You watch it once, and you don't know it's there. You're like, okay this scene's fine. But when you watch it knowing it's there, it really does leap out of the sound track."[1] I think this is about right, as it's hard to say *what* is so inauthentic about The Wilhelm Scream – after all, the actor Sheb Wooley, who originally made the sound, thought he was voicing a man being eaten alive by an alligator and who amongst us can assess what noise we would make if an alligator suddenly started gnawing on our leg? – but there is something profoundly *wrong* with the scream.

So why do sound designers fight to put The Wilhelm Scream into their work? On one level, the scream functions as a wink to other sound designers, a message hidden inside the most massive of mediums that only other enthusiasts and craftsmen will recognize. For these purposes, it is the "badness" of The Wilhelm Scream that actually makes it work, as the inauthentic nature of the scream is what allows the aficionado to recognize it amongst all the other sounds filling up the aural plane.

On a slightly deeper level though, The Wilhelm Scream is a way for sound designers to subtly show the power of their craft. Sound design is the secret weapon of film, and a sound designer's ability to hide the scream from directors and audiences, despite how bad the effect is on its own, says a lot about how sound effects can operate outside of the audience's awareness (as a general note, for the sake of simplicity, I am calling anything auditory other than dialogue, voice-over, or music an element of the sound design). In this sense, sound designers fight to insert the scream because it shows how easy it is to affect the audience without them being aware of the individual sounds that exist within the mix. As any experienced short form creative knows, sound design is critical for making a cut work, and The Wilhelm Scream, in all of its cheesy glory, illustrates the power of sound design by showing how the audience can be convinced of the reality and emotional power of a scene despite the existence of sounds within the mix that would be laughable when isolated.

So how do we understand and best utilize sound design in short form? As The Wilhelm Scream shows, although sound design can radically alter the mood of a sequence, audiences rarely take notice of sound design while consuming filmic content. Given how one of our main goals is to quickly evoke a feeling in the audience without them knowing how we did it – and thus without feeling manipulated – sound design is extremely useful to us as short form content creators. Furthermore, sound design is what allows the short form content creator to skillfully pull off the quick transitions that are so critical to the craft, as sound

> " . . . sound design is extremely useful to us as short form content creators. "

effects can be used to subconsciously prepare the viewer for a shift in space, time, or tone. For example, if you have a montage driven by a fast-paced rock track and you want to quickly cut out the music and hit a beat of silence, the addition of a series of sound effects – a rise and a hit perhaps – at the end of your montage will subconsciously signal to the audience that something is going to change and prepare them for this transition (a transition that would otherwise be quite jarring).

I will go over the specifics of this sort of sound effect usage in a moment, but I would like to begin by breaking sound effects into the two most common buckets that are used when discussing them. These buckets are diegetic and non-diegetic, and they divide sounds into those that are visibly motivated by something on screen and those that do not have motivation of this sort.

Diegetic Sound Effects: Diegetic sound effects are those that are visibly motivated by action that is taking place on screen. So, if two characters are playing tennis, diegetic sounds would be the plunk of the ball hitting the racket, the squeak of sneakers on blacktop, and the sound of a lawnmower in the background. Of

course, these sounds are often added or enhanced in post, but in order to be diegetic they have to have a clear on-screen origin. Although some books on film can be fairly didactic about what constitutes diegetic sounds – for example, I have heard people argue that if one character is talking to the other, and we are looking at the character who is listening, then technically the off-screen sound of the character who is talking would be non-diegetic – I want to be a bit broader, as I think being so narrow in defining what is a diegetic sound loses the essence of things. So, in my analysis, the sound of the character's voice who is talking off screen would still be diegetic, as although that character is not visible at this particular moment, the narrative has firmly established him as being in that space. Or, if you have a scene in a garage and there is the sound of a drill being used, even if that drill is never visible, it is still diegetic, as the drill would be understood to be a part of the world you are currently in. This is the main point to recognize, as I want to refer to sounds as diegetic if they can be understood as being a part of the world that the story is currently in.

For the short form content creator, diegetic sounds have a couple of roles. **The first way short form content creators tend to use diegetic sound effects is to reinforce the reality of a situation.** Much short form content is shot without sound – or is cobbled together from footage from various shoots – and it is up to the sound effects track to make it all "feel real." For example, if one is cutting a car commercial it is often the case that the footage was shot without audio. So, in order to enhance the realism of the piece, the sounds that the car would make in reality will be inserted in post. Although viewers often won't consciously be put off by a lack of diegetic sounds, they will subconsciously feel it, as a lack of sound severs some essential reality of a scene.

This idea of reinforcing the reality of a situation also plays out with the way in which diegetic sound effects can *create* the perception of reality, something which is most obvious when sound effects are attached to motion graphic elements or CG shots (I am about to push the diegetic vs. non-diegetic distinction I posited in the above paragraph to its breaking point, so be prepared to grit your teeth if my way of slicing it bothered you). Motion graphics can do amazing things in our work, but without sound they can often feel odd and unmotivated. Enter sound effects. For example, if you have a lower 3rd title treatment for your talking heads where the type flies in from off screen, adding a "whoosh" can supply motivation and ground the graphic element in reality. Things in motion make noise, and despite the fact that motion graphic elements obviously are silent, adding sounds that make sense with the motion the graphics exhibit helps bring them to life. Sound effects also help to call the viewer's attention to the visual elements that they accompany,

> **. . . a lack of sound severs some essential reality of a scene.**

as the inclusion of a simple sound will often be enough to draw the viewer's attention to whatever is motivating the noise (i.e., if you really want the viewer to look at your lower 3rd, you can shift their attention to that area of the screen much more easily if there is sound attached to the graphic).

The way diegetic sounds can manufacture a sense of reality echoes Michel Chion's discussion of *synchresis*, a term he defines as "the spontaneous and irresistible mental fusion, completely free of any logic, that happens between a sound and a visual when these occur at exactly the same time."[2] What Chion is getting at here is that viewers will, without thinking about it, combine an image and a sound together as long as they happen at the same time. It isn't even necessary that the sound is reality based, as we could add thousands of different sound effects to a shot of a hammer hitting metal and even if the match is fairly "off" in the sense

Images from *C More* promo.

of resembling reality, viewers will still buy the connection as long as the sound and visual happen concurrently and as long as the match is somehow plausible.

Diegetic sound effects – and non-diegetic sound effects for that matter – are also useful for the short form content creator in the sense of **helping to motivate an individual edit.** As we have seen, short form content is often a hodge-podge of all sorts of footage, and sometimes you will use a sound effect just to allow you to make an edit from one shot to another. This can be as simple as using the sound of a door handle turning to motivate a character turning her head, or as elaborate as a sizzle video the video-on-demand channel C More did a few years back, where the whole piece was cut using sound design to motivate nearly *every* edit. So, for example, there is one sequence where the editor starts with a shot of a tennis player hitting a forehand followed by a series of shots of celebrities quickly turning their heads in different directions as if following the flight of the ball as it is hit back and forth. The shots of the celebrities turning their heads would be completely incoherent except for the repeated sound effect of the tennis ball being struck, which motivates the head turns and links the whole thing together. It is a clever and unexpected technique, as the editor is pushing the use of sound effects motivating individual edits to their breaking point but still maintaining control over the cut.

Besides giving a sense of reality and motivation to short form content, **diegetic sounds can also add additional layers of meaning and psychological intensity to a scene.** An example of this would be the "clap of thunder" sound effect at the end of a promo that signifies that something ominous is looming on the horizon and that trouble is brewing for the central characters. Yes the "clap of thunder" is a filmic cliché, but it still can be effective, as the sound of thunder *does* make us nervous by exploiting primal fears and anxieties (think of your caveman ancestor as a storm moved in: a dicey situation which could easily lead to serious issues for him or her). Adding the sound of thunder to the end of a scene, coupled with other textual clues within the frame, serves to alert the viewer to the fact that there is "trouble ahead."

To see how diegetic sounds can add psychological intensity to a scene, imagine a promo for a TV show about a woman who kills her abusive husband and embarks on a journey of discovery while trying to evade capture (let's call this masterwork *Unchained*). In the open of the promo for *Unchained*, we might have a scene where our heroine is cooking her dissolute looking husband steak and eggs. There is no dialogue in the scene, so in order to heighten the anxiety, the editor and sound designer might choose to accent the harsher sounds associated with cooking: the egg being forcefully cracked on the side of the bowl; the scrape of the metal spatula along the bottom of the pan; the sizzle

> **. . . diegetic sounds can also add additional layers of meaning and psychological intensity to a scene.**

of the steak as it is tossed in with the eggs. All of these harsh, abrasive sounds, coupled with the wife's body language, would be enough to cause anxiety in the viewer, who would feel the tension that exists between the couple without even a word of dialogue.

Finally, **diegetic sounds are also useful from a structural point of view**, as they often will be used for breaking up dialogue or voice-over blocks in order to add dynamism and a bit of presence to a piece. You often see this in documentary short form work – such as "Making Of" web content or "Behind the Scenes" (BTS) pieces – as sound effects will help keep the work from being too saturated by voice-over or interviews. So, for example, if you were making a BTS of a fashion show that was driven by talking heads, you might insert quick little montages of the backstage hubbub

and its related sound effects – camera clicks, high heels on cement, women laughing, etc. – in order to separate the different interview chunks. Besides giving a natural separation between ideas and concepts, these breaks create a nice breather and help to avoid fatiguing the viewer with too much information.

Non-Diegetic Sounds: Non-diegetic sounds are those which are not motivated by something which is visible on screen. These types of sound effects have become a substantial part of the sonic experience of short form content as they can push the narrative forward and add an injection of whatever mood is being called for. In fact, I would argue that the aggressive use of non-diegetic sound effects has been one of the most important innovations in short form over the past decade or so, as non-diegetic sound effects open up all sorts

Image from *Prometheus* trailer.

of possibilities for compressing narrative and offering more story and emotion in less time.

The first way non-diegetic sound effects are used by short form content creators is **to motivate, and signal, shifts in tone or time and space**. The way this generally plays out is that if the editor wants to make a sudden shift, she will add something to the soundscape, often a "rise" – which is a sound or musical note that rapidly "rises" in terms of pitch and volume – and let the rise subtly signal to the audience that a change is about to occur. So, for example, if she was editing a frenetic car chase scored to a hip-hop song and wanted to end the sequence with a beat of silence when the car flips over and sails through the air, she might introduce a rise that would then end in a large "hit" – a percussive smacking sound – which would allow her to abruptly cut the cue and move into a beat of silence. This combination of the rise/hit allows the editor to make a

Images from *Prometheus* trailer.

sudden shift by signaling to the audience "something is about to change" and by giving her a way of abruptly cutting the music that isn't completely jarring.

Non-diegetic sound effects are so powerful that they will often be used instead of music. For example, at the end of the second trailer for *Prometheus*, rather than having a musical cue take us through the climax, the furious montage that concludes the piece is driven entirely by the sound design. The soundscape is dominated by a long rise, a grating, industrial drone that sounds like the rotors of a helicopter, and an intense "pulsing" effect that sounds like a mix of an air-raid siren and someone screaming. What's interesting about the way the sounds are used here is that they do a number of things at once, as besides ratcheting up the intensity and allowing the piece to be edited more and more frenetically, they also have a diegetic quality in the sense that they sound almost as if they are being created by the images that are appearing on screen (in particular, they sound like the human's ship being destroyed and the enemy's spacecraft emerging from the ground). This sense of the sound design performing "double duty" is reinforced by the fact that the whole sequence concludes with a muted and faint female voice yelling "No!" as one of the characters faces off against the enemy. The smallness of the voice compared to the all-out aural assault that has been generated by the other elements within the sound design nicely helps illustrate the smallness of the human characters in comparison to their technologically superior Other.

Non-diegetic sounds are also often used **to add psychological texture to a scene.** You can see this in

Bryan Jerden on sound designing the *Prometheus* trailer

Bryan Jerden is one of the top sound designers working in short form. Over his career he has worked on trailers for movies such as **Prometheus, Mad Max: Fury Road, Fantastic 4, Poltergeist, The Dark Knight Rises, Harry Potter,** *and* **Inception.**

Bryan Cook: Over the last decade or so, one of the most innovative areas in short form has been sound design, as it seems like the craft just keeps taking huge leaps forward. Do you agree with this and if so what are the causes of this rapid creative evolution?

Bryan Jerden: I do believe that this creative evolution is happening. I see it happening to myself and I see it happening to the people I work with, who are a band of specialized sound designers who really customize their work towards this short form medium we are talking about.

I think one of the biggest factors in this evolution is the sound itself. Every year I am generating new material, based on better tools, and the library just keeps getting more exciting, developed, and organized. Sound is something that develops over time; it evolves.

I think another part of it is that we are being driven by the visuals. The visuals have gotten so good, so exciting, and our ability as an industry to create great visual effects also motivates innovation on the audio side of things.

The other thing that comes to mind is the music, as I would argue that some of the most interesting music happening in the world today is happening in advertising and specifically trailers. It really is coming into its own as a musical art form.

Bryan Cook: One of the things I have noticed with trailers is how sophisticated the dance between music and sound design has gotten. Ten to fifteen years ago you would have a song, or a couple of songs, and they would dominate the soundscape of the trailer. But now the song is coming in and out, the sound design is coming in and out; it's very sophisticated the way they play with each other. Have you noticed this as well?

Bryan Jerden: Absolutely. Trailers are edited to the rhythm of the music and with that I am making things and creating

continued overleaf

things in a very musical way. I am constantly pitching all of my sound effects to fit the music, as I am doing a hybrid type of sound design where it is really music design as well. And we keep upping the ante with this, as I remember early on a lot of the trailers I was working on were far more just designing practical effects and now it is much more about designing musical stuff.

Bryan Cook: Can you speak to how sound design contributes to the overall narrative of a piece?

Bryan Jerden: It's interesting. I had an epiphany a couple of years ago when I realized that I'm not just creating a collection of sounds but instead I am actually creating parts to a story. When I realized that what I was doing was telling a story through sound, things got really clear for me.

A simple example would be a gunshot. That gun needs to *say* something about the guy who is shooting it. And that is just a small example, but then the whole soundscape has to tell a story. When you start to see things in this way things get really interesting.

Bryan Cook: Let's talk about the sound design work you did for the *Prometheus* trailer. The closing montage in the trailer is driven by sound design rather than music, and one of the noteworthy things about this moment was how you used sounds that seem familiar but are actually quite odd. For example, one of the most prominent sounds in the soundscape reminded me of an alarm or siren but it didn't *really* resemble any alarm or siren I have ever heard. What is the benefit of utilizing sounds that seem like they come from reality but twisting them in this way?

Bryan Jerden: Well, this goes back to my thing about telling the story. I am really trying to tell stories in a very stylized way. Lots of trailers out there, you see an explosion, you hear an explosion. You see a plane or a helicopter fly-by, you hear one. It's a one for one thing.

I certainly do that, but that's not the reason people are getting me involved in stuff. The reason why people get me involved in stuff is because they want it to be more stylized than that. They want it to be subjective. They want it to be emotional.

When I was a kid I was going to be a painter, and I remember when I was in art school learning a technique that looked at drawing on the right side of the brain which had to do with segregating and mixing the logical and the purely creative parts of your mind in order to get your voice out and to do

continued overleaf

the low-end rumbles and eerie creaks that you might find in a horror movie trailer. These rumbles have no visible motivation, but they do make the viewer feel a sense of obscure dread. In fact, these kinds of rumbles and creaks are so powerful that they can terrify us even when they are below the threshold of human hearing (about 20 Hz). Sounds beneath this level are referred to as "infrasounds" and studies have shown that they can cause feelings of fear in animals and humans alike (infrasounds in nature are often caused by natural disasters such as earthquakes, tsunamis, and avalanches, and scientists have speculated that when they see instances where animals are behaving strangely before one of these events – such as they did during the 2004 Indian Ocean tsunami when they began fleeing the area hours before water struck land – it is because they are hearing infrasounds that indicate that a large event is occurring). This fact has not gone unnoticed by sound effects designers, as many a film trailer has a plethora of low-end rumbles and whooshes that aren't fully audible but that serve to disorient and disturb the viewer.

Non-diegetic sounds can also be useful **in an informational sense**. An example of this might be a commercial for a cleaning detergent where you have a Mom debating the merits of two competing products. As she gets information supporting the purchase of Detergent A rather than Detergent B, the sound designer might signal that our Mom has made her decision by introducing a sound effect, such as the ding of a bell, that says, "oh, I get it now." In a case like this, the sound effect lets the audience know that a decision has been made and that the character has

figured something out. What is so great about using sound effects in this way is that you can say a lot in very little time. So, rather than having to spend three seconds showing or verbally explaining that the character has made up her mind, a simple sound effect coupled with a small amount of visual information can do all of that work. In this way, non-diegetic sound effects can be used as little accent notes that comment on the action on screen and lead the viewer to whatever conclusions the creative team wants to lead them to.

Now, despite the fact that I am using the conventional scheme of diegetic and non-diegetic, it should be noted that there are sound effects that are a blend of both categories and can't easily be called one or the other. For example, imagine you were cutting a trailer

"non-diegetic sound effects can be used as little accent notes that comment on the action on screen"

for an action film and you had a shot of a character screaming in anguish. You could, in this scenario, start the effect as the actual scream, but then elongate it and

Image from *Knowing* trailer.

it in a technically sound way. That's really what I am doing with sound.

If you can have part of what you're crafting come from something very familiar, like nature for instance, and you can turn it and morph it into something that doesn't sound like nature at all but seems really exciting and futuristic, then you've got something special there.

Bryan Cook: One of the things about sound design that I think is so cool is how it can subtly signal to the audience the emotional stakes of a scene. The audience doesn't know what you're doing to them, but on the sound track you are signaling to them what's really going on emotionally even if the visuals don't necessarily contain that information. Can you speak to that a little bit?

Bryan Jerden: This is a bit of a cliché to say, but the ballsiest thing you can do as a sound designer is to go to silence. If you have a big sound track going and then you go to silence, the gravity of that moment is massive. When all the sound goes away you are just zeroed in on the mind of the character; on what's going through his head at that time.

Making moves like that in order to draw in the audience is what sound design is all about. Sometimes it is about using some funky little thing you wouldn't even believe *is* the thing. For example, when I'm sound designing an explosion I almost never use an actual explosion. The sounds I do use are completely abstract. I have learned over the years that by putting particular elements together it reads as if it is an insane explosion better than any real explosion you can put in. That to me is at the true heart of sound design.

Bryan Cook: What is the one question you always end up asking yourself while working on any piece?

Bryan Jerden: I think the question from a creative standpoint is what is it not only that I want to convey, but what is it going to take to convey that message? What is the combination of correct inspirations? How do I inspire myself to inspire the audience? I guess it really just boils down to that question of "what's it going to take to make the audience connect with the thing I am trying to say?" That's the thing I ask myself in every trailer I work on.

The last two days I have been working on the *Mad Max* trailers and they have been great. One of the pieces is a sixty-second cut-down that's going to be an international TV spot that is scored with a pop song. The music was the thing right, and so I had to figure out the approach that's really going

continued overleaf

add a number of other elements so that the scream could then be made to function as rise which takes the story from one section to another. In this instance, what you would have is a hybrid where you get the value of both categories, as well as a way of increasing the amount of information being imparted (i.e., by elongating and manipulating the scream it functions as a transitional element as well as becoming a way of signaling to the audience the pathos of the situation for the character who is experiencing it).

In order to see all this play out and show how important sound effects have become to short form content, I want to take a quick look at a trailer for the Nicholas Cage vehicle *Knowing*. The film is a forgettable one – the premise is that Nicholas Cage's character, a science professor named John Koestler, discovers, and then tries to understand, a document whose mathematical code has the power to predict the time and location of all major global disasters – but the trailer is well executed, particularly on the sound design level.

The trailer starts out simply, as we are introduced to the main characters with a few quick scenes scored by an emotionally neutral piano piece. Then, when the story picks up pace and we first see the document with the mathematical code, we begin to get a lot of activity on the sound track. The document has been retrieved out of a time capsule, and as John Koestler's young son Caleb unfolds it and tries to make out what it means, the music cuts out – a rise and a hit allow it to do so fluidly – and we start to hear the sounds of people fearfully whispering words we can't make out

as scraping metal sounds and creepy creaks supply a low-end bed. It is at this moment that we first see one of the "mystery men" – characters who might or might not be dead but who are certainly menacing and scary – and the whispering seems to be connected to him.

We then get our first title – "There is a pattern to predicting the future" – which is brought on by another rise/hit combination and accompanied by some musical notes and atonal, scraping noises that enhance the sense of fear and suspense. At the conclusion of the title, which ends when we get a small design moment where the text flickers a bit, we also get a sound effect that motivates the flicker (the sound effect is a quick digital stutter that would, in my admittedly unconventional scheme, be diegetic).

The trailer then really picks up steam, as we get the premise of the film and watch as John starts to unravel the mystery. There are two main parts to this, the first being a sequence where John explains the document to one of his colleagues and the second being a sequence involving a horrific subway accident that confirms the prophetic power of the list. For the first part, the sound design has to do a lot of work, as John's explanation to his colleague is inter-cut with a complicated little montage that shows him examining the document in his home office while we get a succession of images featuring global disasters. The success of this sequence is entirely dependent on the sound effects track, as all of these quick moments have to be driven by sound effects that either motivate a cut, accent an idea, fill in a pause in the dialogue, or add to the suspense. There

One of the Mystery Men from *Knowing*.

to take it to this level of energy where the emotion is. It was tricky though as everything I threw at it that was noise based wasn't working because the music was the thing; anything noisy just sounded like noise. But what ended up working was using the human voice, and so I started adding these little distorted voice elements that were sweeping across the screen. There is something about the human voice where we are drawn to it very easily and so those voice elements were able to cut through the music without drowning it out. Once I started playing with these voice elements I had found the thing, and all of a sudden I was completely connected and inspired and then I shaped the rest of the trailer around it.

Bryan Cook: You found the key basically.

Bryan Jerden: Yeah, you go looking for it and it's really hard, sometimes it is harder than other times, especially if it's something you have never seen before. Some movies look a lot like other movies and sometimes one comes along like *Mad Max,* and you're like, "wow that's totally different," and your approach has to be different with it.

At the end of the day, the "not good enough" part is the thing you bang on. I am not happy until a trailer sings. It has got to sing for me. It is like a song that builds and builds and builds and then it holds this energy and I am not happy until it does so.

Bryan Cook: It's funny, as I have been listening to you, it almost sounds like you are saying that you are talking to the audience through the sound design.

Bryan Jerden: That's absolutely correct. I live off of the aural aspect of life. It could be a bird going overhead. It could be a helicopter going through the canyon. Sometimes I will be sitting at Starbucks and two cars will pull up playing two different songs but they're in the same key. I am keenly aware of the attributes of sound and I try and relay that to the audience. A woman's scream, you can make it so it's barely even there – where it's almost unrecognizable – but a woman's scream catches your attention.

When you really start breaking sound down at the level that I break it down at, when you realize that "oh this bird is basically that alarm," you can create a soundscape from it that strikes that cord. It puts people in that place. When I am seeing the visuals of a trailer, those visuals inspire me to think on a sonic level and then I am trying to take those feelings and put them into the theater to strike a cord with the audience.

are too many nice little moments to catalog them all – in particular, there is a great low-end whoosh when Cage's character realizes what is happening and turns his head back towards his computer – but the thing to realize is that without the robust sound effects track there wouldn't be any sense that something ominous was going on nor would the editor have been able to elegantly make the quick transitions and narrative leaps he pulls off.

The second part of the sequence is when we get confirmation that the document actually has prophetic powers, as John goes to the location that the document calls out and witnesses a dramatic accident between two subway cars. This scene is absent of music, as instead the sound designer plays with a mix of diegetic and non-diegetic sounds by manipulating sounds that you would hear in a subway car – rumbling, screeching of metal brakes, the closing of the subway door – in order to make them menacing and suspenseful. Although many of these sounds are recognizably "of the environment," they either occur at times that aren't accurate in a realistic sense or are so digitally manipulated that they induce an entirely new sensation in the viewer. The accident between the two subway cars which concludes this section is accompanied by the sounds of the cars smashing into one another and driven by a large rise that leads us into a hard-cut to black that is itself scored with an anvil hit whose reverb drives us into the next section.

In terms of our ending, rather than scoring it with a driving musical score, the creative team does something interesting. They still go for a big crescendo,

but to do so they use the sound of an Emergency Broadcast Signal (EBS). So, the ending begins with three dips to black and shots of chaos and destruction whose cut points are timed with the beeps of the EBS. Then, after the three beeps, we get a line of voice-over that says "This is not a test …" We then get three more beeps, and three more shots separated by dips to black, and we get the completion of the voice-over "… this is an emergency broadcast transmission." During the voice-over – which is digitally altered to sound like a computer is speaking – the sound designer cuts out the EBS beeps which then allows him, once he clears the second line, to radically speed up the pacing of the beeps. Now that the beeps are coming much quicker in succession, the editor can start using straight, quick cuts to add adrenaline and pace and he gives himself even more assistance in this effort by adding in a rise that starts heightening the tension to the level he needs to conclude the piece. The whole section culminates in a large anvil hit and we end on a quiet exchange

Images from *Knowing* trailer.

between Cage's character and his son followed by the logo, which is sound designed with some eerie low-end drones and glitches.

The trailer is only about two minutes long, but it is full of diegetic and non-diegetic elements that push the narrative forward, accent ideas, smooth spatial and temporal leaps, motivate individual edits, and add psychological intensity. And all of this magical stuff happens without the audience ever being consciously aware of what is going on in the audio track. This is true power, as besides color correction, it is hard to think of any other weapon in the short form content creator's arsenal that can add so much to a piece without the audience being aware of its existence. As we have touched on throughout this book, one of our goals as short form content creators is to emotionally impact the viewer without them feeling as if they are being manipulated. Sound design's ability to do this, coupled with how it enables major shifts in tone and time and space, is why it has become such a crucial part of the short form landscape.

1 Stephen Altobello, "Wilhelm." Transcript from *On The Media* (December 30, 2005). http://www.onthemedia.org/story/132618-the-wilhelm/transcript, accessed August 6, 2015.
2 Michel Chion, *Audio-Vision: Sound on Screen* (New York: Columbia University Press, 1994), xviii.

Sculpting the Image:
Effects and Finishing

An author in his work must be like God in the universe, present everywhere and visible nowhere.
Gustave Flaubert, *Letter to Madame Louise Colet*

A star wipe is a wipe that takes the shape of a growing or shrinking star, and is used to impart a sense of "extra specialness" or "added value" to an edit.
Wikipedia

Consider for a moment the lowly star wipe. Besides wondering why the star wipe is still included in the effects bundles of leading NLE software packages – Are there foreign countries where the star wipe is still seen as a valid editorial choice? Are there a surprising number of second grade girls who like to make videos about theater camp and also know how to use professional editing software? – what is it about the star wipe that makes it such a comical device? Why, to put it simply, is the star wipe universally seen as a "bad" effect?

Well, the first problem with the star wipe is how didactic it is. The star wipe imparts, as Wikipedia puts it in the epigraph, "extra specialness" to an edit, by invoking analogies we make between stars and "specialness." So, if you had a montage of a singer who is getting ready for her Broadway debut, and you used the star wipe to go from edit to edit, what you would be saying is "this woman is special and going to be a star." The issue with this is that by inserting the star wipe into the montage, you would be editorializing an opinion that viewers should be forming on their own. If viewers see the montage without the star wipe

> *" . . . viewers don't want to be told things, as instead they want to form conclusions on their own."*

and take in how hard the woman is working and how much she is improving, the conclusion they will come to if the piece is cut correctly is, "as a result of her hardwork, perseverance and talent, this woman is going to be a star." By inserting the star wipe, the editor is *telling* viewers that the singer is going to be a star and, as we discussed earlier, viewers don't want to be told things, as instead they want to form conclusions on their own. In this way, the star wipe is analogous to a writer of bad, genre fiction who keeps telling you how evil the villain is rather than developing the character enough to allow the reader to come up with her own ethical assessment.

The second issue with the star wipe is that it isn't grounded in how we perceive the world. As we discussed in Chapter 2, one of film's great strengths is that it takes advantage of how we process the world visually in order to get information across quickly and evoke an emotional response. Effects follow the same logic, and effects that work well, such as a dip to black or a speed-change, work well because they resemble visual phenomena from our everyday lives (the dip to black has an obvious analog in how humans sleep, and it is quite common to hear people discuss

a traumatic or intense experience by commenting on how it seemed that "everything was in slow-motion"). The star wipe, on the other hand, has no resemblance to anything we experience in our daily lives, as unless you were on a strong narcotic that I would very much try to avoid in the future, the world will never be forming in the shape of a star that is slowly advancing towards you. This is one of the reasons the effect seems so odd, as its lack of resemblance to anything in our world strips it of any emotional resonance. This lack of resemblance to anything we experience in our daily lives is also why it is impossible to animate a star wipe in a convincing way. A lens flare, for example, has a connection to visual artifacts we experience in the world, which is why we can animate them in a way that seems "correct" and helps to not call attention to the fact that there is an effect present. Since stars don't slowly creep towards us (and, let's be honest, stars don't look like that either), successfully animating a star wipe becomes impossible, as what would the physics of that even look like?

The third issue with the star wipe is that it forces the brain to make an interpretive step and thus pulls the viewer out of the story. There the viewer is happily immersed in your fictional world, and suddenly they are asking themselves "why is the screen shaped like a third-grader's drawing of a star? Am I supposed to think something about this star? Is this some sort of metaphor or pun; gosh I hate metaphors and puns." Basically, the interpretive process triggered by the introduction of the star wipe causes the viewer to suddenly come face to face with the creators of the work they were previously enjoying. In other words, since the star wipe is making a comment on the action that is being shown, it pulls attention away from the story and towards the perceived source of the comment. Of course, *all* creative choices that are perceived negatively inevitably call attention to themselves – "that actor is so horrible he must have slept with the producer to get the gig" – but the star wipe takes this a step further, as it is not only a bad creative choice, but one that seems to have some sort of analytic component.

So, the star wipe is "bad" because it is didactic, rips the viewer out of the narrative, and has no resemblance or connection to anything we experience in our daily lives (it is also tacky and ugly but that goes without saying). But, what about all the other options we have for modifying the image? Also, given that there are an infinite number of ways we can affect things on the visual plane – a simple click of the mouse can give us dissolves, speed-changes, lens flares, glitches, split-screens, and anything else that we can come up with – is there even a way to systematically approach these sorts of image modifications? I think the answer to this question is yes, but first we must spend a moment narrowing the field, as the topic of visual effects and image modifications is broad enough that it could make analysis impossible.

For starters, I am going to focus entirely on effects that are visible and have an explicit creative motivation, i.e., effects such as image stabilization and wire removal, where the modification is supposed to be invisible and the objective of the modification is to "fix" something, will be ignored. This is not to

> *By dealing with effects as secondary attributes of the overall image, I am approaching them like modifiers in language…*

denigrate the artistry involved with this sort of image correction, as there is a huge amount of creative and technical prowess that goes into it, but, if done properly, this work is supposed to be invisible, which makes it a bit tricky to analyze.

Next, the things I am calling "effects" are secondary attributes of the image that share the visual plane with other, more primary imagery. In Chapter 2 we looked at things such as CGI, which might ordinarily fall within the scope of an examination of effects, but, for my purposes, I want to treat this sort of visual information as an actual image despite the fact that it was not created in the traditional way with a camera. In other words, the way in which an effect or image is created is irrelevant to me, as CGI can be a primary image and an "effect" can actually be something which was captured in camera and then modified (e.g., if you captured some light leaks in camera and then placed them over your footage with a transfer mode to affect the way the footage looked, I am regarding the light

leaks as an effect). By dealing with effects as secondary attributes of the overall image, I am approaching them like modifiers in language, as just like modifiers, effects will be treated as descriptors which alter the meaning of a noun or other part of speech without being imperative to the grammatical structure or basic meaning of the statement (e.g., in the sentence "Kathy is a tall woman," the adjective "tall" modifies the noun "woman" but if we remove "tall" we still end up with a statement that is grammatically sound and has the same basic meaning). To take an example of how effects function in this manner, imagine a car commercial where you take a shot of a car barreling through the salt flats and put it in fast motion, then what you would be doing here is changing the statement "there is a car in the salt flats" to "there is a *fast* car in the salt flats." So, the effect modifies the original statement, but with or without the effect the shot has the same basic meaning.

Lastly, rather than trying to create a rigorous taxonomy of filmic effects – a task which would be impossible as the list is infinite due to all the ways effects can be combined – I want to approach the topic from the perspective of how we tend to creatively *use* effects, as I believe looking at it this way will allow us to somewhat systematically approach the subject. Let's begin.

It seems to me that there are four main ways that effects and image modifications tend to be utilized creatively (obviously one effect can often be utilized in multiple ways simultaneously, but it is rare to see an effect used in a piece of short form content that doesn't fulfill *any* of the functions I am about to break out). The first, and most problematic, use of effects is **to hide**

or obscure something "wrong" with the image or the edit point. Examples of this could be anything from a dissolve to a lens flare, but the basic idea here would be using an effect to hide something in the visual plane or narrative that is otherwise awkward.

The second use of effects is to deploy them **as a means of transmitting factual information.** Examples of this would be a blur effect that indicates that a character is about to enter into a different reality (a hallucination perhaps), or the use of scratches and other filmic artifacts to make the footage look "old" in order to indicate that a piece is set in the past.

The third way effects are utilized is **to offer insight into the emotions or thoughts of a character.** This concept can be a little trickier than the previous ones, but a good example would be if the creative team took a POV shoot and added a blur around the edge of the frame to indicate that the character whose POV we were assuming is having a strong emotional response to that which he is taking in (perhaps it is his wife folding laundry and it triggers some association to an image from his past).

The fourth and final way that effects are used is **to create a stylistic vocabulary that communicates something about the story/product as a whole.** An example of this would be a commercial for a car company that uses light leaks, flash frames, and fast motion to indicate the speed of their automobile. This use of effects is an amalgamation of our second and third categories of effects as it is a way of giving factual information ("the automobile in front of you is fast and sexy") that leans not on language but on the way in which filmic

> **The thought behind using effects to obscure problematic moments . . . is to distract the audience with the effect so that they ignore the underlying issue.**

content can make you think something by making you feel something ("the way we are using effects will indicate and engender feelings of speed and desire and thus make you associate the object featured within the frame with those concepts").

Using Effects to Obscure a Problem

There are any number of effects that will be called upon for this purpose – wind-blurs, glow effects, lens flares, etc. – but all of them will generally be put on top of the image or edit point to distract the viewer from some sort of issue, such as a continuity problem, unexplained temporal/spatial leap, or awkward edit, that might otherwise disrupt the narrative. The

thought behind using effects to obscure problematic moments such as these is to distract the audience with the effect so that they ignore the underlying issue (it is analogous to how a magician will do something with their right hand – wave a handkerchief, tap repeatedly with a wand – so that the audience will ignore their left hand which is actually doing whatever is necessary to make the trick work).

The reason effects can be useful in this way is a result of how our eyes works. To put it very crudely, the eye is always doing two things at the same time. "Focal Vision" is concerned with object recognition and is the kind of seeing we do when we are paying attention to something, e.g., the way we look at the words we read and the road ahead of us as we drive. When a person tells you to look at something, they are telling you to consciously direct your focal vision to receive whatever sensory input they think you need to receive. The other activity that the eye is constantly engaged in is called "Ambient Vision." Ambient vision takes place at the periphery of our visual field and it is concerned with spatial orientation and picking up cues of motion and color. Ambient vision is generally not a conscious process, and one of its objectives is to keep a look out for anything that might cause us trouble, such as bushes moving in a way that would indicate the presence of a predator. Of course ambient vision and focal vision are constantly interacting with each other. For example, when you are reading and your attention is suddenly grabbed by a bug flying about in the lamp above your head, that would be an example of the interplay between ambient and focal vision.

The dual nature of our visual system is what makes effects so good at obscuring problems with the image, as what the editor is doing when she places a lens flare on a problematic cut point is using the viewer's ambient vision to draw their focal vision away from that which it was paying attention to. For example, let's imagine a creative team cutting a commercial with an edit point that contains an egregious continuity error where the main character suddenly goes from wearing a hat to not wearing a hat. After exploring all other options, the editor realizes that she will just have to bite the bullet and make the cut. So, rather than just doing a straight edit where the continuity error would be incredibly obvious, the editor might add some effect to help distract the viewer; let's imagine a twelve-frame glow effect where the effect starts at 0 percent opacity, reaches 100 percent opacity six frames in (at the cut point), and then is back down to 0 percent by the twelfth frame. What the effect would hopefully do is distract the viewer's focal vision from that which it was observing – the character whose hat is about to go missing – by getting them to focus their attention on the glow. By doing this, the editor might just be able to get away with the continuity error, or, at least, have a better chance of it.

> **The dual nature of our visual system is what makes effects so good at obscuring problems with the image . . .**

Now, in a situation as bleak as the one in the paragraph above, one can't blame the creative team for being a little desperate, but it is a bit frustrating when short form content creators overuse effects in order to distract viewers from boring imagery or a stunted narrative. Although I always get a little uneasy about judging people for this issue, as tight timelines and limited budgets have a way of forcing your hand in this regard, the overuse of effects usually points to something having gone awry with the piece as a whole. As short form content creators, our relationship with the viewer should be grounded in trust and mutual respect, and when we toss a bunch of effects about in an attempt to obscure narrative issues by dazzling the reptilian part of the brain, we violate this pact. As W.H. Auden put it, "In art as in life, bad manners, not to be confused with a deliberate attempt to cause offence, are the consequence of an over-concern with one's own ego and a lack of consideration for (and knowledge of) others. Readers, like friends, must not be shouted at or treated with brash familiarity. Youth may be forgiven when it is brash and noisy, but this does not mean that brashness and noise are virtues."[1] And this is the crux of the problem with overusing effects, as it points to a dysfunctional conversational style that is, well, kind of rude. When the viewer shows you the courtesy of watching your piece, it is incumbent on you as the short form content creator to show them the respect of speaking to them in a thoughtful, considerate way.

> *"the overuse of effects usually points to something having gone awry with the piece as a whole."*

Effects as a Means of Transmitting Factual Information

At the birth of the medium, and for a long time afterwards, effects were used by filmmakers as a way of asserting factual information. For example, a dip to black was used to indicate "a period of time is elapsing between the outgoing and incoming shot." Or, a fantasy sequence might have been preceded by a three-second effect where the image would smear and warp in a way that indicated "this character is about to enter a different reality."

Now, the use of effects has clearly evolved throughout the history of cinema, as these days, thankfully, you will rarely see a three-second effect being used to indicate a reality shift. The reason why content creators have become less reliant on effects for this sort of information transmission is that there has been a gradual realization that the information provided by the narrative *itself* will usually be sufficient. For example, why use a superimposed image of the pages of a calendar fluttering away to indicate the passage of time when a straight cut from a young version of a character to an older but still recognizable version of that same character will be easy enough for the audience to understand if other contextual and narrative cues help support the moment? As Messaris puts it, "the tendency to eliminate explicit explanatory devices amounts to a progressive shifting

of the burden of explanation away from the transition itself and onto the context."[2] This evolution in how we use effects has actually been proven, as the academic John Carey looked at ten commercial features from the 1920s through the 1970s and found that the average duration of space/time transitions went from over six seconds in the 1920s to less than half a second by the 1970s. As Carey's research indicated, filmmakers gradually realized that if audiences received proper contextual cues, they didn't need the extra level of explanation offered by something like a slow dissolve or a shot of calendar pages flying away.

Despite this evolution, in short form you still see effects used as a means of transmitting information. There are a couple of reasons for this, but I think the main one is that with short form work you often have much less context to work with than you do in long form. For example, imagine a thirty-second spot where the main character takes a sip of his soda and is instantly transported to a fantasy world where he is a rock star on stage in front of thousands of fans. Now, there will be an abundance of contextual cues to help the audience understand this transformation – the shift from a drab office to a brightly lit stage and the look of amazement on the character's face as he stares down at the can of soda would probably be enough to let the audience understand "as a result of drinking PepUp soda, Ordinary Joe was transported to a rock concert where he was the star" – but the creative team might decide, given that the shift takes place five seconds into the spot, that the audience needs a little help. So, they might insert some subtle, quick effect –

Image from *Dawn of the Dead* title sequence.

a wind-blur perhaps – on top of the edit to help signal "this character is undergoing a reality shift."

In a similar fashion, effects can also be useful for quickly establishing the narrative world of a piece of short form content. For example, a few years back the legendary title designer Kyle Cooper created the opening titles for the zombie film *Dawn of the Dead*. The title sequence cuts between footage of rampaging zombies, reporters giving updates on the chaos, footage of riots and general societal collapse, and titles that are animated to look like blood smearing. The piece is frenetically edited and filled with digital glitches, static, visible interlacing, compression artifacts, and other analog and digital abnormalities that occur when the transmission of data and visual information fails.

From a practical perspective, Cooper's use of these signifiers of transmission failure brings the piece together by unifying all of the footage, as the piece was clearly cobbled together using shots from the movie and stock b-roll and other scraps, and the presence of the effects on all of the footage helps tie these disparate pieces together. But, from a storytelling perspective, the use of these signifiers of transmission failure also gives

Images from *Dawn of the Dead* title sequence.

the viewer information about the narrative world, as the effects help to show us how deeply society is collapsing. One of the things we take for granted in our digital age is that there is a constant, uninterrupted, and polished transmission of information. By degrading the image with glitches and digital artifacts, Cooper is indicating that this transmission of information can no longer be taken for granted, which in turn helps the viewer see how profoundly society is imploding.

Finally, the use of these signifiers of transmission failure echoes the zombie virus itself. What I mean by this is that the zombie apocalypse, like all pandemics, is rooted in one person passing the virus to the next person until all of society is infected. In this way, the pandemic is analogous to how information moves in our digital age, as the zombie apocalypse is only possible because of the connectivity that marks our modern era (without boats and planes, the zombie apocalypse

Ending of *Dawn of the Dead* title sequence.

is one really sad continent that everyone would just avoid). By structuring his title sequence around signifiers of transmission failure, Cooper is bringing this analogy to the forefront, as the viewer can easily draw the connection between the failure of transmission and the failure of the globally connected world.

To hammer these points home, the title sequence ends on a reporter in the field giving a newscast that is interrupted by zombies bursting in and attacking him and his crew. Fittingly, the last shot we get in the sequence is of a zombie lurching into the foreground and attacking the camera. Cooper then cuts to black as the transmission feed is finally severed, thus signifying that the very fabric of our globally connected, information-based society has been destroyed.

Effects as a Means of Offering Insight into the Emotions of a Character

Effects can also be quite useful as a means of offering emotional insight into the characters being depicted.

It's not that effects can operate on their own here, as without narrative context they would be meaningless, but effects can offer a nice, complementary level of psychological intensity.

For example, imagine a music video for an all-female pop band that centers around the group taking a road trip to forget about a philandering boyfriend who broke the lead singer's heart. In the video, the girls are in a large, classic convertible cruising through the desert and engaging in the kind of antics that girl-bands get up to in music videos (splashing each other with water, giggling uncontrollably, flirting with a ludicrously attractive gas station attendant in coveralls, etc.). Now, for this piece, after talking with the client about what the video is trying to get across, the creative team might decide to lean heavily into lens flares and use them on top of the footage and at various cut points.

The first thing that the lens flares would do in this situation is to add to the intimacy of the piece by taking advantage of the way lens flares, because they are a cinematic "mistake," are a signifier of the authentic. This is the same logic that goes into shooting a piece entirely with hand-held cameras, as what lens

flares do in a situation like this is to signal to the audience that what they are watching is somehow "real." This emphasis on the real in turn indicates something about the emotional position of the characters, as it shows how the journey they are on, and their friendship with one another, is authentic.

The second thing that lens flares will do for the video is to reinforce the sense of liberation that the lead singer feels at finally being free of the callow Casanova who has broken her heart. They do so by bringing the concept of "light" – with all that that concept evokes in terms of emancipation, freedom, etc. – to the forefront of the visual plane. Light makes us *feel* a certain way, and using lens flares engenders the same sense of emancipation and emotional lift that the protagonist is feeling in the viewer.

Effects can be highly effective when used in this way, as they can be a great, unobtrusive means of letting the viewer into the emotional space of the characters. Of course, effects can function on both an emotional *and* a factual plane, with the emotional plane offering some real motivation to the factual cues.

In order to see this in action imagine a trailer for a movie about an alcoholic writer who travels from New York to Las Vegas for one last shot at his fortune (let's call this film *Ace of Spades*). Now, the editor knows that the producers wants a sequence that depicts the character's actual journey, as they want to get across not just that the man went from New York to Las Vegas, but that there was a journey to do too. But, the editor also knows that screen time is at a premium, so the question he would ask himself is "how do I move quickly

through this series of vignettes in such a way that I show that a period of time between each vignette is elapsing while also getting across the emotional status of the protagonist during the journey itself?" By doing this, the editor would hopefully figure out the best way to make a factual assertion about time and space while also offering emotional insight into his character.

The first option might be to simply use a series of dissolves. So, perhaps we have three quick shots of the man downing drinks in a bar in Pittsburgh, which then dissolves into two shots of the man drinking alone in a motel room in Cincinnati, which then dissolves into the man barreling down the freeway past a sign for St Louis. Now, what the dissolves would do would be to (a) indicate that some amount of time has elapsed between these various spatial locations and (b) make the viewer recognize something about the emotional status of the protagonist as he is moving through these spatial/temporal coordinates. Perhaps the dissolves, by virtue of how they are blending the outgoing and incoming destinations, makes the viewer aware of how each destination "is the same" as that which has come before it due to the protagonist's constant status as an outsider. Perhaps the way in which the dissolves blend outgoing and incoming destinations makes you aware of the protagonist's isolation. In any case, the dissolves will make the viewer feel *something*.

Now imagine another choice, this time a dip to black between each destination that contains the same factual information – time is passing between each destination – but with a much different emotive content. Unlike with the dissolves, the dips to black

don't blend the outgoing and incoming destinations together, but instead offer a clear rupture between each section; this rupture in turn contains some emotional insights. Perhaps the rupture between each sequence makes the viewer feel the protagonist's sense of isolation by highlighting the fragmented nature of the journey. Perhaps the dips to black make the viewer feel a sense of the void at the core of the character by highlighting his drinking (the dips to black function as a visual analog of the "black-outs" that accompany his excessive alcohol consumption). In any case, they will definitely make the viewer feel very different than a series of dissolves would.

Finally, imagine that rather than dissolves or dips to blacks, the editor uses jump-cuts with a flash frame – one frame of white – to separate each quick sequence. In this case what you would get is the same idea that time is passing between each location, but with a much different emotional feel. So, while the dissolves might induce a languorous feeling, the jump-cuts with flash frames might give a frenetic, disjointed feel that would give the whole experience a much different tone. Perhaps this frenetic quality would give the viewer a sense of the protagonist's heightened and manic emotional state. Perhaps this treatment would lead to the whole trip seeming much faster, thus accentuating the determination the character has to reach his destination.

"The last way of using effects that I want to examine is the use of effects to create a stylistic vocabulary . . . "

What you can see is that while all of the options would give roughly the same piece of factual information – time is passing between each scene – they would give very different information about the emotional state of the character.

Effects as a Way of Creating a Stylistic Vocabulary

The last way of using effects that I want to examine is the use of effects to create a stylistic vocabulary that gets across something about the narrative or product without necessarily being tied to the characters. This can be seen most clearly in TV commercials, which will often have an elaborate vocabulary of effects that they will utilize in order to make some sort of assertion about the product being featured (that it is modern, youthful, premium, etc.).

This use of effects is common with many products but none more so than car commercials. Car commercials are a curious category. There is a lot of money spent on them, but, at the end of the day, trying to keep a car commercial from looking and feeling like every other car commercial can be a difficult thing. The basic issue is that car companies, understandably, want to show their cars looking beautiful and performing at a high level. But, the problem is, every other car

manufacturer wants to do the same thing, and so the issue that anyone involved with making a car commercial deals with is how do you make a spot that shows cars driving around looking beautiful and performing aggressively without making a commercial that hasn't been seen ten thousand times before? After all, how many times can you depict cars cruising through the LA streets at night or barreling through salt flats before you start boring people?

Well, one of the ways the ad agencies who work for car companies attempt to make their spots stand out is to create elaborate visual vocabularies that attempt to differentiate their ad from every other car spot, while simultaneously asserting something unique about the brand. So, Cadillac might decide that the thing to do is make ads filled with light effects in order to get across the speed and power of their new line. Lincoln, on the other hand, might lean into a technique which features undulating, digital lines moving over sheet metal that is meant to lead the viewer to make a connection between the Lincoln brand and technological sophistication.

On the one hand this can read as a shallow attempt to simply look different enough to get people to pay attention. But, it also is a way to solve the basic problem presented above, which is how do you show cars performing aggressively – which as we know has been shown ten thousand times before – while still asserting something unique about the brand? This idea ties into a point that Roland Barthes makes about photography in general. As he says in *The Grain of the Voice*:

" . . . it is paradoxically through style, and through style alone, that photographs are language. "

To call photography a language is both true and false. It's false, in the literal sense, because the photographic image is an analogical reproduction of reality, and as such it includes no discontinuous element that could be called sign; there is literally no equivalent of a word or letter in a photograph. But the statement is true insofar as the composition and style of a photo function as a secondary message that tells us about the reality depicted and the photographer himself; this is connotation, *which is language. Photographs always connote something different from what they show on the plane of* denotation; *it is paradoxically through style, and through style alone, that photographs are language.*[3]

I think this sums up the way short form utilizes effects quite well, as now we can start to view effects as being an extra level of connotation which short form content creators add to the purely representational plane in order to make assertions about that which is being depicted. It is a way for short form content creators to say to the viewer "this product that you are watching possesses the values X, Y, and Z," with X, Y, and

Z being whatever adjectives and attitudes the agency and brand stewards want to have associated with their product.

So, as we have seen, effects can function in a variety of ways for short form content creators. Let's now look at a piece of short form content that uses effects quite successfully. The piece is a spot for the Jaguar XKR-S that was edited by Neil Gust. Gust has become celebrated over the past few years for his work on car commercials, as he has a unique, design-driven style that is much imitated but rarely equaled.

The piece opens with a quick, two-frame sequence featuring off-center, distorted type reading "Jaguar." The audio is a brief hit of tone like you would hear on the "2-Pop" that precedes content that is being sent out for broadcast. Although there is no way to make sense of the text or the audio as of yet, the moment serves a valuable function by immediately establishing the overall

Images from "Jaguar XKR-S" commercial.

strategy for the spot, which is to combine a laborious, design-centered style with signifiers commonly associated with "real" content such as documentaries.

The spot then moves into a sequence involving a radio tower rotating and a hand-held, off-axis shot of the salt flats with digital lines radiating outwards. The audio track features a drone, sonar pulses, and the sound of men talking over a radio as if preparing for a rocket launch (the sequence ends when the voice that is supposed to be ground-control says "ignition.") The sequence is intercut with quick, one-frame shots of the grill of the car, design elements, and distorted type that says Jaguar and the car model. Besides connecting the car with a rocket launch – with everything that means about engineering and power – Gust is continuing to juxtapose a design-heavy style with visual cues we associate with documentaries (for example, the lines radiating outwards on the salt flats are clearly generated in post and the sand itself is absolute white in a way not found in nature, yet the camera is moving around in a jittery and haphazard looking way). By now we have also been introduced to the color palette of the spot, a color palette that is restricted to green/blue, black, and white. The use of such a restricted color palette is important, as limiting the visual field in this area allows all the other design elements to be absorbed (if the color palette was more inclusive, the viewer would end up just being overwhelmed: by limiting this one element of the visual plane, the spot buys itself the space to play with everything else).

The music then kicks in – a raw, garage-style track by The Jon Spencer Blues Explosion – and we see the

Neil Gust on editing the "Jaguar XKR-S" commercial

Neil Gust is a New York based editor and sound designer who has worked on everything from commercials to network identity pieces. He has won numerous awards for his work, including the 2009 AICE Award for his work on Jaguar.

Bryan Cook: You've done a lot of work in automotive throughout your career. What is it about your style and approach that lends itself so well to that category?

Neil Gust: Cars are the biggest impulse purchase you can make that's advertised. The only bigger purchase you can make is real estate but that's not on TV. When a car company wants to make something visceral about a car it dovetails nicely with my interests in making short, visceral things that you want to see over and over and over again, in the way you want to hear a song over and over and over again. The things that I like to make are like songs. That's my background. That's what I want films to do. The first thing I want someone to say when they see my stuff is, "I want to see it again."

Bryan Cook: Talk a little bit more about making filmic content that feels like a song. That's interesting to me.

Neil Gust: I love music. I listen to records over and over and over again. I find that very pleasurable. I just want to feel like that when I see something. If you see a commercial, and you're like, "I never need to see that again," because it spells everything out and it's so f-ing slow and treats you like an infant in the way that you absorb information, that defeats the point of putting something on that is supposed to repeat. If you're trying to get people's attention in this space, where they are programmed to not pay attention, you have to approach it in a way so that people want to see it over and over again.

That's the thing I care about. I don't have much interest in doing long form things. The shorter the better. The piece I just did is two minutes long and it's the most I ever want to do. I'm always trying to create these formal relationships within a spot that have a seamless, friction-less, feel, like music, and that is just harder with longer stuff. I want to make things that have a rhythm and that dance and have melody and harmony and rhyming. Shots can rhyme across shots. There's

continued overleaf

formal relationships that carry. Not just the cuts that are next to each other, but the cuts that come two shots down.

Bryan Cook: One of the things I really like about your stuff is how hard you work at your moments of transition. For example, in the Jaguar XKR-S spot you did a few years back, you and the team you were working with took the time to roto the car out when you transitioned from day to night, which really makes that transition smooth and impactful. Can you speak to this?

Neil Gust: I cannot take credit for the idea of rotoing the car or creating those graphics like that. Johnson+Wolverton, that's Hal and Alicia. They make that stuff, they decide that stuff, they were the creative directors. They are absolutely brilliant.

But yes, everything has to have a reason. If there's a logic to it, it'll communicate its message in a way that doesn't have to be so overt. You don't need voice-over then. If your visual decisions are based on the logic of the spot and the message that you're delivering, you can scale back how much you have to beat someone over the head and you can just dance.

Bryan Cook: One of the things I like about that spot is how you and the team you were working with combined a laborious, design-centered style with signifiers that I associate with "real" content such as documentaries. I don't know if that was an explicit choice but it's definitely the thing I get out of it.

Neil Gust: The way that Hal and Alicia work. When we were doing Jaguar, they would do these massive shoots. They would have a director but *everybody* on f-ing set had a camera. Everybody had to sign disclosures that they might end up in the spot. When Hal's on site, he's got his Red camera or his Canon camera and his designers are there with cameras. Everyone has a camera. You get different points of view that you can cut to and it makes it feel like there is an epic scale to what's going on. It's all these points of view. When you're shifting the point of view, it just breaks open the size of what you're seeing.

Bryan Cook: In that spot, there's a really brief moment where, for about twenty frames, you cut to the perspective of the driver, a long-haired guy with sunglasses on. That moment, to me, serves a lot of functions in the spot. If you remember that moment and how it got in there, what was the thought behind, all of a sudden, giving us that brief glimpse of the driver?

car for the first time. The car is framed diagonally and it is moving through a space that is more graphic than real as it rapidly drives down a road flanked by pure white. Despite being in this artificial, graphic space, the camera still has an organic quality to it, as it shakes and shimmies as if being hand-held. We then are hurled into a briskly cut montage where the car moves in and out of frame and is never fully centered in the middle of the screen. By combining quick cuts and off-kilter framing, Gust is subtly insinuating that the car is impossible to box in. By violating the car commercial norm of having the car centered and completely in frame so the viewer can clearly see every detail, Gust paints a picture of a vehicle that is, like its namesake, so fast as to make even filming it difficult. We also can now start to see the payoff of combining a design-heavy style with visual elements associated with

Images from "Jaguar XKR-S" commercial.

documentaries, as the contrast between the two visual languages manages to simultaneously evoke the luxurious and unique nature of the Jaguar brand while also signaling that the performance and power that we are seeing is "real" and not manufactured.

After a beat we are introduced to the only character we ever really get a good look at, which is the driver of the car, a young man – twenty-something, hip, and good looking in a slightly dissolute way – whose face we only see once and who is only on screen for about half a second. In the one shot we get of the man, his hair flies in his face as he whips around to look behind him and his body language, coupled with his appearance, clearly indicates that the man is not a professional driver. The moment is brief but important, as establishing the driver allows Gust to anchor his frantic style within someone's perspective. By giving us a glimpse of the driver we are then able to connect the imagery to the psychological experience of someone on screen. The man's gaze quickly being directed backwards also helps to subtly create a little narrative, as the viewer suddenly feels that all this frantic cutting and aggressive driving is actually a result of the driver being pursued in some vague way. It is a very loose construct as you never see another car actually following our hero vehicle, but there is a thought that is implanted in the viewer's brain that "this guy is driving fast and frenetically because he is being followed." This insight then allows you to connect with the psychology that goes into the adrenaline rush of the chase.

We then move into a very complicated montage that takes place at night and involves imagery of the car

Neil Gust: There's helicopters there. You're hearing this helicopter. There's no story to it but there's an interaction between a helicopter tracking this car and the guy driving it. It's pretty stupid but it looks like he's being chased by the helicopter. We didn't really care if you got it or not, it helped with the "Why do we have all these helicopter shots?"

Bryan Cook: What's the one or two questions that you always end up asking yourself when you're working on any piece?

Neil Gust: It's all about communication. What's the take away? How are you supposed to feel when it's done? Who is the audience? Who is the audience and how are they supposed to feel when it's done? Always, I'm hoping that the answer to that is, "I want to see it again." If you don't want to see it again then I've wasted my time.

Bryan Cook: When you're working in short form do you feel any sort of burden around the product you're advertising? In other words, how cognizant are you of the selling component of short form work, or does it not really cross your mind?

Neil Gust: I'm totally aware of it. It's the foundation of why you're there. On Jaguar I was lucky enough that it was a really cool looking thing that we're selling. You have to sell cool, you have to sell sexy, you have to sell visceral. I just want to make short form things to see that you want to see over and over again. I don't care if they're ads. I've made other kinds of films that weren't commercial at all. I like making that kind of stuff. The thing is you can do it on a scale in advertising that you can't do on your own.

Images from "Jaguar XKR-S" commercial.

intercut with footage of the crew setting up the shoot. The effects and the footage are meticulously interwoven, as Gust takes pains to connect the outgoing frame of whatever shot he is using to the three to ten frames of abstract imagery that he peppers throughout. Gust also takes care to ground his effects in elements visible on screen, as there are a few quick shots of people holding cameras, which helps motivate all the flashes and pops of lights that he scatters throughout the montage. As before, Gust is combining a meticulous design-driven style and signifiers we more commonly associate with documentaries and other content that is "real." This interplay between design and a gritty, documentary style harkens back to the end of the Barthes quote from earlier, as combining these two disparate elements creates a potent association of style and real driving prowess ("Photographs always connote something different from what they show on the plane

of *denotation*; it is paradoxically through style, and through style alone, that photographs are language.").

Finally we head into our ending, as there is a quick shot of a crewmember with her arms aloft which ushers us back into daylight. The car drives aggressively for a few more seconds and we then get our concluding title sequence which gives the make and model of the car one last time. This quick title sequence builds off the visual language of the rest of the piece, as it has a raw, frenetic quality, where each frame looks worked over by hand as if it has been shot with a camera rather than created digitally (the type has a grainy, out of focus quality, and rather than moving in a way we associate with motion graphics – which is to say seamlessly in one direction or another – it is jittery and random).

As we can see, Gust and the team he was working with have leaned heavily into our last three categories of effects usage (*Effects as a Means of Transmitting Factual Information*; *Effects as a Means of Offering Insight into the Emotions of a Character;* and *Effects as a Way of Creating a Stylistic Vocabulary*). By doing so they have taken a setup that would otherwise have been quite banal – a car driving aggressively through the salt flats is not a new concept in automotive advertising – and injected some real energy into it. The piece is fun, interesting, and makes you think about the Jaguar brand in a new way. Most importantly, the spot makes you want to engage more with the brand, as the attributes that the effects in the spot evoke (modernity, authenticity, originality) are obviously ones that many luxury car buyers aspire to.

1 W.H. Auden, *Collected Poems* (New York: Vintage International, 1991), 6.
2 Messaris, *Visual Literacy: Image, Mind, & Reality*, 19.
3 Roland Barthes, *The Grain of the Voice: Interviews 1962–1980*, trans. Linda Coverdale (Evanston: Northwestern University Press, 2009), 353.

The Mysterious Art:
Color Correction

Color is the power which directly influences the soul. Color is the keyboard, the eyes are the hammers, the soul is the piano with the strings. The artist is the hand which plays, touching one key or another, to cause vibrations in the soul.

Wassily Kandinsky, *Concerning the Spiritual in Art*

A few years back, I was chatting with my lovely mother-in-law Gunilla, when she said something that I found quite interesting. As we were discussing a mutual acquaintance, she described this individual as being "cherry red." I asked her to elaborate and she informed me that this individual had always struck her as being a "cherry red" person. Given that the individual we were discussing didn't possess a particularly ruddy hue, I was intrigued by this description and probed deeper, and when I did I discovered that nearly *everyone* in Gunilla's life was associated with some color (I was light-blue, my wife was dark-blue, my brother-in-law was purple, etc.).

This process was entirely subconscious in the sense that Gunilla didn't make any attempt to assign a color to people in her life, it was just how she understood the world (she was actually taken aback that I *didn't* do this, and it was clear from our conversation that she had never thought that this perceptual tick of hers was unusual). The assignment of a color to a person can take place at any point in Gunilla's relationship with that individual, and once a color is assigned, it rarely changes

"It might not be easy to articulate or defend, but for some reason every piece feels like it just should be a certain color palette"

(for example, it wasn't until I had been with my wife for a few years that I suddenly was light-blue and my color has not changed since then). Gunilla can't really explain *why* a person is one particular color rather than another, but once she assigns a color to a person she "sees" this color when she looks at them (I mean that literally, as although I am not a light-blue blob when she looks at me, I apparently have a slightly blue cast, almost as if I had been filmed with a filter on the lens that made me take on a blue tint).

After doing some research I figured out that my mother-in-law has a neurological condition called Synesthesia. Synesthesia is a completely benign condition in which "real information of one sense is accompanied by a perception in another sense. In addition to being involuntary, this additional perception is regarded by the synesthete as real, often outside the body, instead of imagined in the mind's eye."[1] Common manifestations of Synesthesia are people who see all numbers as being colored (1 is always red, 2 is always blue, etc.) and people who assign personalities to days or months of the year (March is happy and outgoing, December

is stern and dour, etc.). Not surprisingly, many famous artists have been Synesthetes, as heavy hitters such as Vladimir Nabokov, Duke Ellington, David Hockney, and the supplier of our epigraph Wassily Kandinsky have all supposedly had the condition.

We can't all be Synesthetes (although I wish I were as it seems like quite a lovely condition to have) but it seems safe to say that we all have a slight touch of this amazing quirk. This fact becomes obvious when you go into color correction at the end of the post process. It might not be easy to articulate or defend, but for some reason every piece feels like it just *should* be a certain color palette. Given how subjective color is, there will always be disagreements about what type of palette a piece should have, and it's no surprise that feelings tend to run strong in this stage of the process, as the way a piece is colored can radically alter its emotional tenor.

During the color correction process, there are three things that you will generally do. The first is to **balance each shot and make it look "correct."** This part of the process is all about making the film resemble reality (e.g., making an apple look like an apple and a human being look like a human being). This stage is sometimes referred to as "color correction" in contrast to "color grading" or "secondary color correction," which are the terms used to discuss the stage of color correction that deals with pushing a look into the image (I personally find this distinction confusing and won't use it in my discussion).

The second thing you will be doing during the color correction process is **manipulating the image in such a way that the viewer knows immediately what object(s) within the frame they should focus upon.** For example, imagine a scene in a crowded coffee shop where a couple is having an intimate conversation. The fact that the coffee shop is crowded is good in the sense that it heightens the reality of the scene, but it does present a comprehension challenge in that there are lots of things within the frame that could potentially distract the viewer (e.g., an unusually attractive extra who is hovering about behind the male lead, a piece of art on the wall that is intended to be a background element but that is interesting enough visually that it draws the eye). Most shots are filled with distractions such as these, and by using things such as vignettes, colorists can push the viewer's eye to the part of the frame that contains the information most relevant to the overall story.

The third element of color correction is **using color to evoke an emotional response in the viewer.** This is the most mysterious and subjective component of the color correction process, and success in this area is elusive enough that the colorists who excel at it are often minor celebrities in the post-production world. Anyone who knows the basics of color correction and can correctly interpret their video scopes can make an image look acceptable, but only the truly gifted can take an image and make it more emotionally impactful with a few turns of a dial.

Making the Shot Look "Correct" in the Sense of Resembling Reality

I was sitting around with a colorist I know having dinner one night when I asked him what he would do if he lost his ability to perceive color while in the midst of a session. Being a good friend, he answered this ridiculous hypothetical by asserting that he would immediately go and see his "eye-man" if this occurred, as this would clearly be a serious issue for his professional career (incidentally, I don't know if all colorists have "eye-men," but I hope so, as this sounds very cool). But, I wondered, what if your client on that sad day was Stephen Spielberg, who has made it clear that if you do a good job with the spot you are coloring you will then be tasked with finishing his new film. To make the logistics of this thought experiment a little easier to contemplate, I point out that despite the fact that my friend is now color blind, the one thing he has going for him is that the footage has a great look baked into it – it's Spielberg and Janusz Kaminski after all – so all he has to do is balance the image and make everything "correct" in the sense of looking enough like the world we inhabit to pass muster.

After muttering for a while about how people always simplify what he does – I think it was my comment that "all you have to do is balance the image" which elicited the most vitriol – my friend answered that he could probably pull it off. In his estimation, with just the scopes – waveform to balance blacks and whites, vectorscope to adjust saturation, RGB Parade to isolate any color casts, etc. – he could probably get the spot to a reasonably good place even if he couldn't see color. He would have to trust the scopes to a degree he wouldn't normally feel comfortable with but, as he noted, you should never entirely trust your eyes when balancing an image anyway, so although the loss of his ability to see color would be devastating in terms of creating a great look, for balancing the image, not as much.

What my friend was referring to with this talk of "never totally trusting his eyes for balancing the image," is the well-documented fact that the way our brains interpret visual information is often extremely inaccurate. Our sense of color and light can be affected by context – the well known "brightness-contrast illusion" wherein objects look brighter or darker depending on what is around them in the visual field – or by expectations based on past experience – you expect the sky to be blue and this expectation will impact how you perceive an image of the sky – or even by something as commonplace as hunger – studies have shown that human beings who are hungry tend to focus more on depictions of food than on depictions of other objects, something which could obviously wreak havoc if a colorist was finishing a spot for a fast-food restaurant where the human beings in the frame were supposed to be the main object of interest.

What all of these issues show is how frequently the brain makes a mess out of the information it receives from the eyes. The reason why is not that our brains are flawed, but rather that the brain often makes mistakes as a result of the shortcuts it relies upon to crank

through all the information it is constantly receiving. These shortcuts are great for getting you through your day and helping you to avoid getting eaten by a lion, but not so great when you are trying to make accurate assessments of the black levels on the Ford Fusion commercial you are working on. (Incidentally, issues like these are why you want to color your work with a professional colorist whenever the budget allows it, as I value the process so much that I often take money out of the editorial budget and work a few hours for free in order to get my stuff colored properly. Besides the skill and technical chops these guys and gals bring to the project, they will have a room whose lighting is designed to minimize pollution of the image, a monitor which is calibrated properly, and an awareness of the ways in which the eye can be deceived and how to best overcome these issues.)

In an attempt to avoid some of these issues, many colorists I have worked with preach the importance of quickly assessing what is wrong with an image in order to bypass the brain's attempts to "correct" what the eye is perceiving. This notion is often referred to as the "Forty-Five Second Rule," which is a term that describes the fact that you have roughly forty-five seconds to assess what is wrong with any individual shot before your brain starts "fixing" these imperfections without you even realizing it. Now, forty-five seconds is clearly not a lot of time, so colorists usually have a pretty streamlined process that allows them to take advantage of this window.

The first thing many colorists will do is take a quick look at the image just to get a sense of what is in it,

" . . . the way our brains interpret visual information is often extremely inaccurate. "

before turning their attention to the scopes and starting to correct using these digital representations of the image rather than the image itself. By doing so, the thought is that you can get everything to a pretty good place – making sure the blacks are black without any color polluting them, making sure that there is a nice amount of contrast so everything is "popping," etc. – without wasting those precious forty-five seconds. I find this method particularly useful in dealing with the blacks in an image, as proper use of the Waveform and the RGB Parade is quite easy and does a better job than the eye alone ever will. Proper black levels are imperative to a solid color correction and if this step of the process is not done correctly – if the blacks in the image are not fully under control – getting the image to look "correct" will be nearly impossible (this is not to say one must always have neutral blacks, but one should definitely be aware of what is going on in the blacks as an unintentional cast in that region can cause all sorts of things to happen to the overall image). As Patrick Inhofer puts it in his fantastic tutorial on color correction, "If your blacks have a slight tint to them, it'll immediately start throwing off the rest of

the image. And if the tint of your blacks starts bouncing around from shot to shot, you're doomed. Neutral blacks are the foundation for creating either strong, aggressive images or light, airy images."[2]

The other way to get around the issue is to have a workflow that maximizes those precious forty-five seconds by moving through the image in a systematic way. Most colorists I have worked with prefer to do so by starting with luminance and then moving into color. Generally they will begin by setting the black levels so that the "blacks are black" and removing any color cast within those dark regions. Once that is done, they will balance their whites and pull them up as high as they can go while still maintaining whatever look they are going for. Once both these steps are complete the image should have clean black and whites and a nice amount of contrast and depth. Properly setting your luminance values will also make it much easier to match each shot in a sequence and this is another reason colorists often start here (as Inhofer puts it, "We begin by setting our luminance values for several good reasons. It starts with how the human eye works. It is structurally far more sensitive to subtle changes in brightness than subtle changes in color. When it comes to matching shots, luminance is the key.").

Once the blacks and whites are in a good place, we can now tackle color. In terms of making the image look "normal," this usually involves neutralizing any unintended color casts and making things within the frame resemble their referent. For dealing with color casts, I would suggest leaning on your RGB Parade scope. For me, color casts are one of the hardest things to see with the naked eye. When a color cast is present, I can usually tell that *something* is wrong with the image, but often times I need the RGB Parade to indicate to me where the imperfection lies. This is not at all surprising given how our brains will correct an image without us even being aware of it, as something as subtle as a color cast in one portion of a crowded frame is precisely the type of thing that will be "fixed" by our active minds.

When it comes to ensuring that objects within the frame resemble their referents, the most important thing to note is that objects we see all the time will be the most critical. Human beings have spent a lot of time taking in the sky, water, and grass, and for this reason, skies that are yellow, water that is purple, and grass that is grey will immediately trip the viewer up unless there is something in the lighting condition of the scene that would explain the appearance of the object (e.g., grass can be grey if it is under a moonlit sky). In contrast, objects that we don't interact with every day, such as an eggplant, are much less likely to trigger a negative reaction if they are incorrect.

Of course, the single most important thing to get correct in terms of a proper color balance are any human beings within the frame, which is why skin tones are so important. Human beings are accustomed to looking at and scrutinizing other human beings, and skin tones that are incorrect will immediately trigger a negative response. This is why most NLEs will include an "i-line" or "skin-tone line" in their vectorscope, as unless you are coloring a zombie movie, the objective should usually be to get the skin tones within spitting range of what the NLE recognizes as human skin tone.

Guiding the Viewer's Focus around the Frame

One of the main priorities for color correction is to properly guide the viewer's gaze about the frame. This is an issue when coloring *any* piece of filmic content, but in short form work, where the duration of individual shots is often quite brief, it is imperative that viewers are getting the information and emotive content you want from each frame as quickly as possible. In order to accomplish this, colorists use a variety of tricks to locate the viewer's gaze within the frame and speed up image comprehension.

One of the main ways to accomplish this goal is to darken – or blur – the non-essential portions of the frame (generally the sides and corners of the image) so that the viewer's eye gets pushed to the portion of the frame where the primary action is occurring (generally the center of the image). This technique works for a couple of reasons. The first is that since humans are always going to be hunting for information when they first come across a new image, they will naturally gravitate towards the portion of the image that is the easiest to decode. So, if you have a shot and one portion of it is extremely dark and murky, the viewer is going to look first to the part of the frame where information is clearly visible, as decoding this portion of the frame will involve less work to figure out what is happening and can be accomplished much

" . . . it is imperative that viewers are getting the information and emotive content you want from each frame as quickly as possible . . . "

more quickly. Conversely, the colorist can guide the eye by brightening or sharpening the area of the frame where the primary subject exists. Human beings come in for this treatment with some regularity, and if you pause a Hollywood film and look at the faces of the actors being depicted, don't be surprised if they seem just a touch more lit than everything else in the frame.

The second reason that darkening and blurring the non-essential portion of the frame can be helpful in terms of focusing the viewer's attention is that the technique resembles how our eyes take in the world in our daily lives. Take a moment and look up at an object across the room from you. Notice how the object that you're focusing on is clear and you can make out a large amount of detail about that object? Now pay attention to the peripheral part of your visual field. Notice how everything towards the outer edges of what your eyes are looking at is darker and fuzzier than the object you are staring at? This is just the way the eye works as, "Peripheral vision is weaker in humans, compared with other animals, especially at distinguishing color and shape. This is because receptor cells on the retina are greater at the center and lowest at the edges."[3] So, when you darken and blur the edge of the frame you are basically mimicking the way the eye works when it focuses on something and forcing the viewer's eye to adapt the perspective that you want (basically, you have set the focal object for them).

This technique also works because of how we intuitively understand our interlocutor's intentions. If I darken and otherwise obscure part of the image, what I am saying to you, the viewer, is "you don't really need to pay attention to what is over here, instead, use your cognitive energy on the portion of the frame I have left un-obscured." This is how we communicate with one another in general and it is analogous to me telling you a story that goes, "So I was walking down a crowded street and I saw Monica holding hands with Jim and they looked really lovey-dovey." In this narrative the "crowded city street" is just a detail to establish time and place which is why it would be unusual if your response to this narrative was not "oh my God, are they finally together!?" but instead, "tell me more about this crowded street,

were there a lot of trash cans and parked cars there?" Darkening or blurring the non-essential part of the frame works in a similar fashion, as it allows some of the setting – "crowded street" – to enter the story, without distracting the viewer from the heart of the narrative.

Another way to guide the viewer through the frame is by taking advantage of how contrasts in color help create separation. For example, if you have a red square and you place it inside a larger orange square, the red square will pop less than if you place it inside of a color more distinct from itself, such as blue. This applies throughout the color spectrum, as any time you have two colors that are on opposite sides of a color wheel (complementary colors), once you place them next to each other they will both stand out in a way that they

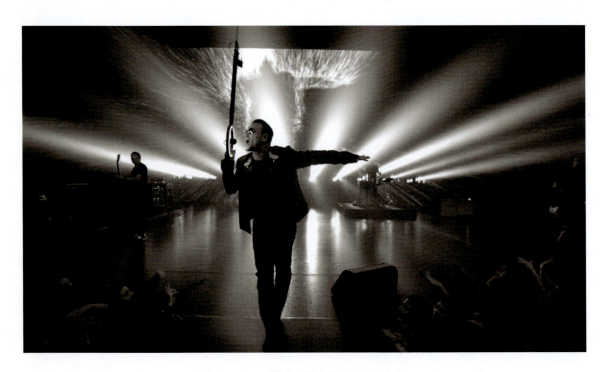

Image from U2 "Invisible" commercial.

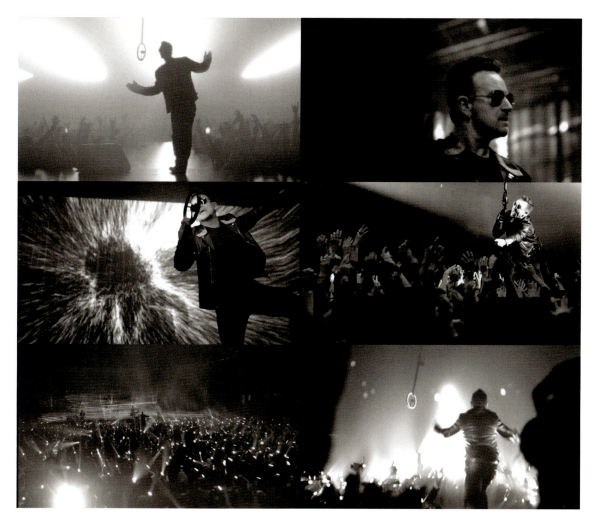

Images from U2 "Invisible" commercial.

wouldn't if they were next to other colors that were more similar to themselves.

This notion is the principle that grounds the common Hollywood technique where orange/yellow gets pushed into the highlights and teal/blue gets pushed into the lowlights. If you take a look at a color wheel what you will notice is that orange and teal are on the opposite sides of the wheel from each other.

By coloring the image so that the frame is primarily comprised of orange and teal, the colorist gets a large amount of separation and dynamism. The reason Hollywood colorists often choose to use orange and teal as their contrasting colors is, as we noted above, because human skin tones fall within the orange area of a color wheel. So, if you color a shot so that the background is a cool, teal color, the human beings

in the foreground will pop off the background and immediately announce themselves as the thing that viewers should focus on.

One of the easiest ways to see how important it can be to properly guide a viewer's eye around the frame is to look at a piece that is in black and white. Black and white is a great look, but without color it can sometimes be tricky to create the kind of separation you need in order to highlight the key elements within the frame. But, a good colorist can fix this problem by selectively using secondary windows to "pop" the most important areas of the frame and darken the non-essential portions of the image. For example, take a look at some of these stills from the U2 music video for "Invisible," which also became a commercial for Bank of America. The commercial was colored by Stefan Sonnenfeld at CO3, and although it is in black and white – and was shot that way on RED EPIC Monochrome cameras – it must have been quite tricky to color (that sounds weird but hear me out).

The first issue is that given how the video is lit with a bunch of strobing lights frenetically moving about, it must have been quite laborious to set the exposure, as it would definitely be shifting at every cut point (at one point everyone in the crowd has a flashlight, which means there was probably upwards of five hundred discrete light sources at times). Second, this is a *very* busy frame Sonnenfeld was dealing with, as it features crowds going crazy, U2 on stage, a video display playing in the background, and lots of movement within the frame and with the cameras. Although the director, Mark Romanek, gave Bono an unusual microphone/Ring Light gadget to make sure he was clear amidst all the chaos, he frequently tosses the microphone/Ring Light aside, which means that in order for him to be visible amidst all the other things competing for attention in the frame, Sonnenfeld has to do a lot of work to keep him prominent. He is quite successful in this regard, as my eye always feels like it knows exactly where to go in every frame despite the presence of potentially jarring highlights blasting through the background and a whole lot of action in the foreground.

Using Color to Evoke an Emotional Response in the Viewer

Henri Mattise, besides being a legendary painter with an excellent beard, was also a wise fellow, and he supposedly said the following about color, "It is only after years of preparation that the young artist should touch color – not color used descriptively, that is, but as a means of personal expression." I think we all know what he means, as color is this strange, powerful force that, at least for me, often feels a little out of my control. I will be doing rough color on a piece and move a slider a few ticks to the right or left and then – "ahh" – there it is, suddenly the whole piece will emotionally make sense to me, almost as if I was randomly trying keys in a lock and one suddenly sprung the door open. At that moment there is a real sense of satisfaction but also something slightly disconcerting about

"color is this strange, powerful force that, at least for me, often feels a little out of my control."

the whole process as it feels, well, like I got lucky. I am not a colorist so I try not to be to hard on myself, but accompanying the feeling of elation at having made the piece really sing is the foreboding notion that I could have just as easily destroyed it. I am a fairly analytical person, and what I find unsettling about color is how powerful it can be and how hard it is to understand. That said, let's try.

I think when it comes to using color in an emotionally evocative way there are two things to consider. These two things are very much related but it helps me to think about them separately and then combine them together. **Let's begin with the first issue, which is the way that individual colors impact us.** Now, this is a notoriously difficult thing to examine as red, for example, can mean love to one person in one context and death to another person in another context. This is because colors, like smells, have all sorts of associations to people that are quite subjective. That said, there are widely shared interpretations of all colors – most cultures view pale-blue as a tranquil, contemplative color rather than an anxiety producing one – and although

these interpretations always end up being affected by whatever stimuli a given individual has received in their lives – if every day of your life I had popped out from behind a pale-blue wall and startled you it is probably safe to say that when you came across the color pale-blue it would engender feelings of anxiety – there are some commonalities that do exist.

There is a book entitled *Drunk Tank Pink* by Adam Alter that begins with an anecdote that expresses this. Back in the late 1970s, a professor by the name of Alexander Schauss began doing research into the effect colors can have on people. After conducting a number of experiments, Schauss became convinced that bright pink had a calming effect on those who looked at it. With this knowledge in hand, Schauss went out into the world and suggested that prisons should experiment with painting their walls bright pink in order to pacify their inmates. Two commanding officers in the Navy took him up on the idea and painted one of their holding cells in the suggested hue. The results were remarkable, as new inmates would enter the cell agitated and irate and within fifteen minutes they would have calmed down significantly. In fact, despite how aggressive new prisoners traditionally are, the officers reported not a single violent episode during the seven-month trial. News of the results spread and soon jails across the country were painting their cells bright pink. The color was so widely utilized in the cells where violent drunks were held that this shade of pink was thereafter referred to as "Drunk Tank Pink."

According to Alter, color can affect us so deeply for both physical and associative reasons. As Alter notes

when discussing a study done in Canada – where researchers used blue-green lights to mimic sunlight in order to trick the bodies of sawmill workers on the night-shift – and a series of experiments that were conducted in Japan and Scotland – where civic leaders replaced the yellow streetlights in high-crime areas with blue lights that emitted a more calming light as well as mimicking the lights on the top of police cars – color operates on the physical and associative levels all the time:

> According to today's color psychologists, colors play a pow-erful role in human decision making for two reasons. The first is that color affects us physically, as the sawmill workers showed when their body clocks adapted better to shift changes under blue rather than white or yellow light. The second reason is that we associate colors with almost every imaginable pleasant and unpleasant object that pop-ulates our planet, which might explain why crime rates declined in Japan and Scotland when local authorities introduced blue streetlights that mimicked the lights atop police cars.[4]

I think this view of color as being both physical and associative is as good a place as any to start, so let's start breaking this down by examining the three primary colors – red, yellow, and blue – as well as the three secondary colors – orange, green, and purple – that are generally considered to be the foundation of color. Before I do I want to stress once more that I don't think colors can be said to "mean" something in a locked, specific sense. Yes individual colors tend to act upon most humans in similar ways, but obviously the shade of a color and the context in which it appears will have an effect as well. Let's begin.

Red

Let's start with a simple question: Why is the "red carpet" which stars and celebrities walk on while going into an award show always red? After all, that carpet could be yellow or purple or green but for some reason it is always red. So why, besides simple convention, is this so?

The first reason red carpets are red is that red "pops," so if you have a crowded space filled with a bunch of people wearing similar clothes as you would outside an award show, using a red carpet allows the carpet to stand out from the background and makes it a strong focal point. Red, because of how vibrant it is and how it is somewhat uncommon in the world, stands out

Color wheel.

from almost every background, which is why stop signs, fire engines, hunters' jackets, and red lights are all red. Red stands out because it is uncommon but also because it has one of the longest visible wavelengths, which makes it easy to spot from a distance.

The second reason why red carpets are red is that red is the color of lust and desire, and most of the people who are strolling up a red carpet are worthy of lusting after and are handsomely compensated for that quality. Red has always been regarded as the color of carnality, as it is no accident that Hester Prynne's "A" was scarlet or that the color of the lights brothels were made to display in certain countries was red and that these areas subsequently became known as "red-light" districts. This association between red and sex isn't merely anecdotal, as many studies have found that the color red can have a profound effect upon people in the sexual sense.

For example, a French study took sixty-four women and had them post personal ads looking for male companions. Over the course of the study, the women's ads remained identical, except that every two weeks the scientists running the study would digitally change the color of each woman's shirt. There were six colors they would rotate through – red, black, white, yellow, blue, and green – and what they were interested in looking at was whether or not any one of those colors was more likely to elicit a response from the males looking at the ads. What they discovered at the end of the year was that although black, white, yellow, blue, and green each had a 14–16 percent response rate, when the women's shirts were red, they had a *21 percent* response rate. In other words, the women were significantly more likely

> ❝color . . . can affect us so deeply for both physical and associative reasons.❞

to get an email from a male suitor when they were wearing red, even though nothing else in the ad had changed.

In another study, a team of researchers assembled a group of heterosexual men and showed each of them a picture of a woman wearing either a red or a blue shirt (the photos were identical other than shirt color). The men were then taken into a separate room and told that they would have a conversation with the woman in the photo and that they should arrange the seating area however they liked. What they discovered was that the men who had been shown the photo where the female was wearing the red shirt moved the chairs five feet apart while the men who had been shown the photo with the woman wearing the blue shirt moved the chairs six feet apart. As Alter puts it "The message here couldn't be simpler: If you're trying to attract a member of the opposite sex, red dresses and red shirts give you an ever-so-slight advantage."[5]

The reason why red is so connected to sex is attributed to our biological makeup, as red is a color that connects to signs of health and fertility. "Redder facial tones indicate highly oxygenated blood, a marker of

> *Red has always been regarded as the color of carnality*

cardiovascular health. Arousal also creates a flush of red … and skin reddens during peak fertility, signaling to men that women are fit for procreation – an important element of attraction."[6] Red is also connected to male sexuality in animals, as many mammals, such as the mandrill, display bright patches of red on their face and genitals to indicate virility and their alpha status.

The third reason why red carpets are red is that red has historically been a sign of power. Throughout history, institutions and individuals such as the Catholic Church, the Han Dynasty, the Bolsheviks, and the Emperor Charlemagne – who painted his palace red and wore red shoes at his coronation – have used red to signal power and dominance. Given this fact, it should come as no surprise that red is the most popular color on national flags – with white and blue next in line – as it is found on 74 percent of flags currently being flown around the world.

This association between red and power is so deep that it even seems to affect the results of sporting events, as was found in a fascinating look at results from the 2004 Olympic Games. In this study, researchers looked at the results from sports such as tae kwon do and boxing that featured individuals pitted against

each other in violent combat. What they found in the 457 matches they looked at was that the competitor wearing red beat the competitor wearing blue 55 percent of the time. Even more interesting was that in matches where the competitors were identically seeded and thus hypothetically evenly matched, the competitor wearing red won 62 percent of the time. As Alter says about these results, "Since the outcome of pugilistic events like boxing and wrestling are decided in part by which competitor is more dominant, aggressive, and psychologically commanding, the outcome is subtly biased in favor of the competitor who wears red."[7]

As we can see, red is a color we associate with action, energy, love, sex, and power. It is also connected to rage – hence the expression "he saw red" to describe someone who was angry – and violence (possibly due to its connection to blood). It is a color that always must be used judiciously – any designer can attest to how a tiny splash of red can instantly enliven and unbalance a composition – but one that always must be considered. As noted philosopher Taylor Swift puts it, "Red is such an interesting color to correlate with emotion, because it's on both ends of the spectrum. On one end you have happiness, falling in love, infatuation with someone, passion, all that. On the other end, you've got obsession, jealousy, danger, fear, anger and frustration."

Orange

In 2004, a series of protests and political rallies designed to call attention to a fraudulent election

that had taken place earlier that year broke out in the Ukraine. The peaceful uprising became known as the "Orange Revolution," and it ended up being the most famous of a group of "color revolutions" that swept through the former Soviet Union at the beginning of the 21st century. The reason the uprising became known as the Orange Revolution is that the first set of protestors had all been supporters of the opposition leader Viktor Yushchenko's campaign for president, and when they took to the streets to protest the election, they wore articles of clothing and carried banners dominated by the distinct, vibrant orange Yushchenko had used throughout his presidential campaign. As the movement picked up steam and hundreds of thousands of protestors started to flood into Independence Square in Kiev, newcomers who might not have been Yushchenko backers during the disputed election *also* began wearing the same shade of orange to identify themselves as supporters of the larger goals of the uprising (fair and free elections, true representation, a clean break with Russia, etc.). Orange eventually became synonymous with the movement, and the world was captivated by the images coming out of Kiev that showed Ukrainians of all ages braving the frigid winter in their bright orange clothing.

The fact that the world became enchanted by this imagery was pivotal to the ultimate success of the protests, as a key objective of the protesters was to use mass media to embarrass the ruling elite so that they would be forced to call for a recount. Ukraine still had close ties with Russia, but it also was doing a fair amount of trade with the West, and there was a desire amongst

"It is almost impossible to imagine orange as a malevolent color"

the ruling elites to be seen as a modern, economically liberal state. The protestors knew this and, given their reliance on non-violence, they needed pressure to be applied from outside of Ukraine in order to move the needle internally.

Given this need, orange was the *perfect* color for the revolution, as it helped signal to the world that the Orange Revolution was a peaceful movement concerned with righting a wrong and not destabilizing the region (just switch "Red Revolution" or "Black Revolution" for "Orange Revolution" – and then imagine all those thousands of people in jet-black outfits in Independence Square – and you can see what I mean). Furthermore, although orange is an active, kinetic color, it, unlike red, is not connected to violence and extreme passion. Orange, like the Sun it is so often linked to, is a source of power and vitality, but also endurance and life. If red has the capacity to incite disquiet due to the extremes it can evoke, orange is its more welcoming and passive sibling.

Here is how Patti Bellantoni describes orange in her excellent look at color and film, *If It's Purple, Someone's Gonna Die*: "Orange is a warm color that signals a

sweet presence … Our research has shown orange to be cheerful, simple, and uncomplicated."[8] Orange is the color of healthy skin tones, sunsets, many types of fruit, and a host of other things we tend to see as welcoming. It is almost impossible to imagine orange as a malevolent color – villains never wear orange – as it is passive and open (perhaps it is for this reason that prisoners wear orange, as the color clearly signals that the prisoners are in a position of passivity and it also makes them easier to spot if they escape).

All of these associations we have to orange helped make a big difference in the "Orange Revolution," as the protestors came to be seen not as a destabilizing force, but as on organic, welcoming mass that simply wanted to see justice realized. The historical record of large groups of citizens overthrowing a government is spotty at best – and it is particularly dicey in an Eastern European country that was victimized by both the Soviets and the Nazis – and orange served to show the dynamism of the movement as well as its fundamentally positive objectives. The movement was ultimately successful, as within a year the results of the contested election had been nullified and a recount indicated that the choice of the protestors – Viktor Yushchenko – had clearly won. A big victory for the democratic process and the color that helped make it possible.

By virtue of being the brightest color in the spectrum, yellow has a lightness to it, but it also "pops" in a way that draws attention to itself.

Yellow

The Golden Poison Frog, aka *Phyllobates terribilis*, is often described as the world's most poisonous animal. It is not venomous, i.e., it doesn't deliver its poison as a means of subduing its prey, but its skin *is* coated with an alkaloid poison which immobilizes and then kills anything that would dare to eat it. Although the Golden Poison Frog is a cheerful, social little fellow who seems content to raise his babies and ignore everything besides other Golden Poison Frogs, he is so poisonous that just one contains enough toxins to kill ten to twenty human beings or roughly two African Bull Elephants. Besides endowing the Golden Poison Frog with massive amounts of deadly poison to ward off predators, nature also made the frog a distinct yellow color in order to let it stand out from its surroundings and signal to possible predators that they really, really don't want to take a bite out of a Golden Poison Frog, despite how delicious it might appear to be. This contradiction between the deadly skin of the Golden Tree Frog and its mellow nature is a pretty common one in nature, as many peaceful but poisonous animals are bright yellow. Even the life-giving orange-yellow orb hovering above is capable of massive destruction if not heeded (I am pale of complexion and every time I watch a movie featuring people lost in the desert and dying from lack

of water I think to myself "the sunburn would definitely get me first").

Bellantoni describes the contradiction like this: "Yellow is a contrary color. It is the color of both jonquils and yellow jackets. One of the reasons yellow is the color used for caution signs is that it's visually aggressive. It appears to come toward you. We've built it into our consciousness as a cautionary color. Venomous reptiles and amphibians often are yellow – a warning to all who come near, a big beware built into our genetic code."[9] By virtue of being the brightest color in the spectrum, yellow has a lightness to it, but it also "pops" in a way that draws attention to itself. Especially when fully saturated, yellow stands out in any environment, as one need only think of Travis Bickle's bright yellow cab moving like a shark through the dark NYC night to see how malevolent the color can be. There is always something interesting about a person or object that stands out aggressively from its environment, as on the one hand this person or object can be seen as refreshingly present, but on the other hand this difference tells the world, "look at me but watch out, there is something in my brightness and individuality that you possibly should fear."

. . .an excess of green can also signal an indifferent world that could care less about the humans who inhabit it.

Green

In 2011, Warner Brothers re-released *The Lord of The Rings Trilogy: Extended Editions* on Blu-Ray. The reception was … interesting. Everyone agreed that the visuals in all three films were quite good, but the talk in areas of the Internet where things like this get discussed started to focus more and more on what came to be known as "the infamous green tint." The tint was only on the first film in the trilogy, *The Fellowship of the Ring*, but it quickly divided the vocal LOTR community. The majority of participants argued that the green tint was no big deal ("the 'tint controversy' is a tempest in a teapot," "The infamous 'green tint,' when it's visible, is ever so slight and it won't ruin your enjoyment of the movie"), but a vocal minority declared war against what they perceived to be a technically flawed release ("The green tint is hideous!! I really find it annoying!!!," "Is (*sic*) Jackson wanted the film to look like it took place in *The Matrix* and not Middle-Earth he is an idiot"; "F-WB's for destroying a masterpiece with their corporate greed"). The debate raged on for weeks and eventually Warner Brothers and Peter Jackson were forced to weigh in and affirm that nothing had gone technically awry with a batch of the Blu-Ray's – which was one of the main theories as to why some people saw the green tint and others did not – and to affirm that yes, the films had been

re-graded and yes, the Blu-Ray version accurately represented Jackson's vision for how the film should look.

Besides reaffirming that fantasy film lovers are not to be trifled with, the debate touched upon something interesting about the color green. The main objection of those upset by the green tint was that it had taken a cheerful and bright color palette and flattened it out. As one commenter put it, "For me it's not so much the snow on the mountains that's the most objectionable but everything from Hobbiton. The tone of that sequence is completely obliterated by the green. It was supposed to be a joyful and happy place but now it's all dull and dreary and dark." This thought is what underscored the constant references to *The Matrix*, a film that has a prominent green tint on all of the scenes that take place inside the world of the Matrix.

The "green tint" firestorm was a great example of the paradox of green. As Bellantoni puts it, "Green is really a dichotomous color. It's the color of fresh vegetables and spoiled meat. Perhaps its duplicity comes from our earliest times on this planet when green signaled both food and danger. It is a simple fact that green, in its plant manifestation, signals life itself. Green in the atmosphere, however, can signal a low-pressure system that can spawn a tornado, and 'Beware of the green water' is a sailor's warning. So green can signal health and vitality or danger and decay."[10] I think there are a couple of ways to look at this.

The first, and this is the most obvious, is that green is the color of nature. Nature is generally regarded as a wonderful thing by most people – I could do without sunshine and mountain tops but I know many people who just go gaga for the stuff – but one need only think about the lush greens of the jungle in *Apocalypse Now* or *The Thin Red Line* to see how an excess of green can also signal an indifferent world that could care less about the humans who inhabit it. We have always needed nature to survive, but throughout our existence as a species, nature has also sometimes been quite cruel to us. A fear of what nature is capable of is universal, as human beings have spent a large part of their existence watching nature very closely to see what she was going to do. In other words, we need nature, but we also need to control it, and an excess of green can signal a loss of control.

Another way of looking at an image that is primarily green is to say that the image lacks the color red. As we discussed earlier, red is the color of passion, love, and violence. Thus, a world dominated by green is a world that lacks these attributes. This – as well as the connection to the green GUI of early computers – is why the green cast of the world of the Matrix works so well for the film. Yes the Matrix is a pleasant simulation, but it is ultimately an illusion – and a cold one at that. The filmmakers signal this by pushing the grade of the Matrix toward green, as you intuitively feel that there is something artificial and inert about Neo's life within the Matrix without being able to put your finger on what it is.

Blue

In 2011, Dulux Paints conducted a worldwide survey to determine what was the most popular color in the world. The survey involved respondents from thirty different countries and the winner by a wide margin was blue, which was the color that 42 percent of the males and 30 percent of the females reported as their favorite. It was also the color that was the least disliked by most of the cultures surveyed.

There are a number of reasons for this. For starters, blue is generally regarded as an honest, trustworthy color. Because of how social human beings are, and how imperative collaboration has been for our success as a species, honesty is an attribute that we value extremely highly. In fact, in a survey that asked respondents to rank personality traits, the one that came in dead last on the desirability scale – out of a whopping 555 possible traits – was "liar."[11] This fact plays into how positively we view blue as, perhaps because of the associations we have with blue skies and water, blue is seen as a forthright, honest color.

Blue is also generally regarded as the color that signifies stability and prudence. It is on the opposite side of the color wheel from orange, red, and yellow, and whereas those colors signify change, blue signifies consistency. This is why blue in many countries – most notably the UK – is associated with the conservative side of the political spectrum and its opposite, red, is usually associated with the Left (the US is an exception to this rule, although the association of the Republican party to the color red and the Democratic party to the

Blue is also generally regarded as the color that signifies stability and prudence.

color blue is a recent phenomenon that is traced back to the 2000 election).

Blue is also a color that we associate with thoughtfulness and creativity. For example, researchers did a test where they had subjects complete six different cognitive tests on computer monitors that had blue, red, or white desktops. If the test involved paying close attention, such as proofreading, the subjects who did the test on the screens with red desktops did significantly better (probably because red is a color that gets us to pay attention). If the test involved thinking creatively – such as when the researchers had the subjects draw pictures or brainstorm – the subjects did almost twice as well when the blue desktop was used.

Blue's associations with qualities like thoughtfulness, stability, and consistency are why it is so commonly used in the commercial space. Fortune 500 companies such as Walmart, Facebook, IBM, Intel, The Gap, Pepsi, and Best Buy use blue heavily in everything from their logos to the interiors of their stores. These companies have spent a lot of money

researching the effect of color on consumers, and one of the things that they have found is that the ambient color of their stores affects purchasing. As Simon Lee and V. Srinivasan Rao put it, research has shown that "a blue environment led to more simulated purchases, fewer purchase postponements, a stronger inclination to shop and browse than a red environment ... (and that) a blue interior was considered more likeable by subjects and was associated with greater shopping and purchase intentions than an orange interior."[12]

Purple

Purple is a strange one. Often associated with royalty – possibly because purple was a hard dye to make in the past which made clothing that was purple quite expensive – purple is a color that gets a big reaction, either positive or negative. For example, in the aforementioned Dulux Paints' study, 20 percent of men associated purple with courage and bravery, but 22 percent of men and 23 percent of females considered it their least favorite color.

The general line on purple seems to be that it is connected with wisdom and truth. The reason for this is probably that purple is a mix of blue and red, and as such it takes on the contemplative, thoughtful side of the former, while also having the drive and passion of the latter. Given that wisdom is basically the result of living a life fully and then reflecting upon the lessons that have been learned, a combination of action and contemplation would seem to be necessary (as Hermann Hesse put it, "Knowledge can be communicated, but not wisdom. One can find it, live it, be fortified by it, do wonders through it, but one cannot communicate and teach it.").

Because of this connection to wisdom, exclusivity, and royalty, purple is a color often connected to spiritual pursuits. For example, during the Christian observance of Lent, when worshipers fast and pray for penance for the four to six weeks leading up to Easter, priests usually don purple vestments. Furthermore, the church is often draped in purple cloth during Lent, which connects worshippers to the sacrifice Christ made for them, as well as helping to visually separate Lent and Easter from the rest of the year.

Now that we have looked briefly at the six main colors in the spectrum and how they tend to affect people, we can start to examine the second element to using color to evoke an emotion, which is taking the colors you chose to maximize and those you chose to minimize and creating an evocative balance between them. If you color a piece so *every* color is vibrant and present, it makes it hard for the work to achieve emotional clarity, so one of the most important tasks of color correction is figuring out which colors should dominate and which should take a secondary role. Here is a sampling of some of the popular color schemes that short form content creators will lean into in order to do so.

"purple is a color that gets a big reaction, either positive or negative."

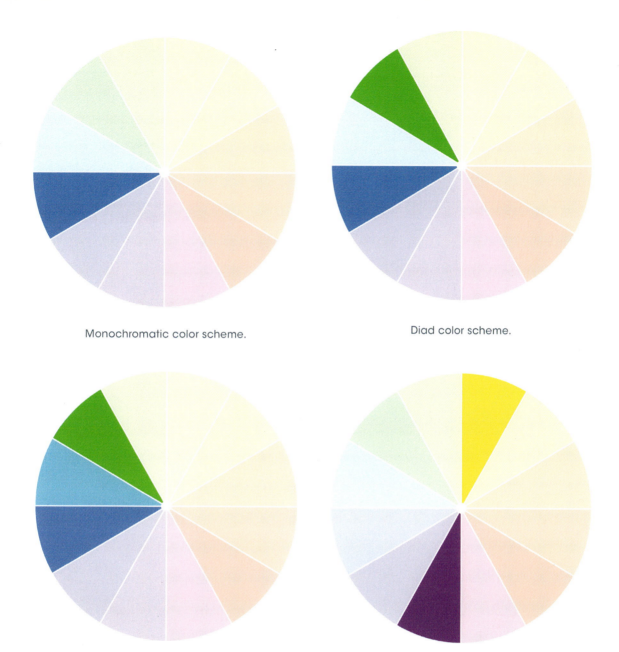

Monochromatic color scheme.

Diad color scheme.

Analogous color scheme.

Complementary color scheme.

Monochromatic color schemes are those that consist of shades and hues of the same color. Monochromatic color schemes are quite common in short form filmic work, as they immediately signal the emotional intentions of a piece and the product it is selling, as well as helping the piece to "pop" from the other short form work surrounding it. As we have discussed, a big part of short form work is quickly signaling to

Triad color scheme.

the three colors is the dominant note and the other two act in a supporting role. This sort of color scheme has a casual, natural feel, and doesn't demand all that much from the viewer. The analogous color scheme is a good, safe choice much of the time, as it has the emotional clarity of the monochromatic color scheme but without its artifice.

Diad color schemes are similar to analogous color schemes except that they remove the color in the middle. This sort of scheme keeps some of the naturalism and casualness of the analogous color scheme, but by removing one of the colors it simplifies things and adds a touch of dynamism.

Complementary color schemes are all about contrast, as they utilize two colors that are opposite one another on the color wheel. As we mentioned earlier, complementary color schemes are very useful when you want to create a lot of contrast in the scene

the audience what you want them to feel, and using a stripped down color palette can help to do so.

Analogous color schemes use three colors that are next to each other on the color wheel. Generally, one of

Rectangle and Square color schemes.

Image from "Make The Moment Shine."

and when you have an object of interest within the frame – usually people – that you want to pop off the background.

Triad color schemes are those that use three colors that are arranged in a triangle around the color wheel. As with other color schemes featuring three colors, one color should dominate and the other two should be accents. Color schemes like this can get a bit busy so it is important to make sure that the object(s) of interest remains clear.

Rectangle and **Square** color schemes are those where four main colors are used, either in the shape of a rectangle or more evenly spaced around the color wheel such as you would find if you drew a square across the wheel. With four colors involved it is even more imperative to make sure that (a) one color is clearly dominant and (b) that the image isn't a total mess.

So, now that we have seen some of the main tasks that will take place in the color correction phase, let's take a look at a commercial for the Samsung Note that illustrates some of these techniques. The spot was created to advertise a partnership Samsung has with Swarovski, and it was graded by Jean-Clément

Jean-Clément Soret on grading "Make the Moment Shine"

Jean-Clément Soret is the Global Creative Director of Color Grading at MPC. He is a five-time Best Colorist winner at the British Arrow Craft Awards, and was voted Best UK Colorist four years in a row and Best UK VFX artist by Televisual Magazine. Besides working on short form content, he has also graded features films such as Trance, Snatch, 127 Hours, Mandela: A Long Walk to Freedom, *and* The Twilight Saga: Eclipse.

Bryan Cook: Given how limited short form is in terms of total running time, how imperative is it for the grade to quickly establish and maintain the emotional tone of a spot?

Jean-Clément Soret: Let's say that you're on a thirty-second spot, I think that it's quite critical that from the first shot the look is there and then the rest of the ad is just usually matching … it's a bit like composing a jingle. You have a very short amount of running time so bang, you're in immediately.

It's different for feature films because usually you have long sequences and so you have the freedom of very different looks. Like a lot of grain, no grain, very sharp, very soft, which you can't really have in one commercial. Usually you have to have some sort of unity in short form. There is a backbone to the project.

Furthermore, usually you're being asked to create maximum impact in short form because you have to be noticed right away. Which is not necessarily a lot of contrast and a lot of color, it can be its own look, but it has to be very, very consistent. You have to make sure that you have maximized a specific look and that you've matched shot to shot to that maximum.

It was easier when you had the print because the print was already, like, let's say 70 percent there, and you were just improving a few things, but you already had the look there. Now you start from nearly nothing as it all looks very flat and ugly but it's all there. It's up to you to bring it back. The question I'm asking every time I grade is "have I brought back everything or have I left anything behind?"

continued overleaf

Bryan Cook: One thing I've always noticed about your work is I think you've got a really good sense of grain. Could you speak a little bit about film grain and what you think grain does for the overall feel of a piece.

Jean-Clément Soret: Very often we're trying to emulate film where, typically, when you have a bit of overexposed film, you would have grain in the highlights, and when the film is underexposed then the grain is in the shadows. So you can adjust not only the size and the amount of grain but also the location of the grain. Is it in the mid-tones, in the highlights, in the blacks? You can have a bit more blue grain, which is typical of underexposure, or more yellow grain, which is typical of overexposure. It's playing with these parameters to try to emulate film.

Also, there's a lot of things people are used to which we can play with. With a hand-held piece, let's say with a comedy, you expect a little bit of imperfection and grain because it's human, organic. While if you have a sleek car commercial, which has to be super pristine, sharp, then you wouldn't put grain there.

Bryan Cook: That connects to something I've definitely noticed about your body of work, which is that you have this ability to generate a look that I would call both classic and modern. How do you go about achieving this blend? Is that something you're consciously striving to do or is that just your innate aesthetic?

Jean-Clément Soret: When I was working on film, I used to work in a lab where I manufactured all sorts of amazing stuff like Technicolor dye transfer print, hand-painted black and white, etc. I was really lucky to be able to do that and to transfer these to videotape. When I then moved to commercials I had all that culture and all that background that I was able to use creatively by trying to emulate all these wonderful looks.

I've always built on what I know, and what I know is very much a classic background. It comes from film, from print, from processing, and I've built on top of this to replicate something that happens naturally in film.

Bryan Cook: You graded a spot for Samsung entitled "Make the Moment Shine" that I want to discuss for a moment. The heroine in "Make the Moment Shine" is often attired in clothing that is red or blue. Using these colors helps in terms of focusing the eye – as she quickly pops off the background where the highlights have a yellowish cast –- but, more importantly, it also connects her to those colors. How do you

Image from "Make The Moment Shine."

Soret, the Global Creative Director of Colour Grading for MPC. The spot is pretty flimsy on the narrative front, as its story could be summed up as "a hip young woman uses her phone as she does cool things in awesome clothes," but the piece is a lot of fun, and the color and art direction is the main reason why.

As you can see from the stills, Soret and the directors Leila and Damien de Blinkk leaned into a triad color scheme based on the three primary colors of the spectrum. The first step was to take the highlights and push a bit of yellow into them. Then, drawing a triangle in two directions from there, you end up at blue and red, and, no surprise, you can see that the woman's outfit is almost always dominated by either blue or red. In order to really let yellow, red, and blue dominate, Sorel also minimizes orange, green, and purple, as none of the secondary colors has much of a role to play. So now we have our heroine popping out from the background, a stripped down color scheme with the three secondary colors knocked way back, and we are connecting our heroine with blue (honesty, stability, etc.) and red (passion, change, etc.). It might seem strange to connect one person with those contrasting traits,

Image from "Make The Moment Shine."

but for a sexy, young, career girl it is a great blend, as what could be more attractive than a beautiful woman who is thoughtful *and* exciting.

In order to separate the heroine from the background even further, Sorel utilizes some subtle vignetting and blurring, as many of the shots have a haziness around the edge of the frame that helps draw your eye towards our heroine. Sorel wisely avoids using a heavy, dark vignette, and as a result the piece retains a light, airy feel. This light feel is accentuated by how Sorel avoids letting the blacks get "too black," as all the dark regions tend to be a little milky and take on the cast of whatever colors they are closest to (so, the blacks might have a slightly blue cast when they are in her blue shirt and a slightly brown cast when they are falling on the backseat of the taxi she changes in).

Despite the way he pushes yellow into the highlights, Sorel does a great job keeping the skin tones warm and natural. This helps the woman pop from the background, but, even more importantly, it keeps her looking beautiful and attractive, as yellow is not a great color for skin, particularly when it starts to bleed a bit into green (which the highlights occasionally do). This

think this connection between the heroine and the colors red and blue affects the audience's perception of her?

Jean-Clément Soret: When there is an art direction that's there, of course you always respect that and enhance that. Make sure that those colors are present in the image, one way or another. The yellowish highlight … It's something I do because I don't like whites to be super white. When they are perfect, it looks very high tech and it's suitable for some spots, but in this one it felt more human to have warmer highlights. I remember when we were doing that spot we realized about halfway through that there was no green left in the image. We had unconsciously suppressed all the green and moved it towards yellow and blue. And we thought, "Oh yeah, that's cool. We like it. That's the look of the film."

But to go back to my background and how I can mix modern and classic, this is a good example, because on that spot I treated the contrast in a classic way, which means you use a soft toe and soft shoulder and make sure things don't clip harshly. When you do this, the colors all come together in a very natural, very classic way. And then you build on top of that and that gives you more freedom. If your base is wobbly and you've started to crush and clip things and have unnatural color balance, everything you build on top is just fixing what you've done wrong to start with.

Bryan Cook: One of the things that I like about your approach and your aesthetic is that you don't view the blacks and the whites as off-limits. People often feel like the blacks must remain black and whites must remain white but you play around with casts in your whites and blacks a lot. Could you talk a little bit about how you approach the highlights and the lowlights?

Jean-Clément Soret: It's part of the whole thing. Your blacks can be anything you want. The more color you put in the blacks then the more of a look it becomes, so it's to be done with some degree of subtlety. Typical example: If you want an aged film look, then you put some magenta in the blacks and green in the highlights. That is kind of an extreme example of course, but usually it would be a lot more subtle than that.

Very often with digital cameras they give you black blacks and white whites, and that's the way it comes out in the RAW files. A lot of the time I introduce blue in the low-mids and warmth in the highlights. Immediately it gives you a very natural and organic look. It's funny because, again, that's very much how actual film works. It doesn't have any pure whites and pure blacks. You take any piece of negative and you print

continued overleaf

Images from "Make The Moment Shine."

seems like a minor thing, but it illustrates perfectly why great colorists get paid the money they do, as a bumbler such as myself would have been able to push some of the overall tint Sorel does into the image, but I would never have been able to keep the skin tones looking so good at the same time.

Lastly, as a result of keeping the colors limited to the primary portion of the spectrum and keeping the blacks a bit milky, Sorel manages to get a feel that is both classic and modern. It's hard to pinpoint exactly what gives the spot its slightly retro feel, but there is an element of the look that harkens back to the film stocks used during the French New Wave (in particular, the spot reminded me, and a creative I was working with at the time, of Jacques Demy's *The Young Girls of Rochefort*). The subtle, retro feel adds a really nice dimension to the story, as one gets the sense that our girl is a modern version of the fashionable

and independent heroines of 1960s and 1970s French cinema. This visual allusion is not a minor thing, as the main target for a Swarovski bejeweled cell phone case is most definitely a fashionable and independent young woman, and if you want to make a fashionable and independent young woman's day, just compare her to Catherine Deneuve or Anna Karina. Furthermore, by making this connection, Sorel gives us a glimpse inside the girl's psyche, as I couldn't help but imbue her with qualities and characteristics – independence, whimsy, intelligence – that I associate with the heroines of the French New Wave.

As one can see with the Samsung spot, color can be an incredibly powerful tool in short form content creation. Short form is all about making an impact and quickly establishing an emotional tone, and a thoughtful grade can do wonders for these efforts. Of course a good grade is also critical for making your images look beautiful, and when you're in the business of selling things, beauty is rarely a bad thing.

it, the vast majority of the time you'll wind up with blue blacks and yellow highlights.

Bryan Cook: You're very subtle with vignettes and you definitely don't let them overpower your frame. Could you talk a little about vignettes and what you feel about them?

Jean-Clément Soret: I think vignettes are often used in the wrong way. It's a bit like highlight tinting or harsh blacks. With heavy vignettes it was fun to do that in the 90s when we had a very limited amount of toys and we didn't know what to do to impress the audience. But we've all moved on from there and color grading is a lot more mature than it was. Now we tend to respect the image a lot more and I think the way we use vignettes is part of that.

The way I do vignettes, and some of the other colorists I know do the same thing, is as if it was an optical thing. Like if your lens was doing it, which is a very soft fall-off. A bit like those anamorphic lenses. They always have a big fall-off at the edges, which is what we try to replicate. I think it's a bit like when you clip the highlights and you have some solarization. It can be a nice effect, but 90 percent of the time people don't want it. To be honest, it's a bit lazy to use a big heavy vignette. It's like, "Ding! Okay, it's done. Okay. Let's move to the next shot," rather than spending a good ten minutes trying to craft the image in a natural way.

Bryan Cook: What is the one question you always end up asking yourself while working on any piece?

Jean-Clément Soret: I don't think there is just one question but questions I often ask are, have I reached the maximum potential? Have I explored all possibilities? Is what I've done useful for the piece I'm working on? Does it bring something? Is it helping the narrative? Helping the story? Have I improved the spot in any way? Have I disappointed or brought something?

I consciously try not to feel comfortable or apply recipes because you just can't do that. You've got to dig a little bit to make sure that you've used the image to its maximum potential. Very often I push things a bit too far and then I trim back. To me it's a much better approach to do it this way than to start in a shy way and have everyone say "Oh yeah! Looks great!" And then you carry on and you've missed an opportunity.

1 MIT, Synesthia and the Synesthetic Experience, http://web.mit.edu/synesthesia/www (October 7, 1997).

2 Patrick Inhofer, *Patrick Inhofer: Color Correction*, http://splicevine.com/july-color-correction (July 1, 2012).

3 Wikepedia, Peripheral Vision, http://en.wikipedia.org/wiki/Peripheral_vision, accessed August 6, 2015.

4 Adam Alter, *Drunk Tank Pink* (New York: Penguin, 2013), 162.

5 Alter, *Drunk Tank Pink*, 170.

6 Matt Huston, "The Siren Song of Scarlet," *Psychology Today*, April 2013, 39.

7 Alter, *Drunk Tank Pink*, 175.

8 Patti Bellantoni, *If It's Purple, Someone's Gonna Die: The Power of Color in Visual Storytelling* (Burlington, MA: Focal Press, 2005), 46.

9 Bellantoni, *If It's Purple, Someone's Gonna Die: The Power of Color in Visual Storytelling*, 42.

10 Bellantoni, *If It's Purple, Someone's Gonna Die: The Power of Color in Visual Storytelling*, 161.

11 Norman Anderson, "Likableness Ratings of 555 Personality-Trait Words," *Journal of Social Psychology* 9 (1968): 272–279.

12 Simon Lee and V. Srinivasan Rao, "Color and Store Choice in Electronic Commerce: The Explanatory Role of Trust," *Journal of Electronic Commerce Research: JECR* (Long Beach, Calif.), 11 (2010): 110–126.

Fade to Black

If the piece stinks, just make sure it has a good ending.
Bryan Cook

The cynical bit of advice in the epigraph above was something I once said to an agency client – who we will call Bob – towards the end of a session. Bob's commercial was, as we all freely admitted, a train-wreck. The shoot had been one of those where everything that could go wrong – weather, actor with food poisoning, director with delusions of grandeur – did go wrong, and we had not been able to entirely mitigate the issues in post. So, as we sat there in my bay, peeking through our fingers at the blight upon our culture that we had created, we brainstormed options. My argument, and the one which won the day, was that we needed to discard all logic and make an exciting ending that basically occupied the last two-thirds of the spot. No the spot wouldn't make sense – narrative logic was a luxury not afforded to us on this occasion – but we only had four hours before the clients were stopping by, and, unless we did *something*, we were in a world of pain.

So we got to work. The music got huge, the edits got fast, the colors got bold, the sound design got epic. By the end of it all I had no idea what the commercial was communicating, but, if you stepped beyond those parameters, the spot kind of worked: It certainly *felt* like it meant something. As we watched it down and waited for the clients to enter the bay we realized that if they spent ten seconds thinking about what they were watching we were doomed but, if they jumped aboard the narrative rocket ship we had built, we might be OK.

They finally showed up and handshakes were made, drinks handed out, pleasantries exchanged, and lights dimmed. I said a silent prayer and hit play. At the end of the thirty seconds I hit play again and ran it one more time before turning around to face the room. They were, as clients often are at creative reviews, inscrutable. I noticed they were all looking in the direction of one of the men, who I took to be the boss, and so I turned and addressed him (at this point Bob looked ready to vomit, so I took the lead). "Any thoughts? We were trying to do something different with the category and really appeal to viewers emotionally, did we go too far?" The Boss, aka El Heffe – a distinguished looking guy with a commanding presence and magnificent CEO hair – stared at me. I waited. He stared some more. Finally, in a surprisingly quiet voice, he turned to his staff and said, "See, this is what I have been talking about. This is a great commercial! This is a commercial that makes me *feel* something!" I looked over at Bob as the rest of the clients quickly chimed in to support El Heffe's verdict. He looked pale and spent, but relieved. I was as well. The spot would never

be great – or even good – but, we had been there late the last three nights trying to save it and all I wanted to do was to get out of there at a reasonable time, head to a bar, and sip a cold beer, so it was a major victory.

Was our victory cheap? You bet your ass. Did I feel a little dirty? Certainly. But, in a strange way, it also felt good, as what we had done was to utilize the techniques I have been describing throughout this book to make something inherently terrible, not so bad. No awards would ever be given for the spot – heaven knows they shouldn't have been – but, by calling upon all I had learned studying and working alongside some of the most talented people in the short form game, I had at least made it acceptable.

And, as I sat at the bar having that cold beer a few hours later, I realized why I was actually writing this book. Sure I wanted it to be an in-depth analysis of the craft of short form content creation, but I *also* wanted to write a book that would celebrate the amazing work my short form colleagues do every day. People like Bryan Jerden and Jean-Clément Soret and Neil Gust usually don't get their names in credit sequences, aren't honored at nationally televised award shows, and will probably never be stopped on the street and asked for an autograph. But they, and thousands of others who I didn't get a chance to talk to, regularly make exceptional content that impacts our culture and pushes the craft of filmmaking forward. Furthermore, I hope that if you are a student in filmmaking you will read this book, take a look around at some of the short form you interact with every day, and consider whether or not short form might be right for you.

If you are a student let me leave you now with a piece of advice one of my mentors once gave me. I was showing him an edit that wasn't going well and wanted his take on what I could do to make it work better. He watched it down a few times and after informing me that the problems with the piece were too profound to fix easily – "this whole thing is a goddamn mess" were his exact words – he told me to get some coffee, scrap the whole thing, and start again. It was already late and I must have looked crestfallen that I now had so many more hours of work left that evening, so he patted me on the shoulder and gave me his sage words of wisdom. "Bryan, the world is full of ugly shit and this piece is just going to be more of that. I know it's late but do you really want to put more ugly shit into the world?" Not the most stirring of speeches but effective nonetheless, and even now, when it is late and I am starting to think about cutting corners, I remember those words, buckle down, and get back to work.

Index

Note: Page numbers in *italic* indicate figures.